NATURE TRANSFORMED

SEAN M. ULMER, EDITOR]

JANICE BLACKBURN]

TERRY MARTIN]

DAVID McFADDEN]

Wood Art from the Bohlen Collection

NATURE TRANSFORMED

UNIVERSITY OF MICHIGAN MUSEUM OF ART

ANN ARBOR, MICHIGAN

in association with

HUDSON HILLS PRESS

NEW YORK AND MANCHESTER

Published in conjunction with the exhibition *Nature Transformed: Wood Art from the Bohlen Collection*

University of Michigan Museum of Art
Ann Arbor, June 12–October 3, 2004

Mobile Museum of Art
October 7–December 31, 2005

Museum of Arts and Design
New York, 2006

This exhibition and companion publication have been made possible by foundation and individual sponsors who wish to remain anonymous and by the Friends of the Museum of Art.

© 2004 The Regents of the University of Michigan

Library of Congress Control Number: 2004102419
ISBN: 1-930561-08-3

Distributed by
Hudson Hills Press LLC
74-2 Union Street
Manchester, Vermont 05254
Paul Anbinder: Founding Publisher
Randall Perkins and Leslie van Breen: Co-Directors
Distributed in the United States, its territories and possessions, and Canada through National Book Network, Inc.
Distributed in the United Kingdom, Eire, and Europe through Windsor Books International.

Designed by Jeff Wincapaw with assistance by Jennifer Sugden
Edited by Eugenia Bell, Karen Goldbaum, and Marie Weiler
Proofread by Sharon Vonasch
Color separations by iocolor, Seattle
Produced by Marquand Books, Inc., Seattle
 www.marquand.com
Printed by C&C Offset Printing Co., Ltd., China

Front cover: Todd Hoyer, *Untitled* from *Suspended Sphere* series, 2000 (detail, plate 64)
Back cover: Dick Codding, *Untitled*, 2000 (detail, plate 106)
Pages 2–3: Alan Stirt, *Spiral Ceratite*, 1997 (detail, plate 5)
Pages 4–5: Hans Weissflog, *Big Spider Bowl*, 1996 (detail), ash, 17 × 17 × 3½ in.
Page 11: Hans Weissflog, *Star Bowl*, 2002 (detail, plate 22)
Pages 24–25: Hans Weissflog, *Big Spider Bowl*, 1996 (detail); Todd Hoyer, *Moving On*, 1993 (detail, plate 38)
Page 71: Mark Bressler, *Spirit Dancer*, 2002 (detail, plate 16)
Pages 80–81: John Morris, *Head*, 1999 (detail, plate 81); Steve MacGowan, *Prairie Avenue*, 1998 (detail, plate 102)
Page 117: Mike Irolla, *Hemlock Canyons*, 2001 (detail, plate 26)
Pages 126–27: Arthur Jones, *Exhibitionist*, 2001 (detail, plate 132); Alain Mailland, *The Stone Eater*, 2000 (detail, plate 145)
Page 159: Robert J. Cutler, *Essence*, 2002 (detail, plate 46)
Page 163: Hans Weissflog, *Big Spider Bowl*, 1996 (detail)
Pages 164–65: David Nittmann, *Shamrock V* from *"Bodydrum" Basket Illusion* series, 2001 (detail, plate 52)

Unless otherwise indicated, all of the works illustrated by plate numbers are currently in the Robert M. and Lillian Montalto Bohlen Collection.

The following works are among those donated to the University of Michigan Museum of Art, Ann Arbor: 1, 7 left, 14, 16, 18, 22, 26, 35, 37, 48, 53, 57, 61, 64, 68, 69, 89, 98, 100, 105, 107, 108, 109, 119, 123, 142, 145, 146, 148.

The following works are among those donated to the Mobile Museum of Art: 74, 125, 134, 147.

The following works are among those donated to the Museum of Arts and Design, New York: 7 right, 12, 92.

The following works were formerly in the collection of Dr. Irving Lipton: 24, 43, 48, 49, 55, 56, 57, 66, 87, 96, 97, 100, 122, 123.

All plate photographs by Dirk Bakker

CONTENTS]

DIRECTOR'S FOREWORD

The University of Michigan Museum of Art (UMMA) takes as a core part of its mission the development and presentation of projects that challenge the received wisdom in the visual arts; that ask visitors and readers to question their perceptions of form, materials, technique, and indeed the history of art itself; that present new artists and fields of visual creativity for in-depth investigation. This exploration of wood art falls squarely within this enterprise, in part because it simply takes as a given the conceptual and technical sophistication of the nation's most accomplished artists in wood, putting to the side the rather tired discussion of art relative to craft and instead challenging ourselves to look attentively at the artists and works of art we present here.

My own familiarity with wood art is of some duration, although it is far from my own areas of specialization as an art historian and curator. From visits to commercial galleries in Los Angeles and Santa Fe, to collecting institutions in this field such as what is now the Museum of Arts and Design in New York, to temporary exhibitions at institutions such as the Detroit Institute of Arts, I have developed an orientation toward the wood art of the last twenty years as incarnating the vision and audacity of the best work in any contemporary art medium. One must add to this the technical sophistication—often painstaking and hard won—that is to be found in these works and which often separates wood art from certain other media of recent times in which the conceptual requirements of the work require little technical mastery on the part of the artist.

This awareness led me to Robert Bohlen, whose collecting activities from his home in Brighton, Michigan, had made him a renowned figure in wood art circles particularly and in collecting circles more broadly. The 2000 exhibition drawn from the Bohlen collection, which was held at the Detroit Institute of Arts, had helped to shape the growing public and curatorial understanding of wood art. When Bob and I first met, I saw immediately that his collection of wood art contained works of the highest quality by the majority of the most talented wood artists in the United States—and the collection has only grown in scale and quality since that time. My appreciation of Bob's collection in visual terms, and my disinterest in the shopworn debate of art versus craft, led us to think about partnering to present a new project that would go beyond the DIA exhibition to assert quite straight-forwardly (without the prevarication that has typified past work in this area) the presence of wood art as art.

Any thoughtful approach to the material presented here and in the companion exhibition organized by UMMA makes clear that the makers of the turned wood objects in the Bohlen collection are artists—creative talents giving shape to their deeply personal visions, using unique and often difficult materials to a variety of ends. These include the representation of the real world, if one can call it that, as well as the creation of abstract, nonrepresentational works in which form, texture, materiality, and the artist's conception become the subject matter. Are these not the criteria by which the success of artistic endeavor in other materials is to be judged? Have we not for some time now been ready to take these criteria to works of, say, decorative arts, in order to de-emphasize the "decorative" and underscore the "art" and the unique vision of the maker? Have we not seen this trajectory in the medium of glass, for in-

stance, to the point where, taking an obvious example, the work of Dale Chihuly would be examined as art?

There are clear reasons why wood art is only now coming to be appreciated as an art form, worthy of discussion alongside the greatest achievements in stone carving, metal casting, or, more recently, works made in glass. It is not my goal to explore these reasons at length here—the essays that follow each touch on aspects of this history. But I must note in passing that impediments were raised most notably by the origins of the medium in the creation of functional objects and, secondarily, by the often humble and seemingly commonplace nature of the materials from which they are made. These characteristics have often prompted a superficial response to objects made of wood, turning the act of looking into a purely aesthetic judgment or an assertion of taste rather than the deeper probing and closer looking we do in response to works of art in other media. Both of these points are increasingly irrelevant to a discussion of wood art today: one can of course see trace relationships to functional objects in many of the objects under investigation here, most notably perhaps in the turned wood vessels. But is this not akin to the relationship of a nineteenth-century stone carver to the cult practice of sculptures from antiquity or the Renaissance? A closer investigation of the materials used reveals that many are scarcely commonplace, involving unique and special examples of exotic woods, painstakingly found or gathered by the artists for their unique qualities of color, texture, pattern, and feel. And is this not akin to the practices of modern and contemporary sculptors in stone (such as Barbara Hepworth), glass (such as Christopher Wilmarth), or steel (such as Mark di Suvero) who have taken basic, even elemental, materials and elevated these through their artistic vision?

Not all objects of wood, and not all turned wood bowls, for instance, can be seen as works of art. Perhaps the nub of the question here is the moment when the individual object crosses the boundary to become a work of art. The answer would seem to be in the criteria we apply to all works of art and the questions we bring to works of art from the past and the present. Is the artist expressing or exploring some larger question—including the process of art making itself? Does he or she have the technical means to explore such a question? Are the materials used in compelling ways, ways that often make a stride forward in expressing a vision that has previously gone unarticulated in visual terms? Has the artist gone beyond what might be termed production work—typically involving repetition and consumption and a rather "safe" comfort zone—to create a work of fine art? What are the influences that have shaped the artist's vision and the ways in which the materials are used, be these influences cultural (the traditions of Asian, African, or Inuit art, for example), historical, or technical?

These are among the questions we ask you to take to your examination of wood art from the Bohlen collection. In doing so, you will be following in a time-honored process of expanding the definitional boundaries of the visual arts—boundaries that once would have arguably precluded most of what is now highly sought after in the contemporary practice of photography, sculpture, or installation art. One can scarcely imagine what a sculptor of the Italian Renaissance would have made of a sculpture by, say, Ursula von Rydingsvard, or an installation piece by, say, Tracy Emin. And yet works by artists such as these are capable of moving us profoundly today, stimulating us visually and intellectually. The art of wood, including the turned wood vessel, might well have evinced such a quizzical response were

it to be presented as "art" in the past. Our belief is, quite simply, that the best of wood art is susceptible to the serious questioning, interpretation, and investigation we take to any work of visual art—for its capacity to broaden our understanding and enrich our human experience.

For their role in moving the understanding of the art of wood to this point, it is the artists and their collectors who have counted centrally. Without the support of collectors—be they individual or institutional—the wood artists who have advanced the medium might still be unrecognized and unappreciated. In this instance, this book and exhibition would not have been possible without the vision and commitment of Bob and Lillian Montalto Bohlen. Their passion for wood art has been profound, to the great benefit of the many who will profit from this book and exhibition. Their vision will impact art lovers well beyond the temporal frame of this project: their gift of much of their wood art collection to the University of Michigan Museum of Art has vaulted this museum into the top tier of museums nationally with collections in this area, to the benefit of generations to come. For this, and many other acts of friendship, my gratitude to them is truly heartfelt.

The talents without which such a project would simply have never come to be are the artists included herein. Hailing from many locations, working in many vocabularies and with materials as varied as their visions, these artists have pushed the medium to an extraordinary height of conceptual and technical sophistication. We as a culture are the richer for their drive to create.

Many others must be thanked as well. David McFadden, Terry Martin, and Janice Blackburn

have contributed rich and varied essays to this book, drawing on their years of thinking about wood art. Their contributions are the heart of this volume. Ed Marquand and the entire team at Marquand Books in Seattle have contributed equally to the success of this volume, devising a design and layout worthy of the groundbreaking forms described herein. I have worked with Ed and his team on several occasions now; their consistent professionalism, inspired and respectful partnership, and creativity place them at the top of the book trade and have earned our admiration and friendship. Others who have provided critical assistance in the development of this project and contributed to the growing regard for wood art nationally, include Ray Leier and his staff at del Mano Gallery, Los Angeles; Albert LeCoff and his staff at the Wood Turning Center, Philadelphia; and Paul Richelson, Assistant Director and Chief Curator at the Mobile Museum of Art.

Staff at the University of Michigan Museum of Art have carried out this project with their typically energetic, resourceful, and creative grace under pressure. Chief among the members of this team is Sean Ulmer, University Curator of Modern and Contemporary Art. Sean has developed the project from my first conversations with the Bohlens, is entirely responsible for shaping the selection of objects presented here, for putting together this volume, and truly giving life to this project—with his extraordinary eye for installation that will create a wondrous gallery experience in the companion exhibition. Karen Goldbaum, Executive Editor, has been an excellent partner to Sean in shaping this volume, giving it the care and feeding that she gives to all of this Museum's numerous publications. She received very valuable editorial assistance from Eugenia Bell. The full team at UMMA have brought their energies to bear on this project: Kevin Canze, Katie Carew,

and Brendnt Rae for devising and carrying out the gallery installation; Katie Weiss, Exhibitions Assistant, and Gina DiBella and Jamina Ramirez, Interns, for working on research aspects of the project and assisting its curator with the myriad details that are a part of any exhibition undertaking of this complexity; Lori Mott, Registrar, and Ann Sinfield, Assistant Registrar, for assisting with all aspects of the processing of the generous Bohlen gift of wood art and for overseeing the exhibition's tour; Ruth Slavin, Curator for Education, for advising on the development of effective and compelling interpretive strategies and programs; and Terri Gable, Accountant, Kathryn Huss, Administrator, Courtney Lacy, Associate Director of Development, and Stephanie Rieke, Associate Editor and External Relations Coordinator, for ensuring that the project comes in funded, on budget, on time, and that it finds its audience.

James Christen Steward
Director
University of Michigan Museum of Art

AN ART OF OUR TIME DAVID McFADDEN

WOOD SCULPTURE TODAY

The Roman poet Ovid, commenting on the magnificent bronze doors made by Vulcan for the Palace of Apollo, said, "the workmanship surpasses the material (*materiam superabat opus*)." Embedded in Ovid's provocative words is the concept that the skill and knowledge of technique are ultimately more significant than any material chosen by the artist. While this point may be argued from several different vantage points (the history of art and decorative arts in Japan, for example, suggests that materials are never neutral[1]), it also implies a hierarchy of values that informs our appreciation of any material. While intrinsic values are obvious in the context of precious metals—gold, silver, or platinum—and in the ancient world the highly esteemed medium of bronze, they are less readily apparent in so-called humble natural materials—clay, fiber, or wood. For these secondary materials to express the qualities we identify as art, they must be radically transformed. Ovid's praise for Vulcan's ability would be even more dramatic and surprising if the artist's medium were of the latter variety. It is deep engagement with materials and processes that can ultimately result in stellar works of art. The choreography of materials and techniques that transforms the mundane into the magic is central to the meaning of the art, craft, and design.

Among the many media used by artists and craftsmen over the centuries, wood carries with it a long association with function, whether in the form of vessels for food and drink or as one of the basic, and nearly timeless, raw materials of architecture. At the same time, however, the history of art over the centuries and across cultures

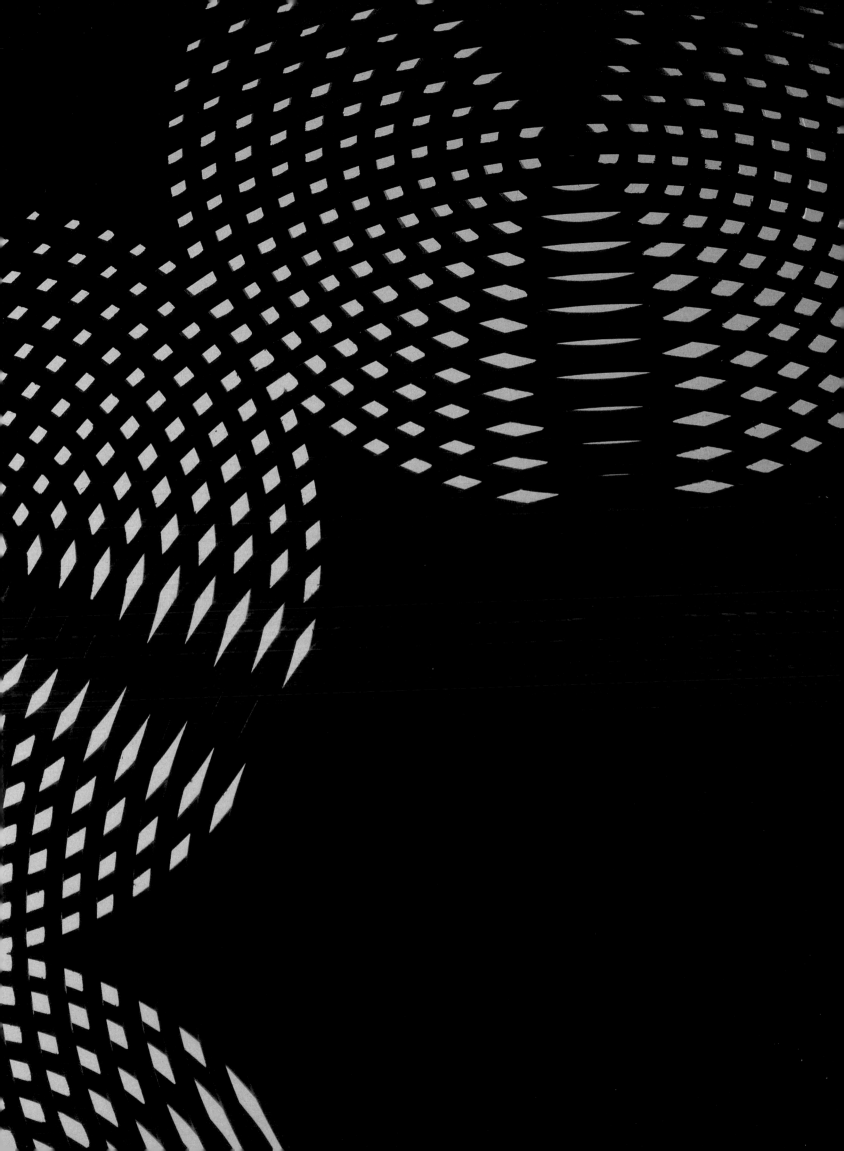

clearly reveals that wood has also been a major medium for the production of sculpture, ranging from the diminutive and elegant German wood carvings of the fifteenth century to the awe-inspiring abstract works of Constantin Brancusi. Adding to the complexity of wood's history as an art medium is the fact that a highly specialized technique—turning wood on the lathe—became identified in the last century as the primary means of manipulating the material. The turning of wood to create vessels or elements of furniture can be traced back to the ancient world. By the period of the Renaissance, wood turning had been adopted as an aristocratic art form;[2] by the nineteenth century the technique was primarily identified with rural crafts practitioners.[3] And in the twentieth century, wood turning experienced a dramatic revival in the workshops of thousands of hobbyist turners. Beyond the hobbyist's world, however, was the rediscovery of wood—turned, carved, incised, and even painted—by an international group of artists. These are the artists who have explored the territory between art and craft, and who have ultimately erased the artificial boundaries that have separated them into two distinct categories. It is the work of such artists—innovative, provocative, astonishing, and unorthodox—that has attracted the eye of an avid and passionate collector like Robert Bohlen. The Bohlen collection, in its diversity and range, provides unique opportunities to explore and appreciate the seamless merging of art, craft, and design that gives the field of wood art such energy today.

The Bohlen collection can be interpreted in many ways. It is at once the story of the burgeoning field of wood art and its acceptance within the larger museum community. It is certainly the biographical record of artists from around the world who have committed their talent and energy to the field. It is also the story of a wide range of techniques employed by these artists,

ranging from the most traditional of lathe turning to radical modifications of surfaces by carving, painting, or even burning. These aspects of wood art have been admirably covered in many of the recent publications documenting private and public collections in the United States and do not need restating.

Since this is not intended to be an exhaustive survey of interpretative possibilities, I would like to look at four aesthetic issues pertinent to the field of wood art, as revealed through the objects themselves. By looking at some of the larger artistic concerns that intrigue and inspire artists working in wood today, we may be better able to understand and appreciate the transformation of the field in the past few decades from a sideline area of interest to a mainstream position in the material arts.

The categories to be explored through selected works include objects in which the artist has specifically chosen his or her raw material to reveal its inherent character or even its flaws. An artist such as Mark Lindquist (see plate 1) conveys a sense of the visual and actual weight of the material in his roughly, and intentionally unfinished, works. Internal structural liabilities in the wood are highlighted in his work, making the surfaces appear muscular and powerful. Likewise, the wood and bronze compositions of Ron Gerton (plate 131) use flaws in the wood to produce a poetic and poignant reminder of decay and change. It is in works such as these that the element of time is described in purely visual terms—not the time invested in the making of the object, but the time that seems to be stilled and held as a preserved moment through the intervention of the artist. The bronze root that twists and twines through and around the wooden vessel is suggestive not only of a flowing stream of water but also of the veins and capillaries that carry life to the limbs of both trees and human beings. Robert Chatelain (plates 33, 34) holds

1 MARK LINDQUIST
Double Totemic Sculpture, 1994–95
Oak burl, 43 × 27½ × 27½ in.

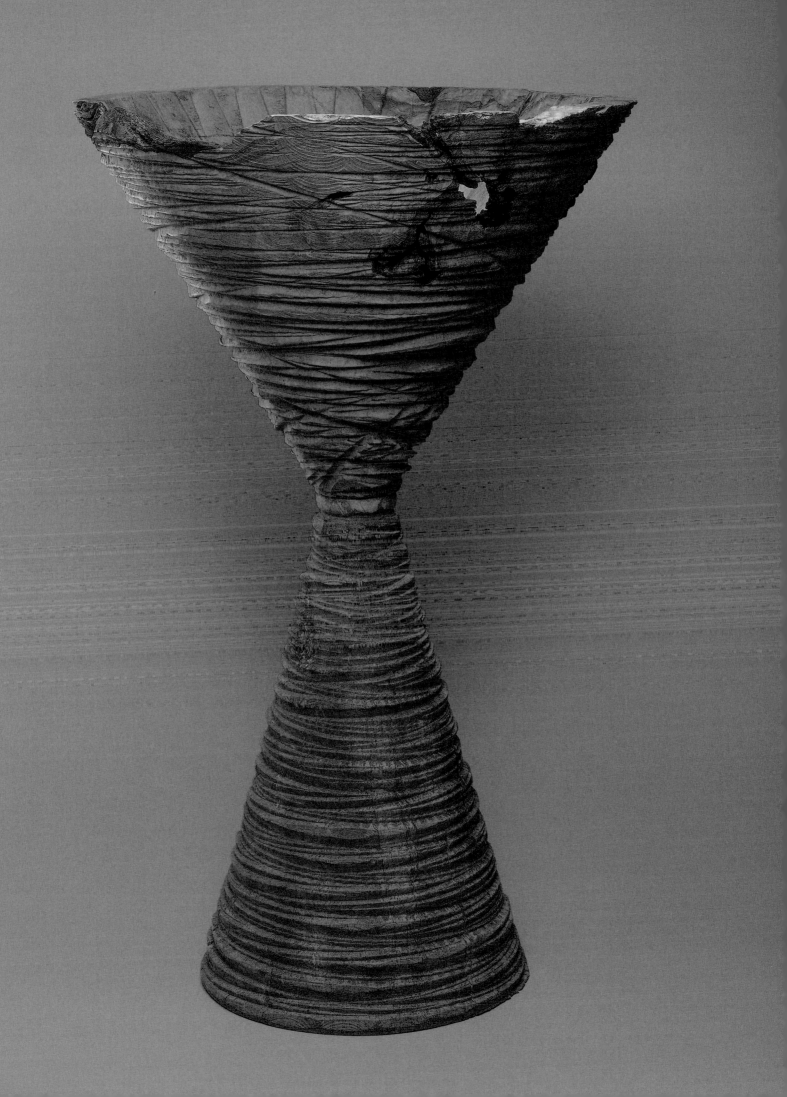

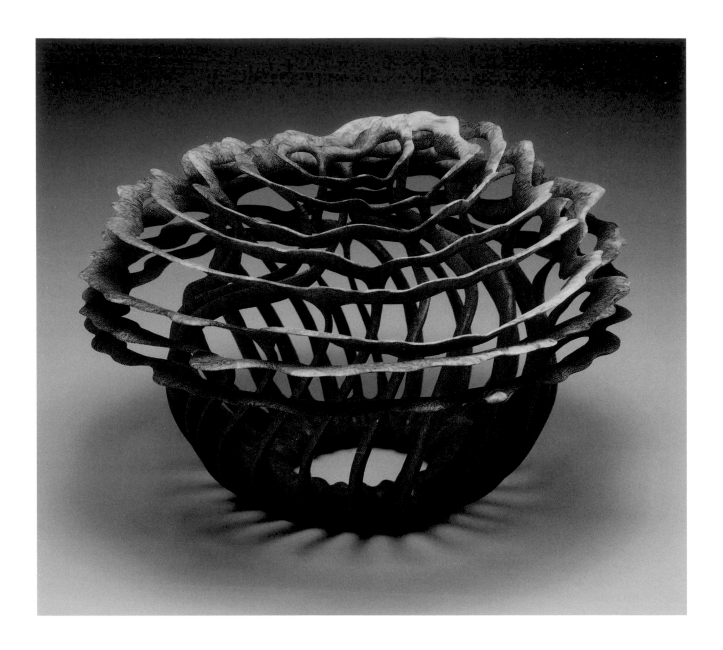

2 ALAIN MAILLAND
Grace, 2000

Locust burl, 7¼ × 10½ × 10½ in.

deterioration and decay in check by creating a rigorously pure external form. In Chatelain's work, the visual action appears to be floating on the surface of the vessel, recalling for all of us in this century the extraordinary view of earth from the space shuttle. Derek Bencomo acknowledges his debt to nature in both the selection and finishing of his weightless works (see plate 111). Bencomo adds yet another layer to our understanding of the effects of natural forces on the medium by suggesting that the form is reacting to wind currents to produce a fluttering surface that glistens with light and color. Like Gerton, Bencomo gives the viewer a unique "stop motion" vision of lightness and movement that we know to be impossible in this medium. Lastly, Alain Mailland's *Grace* (2000; plate 2) reinforces the idea of time and movement in nature

in a form that at once suggests the graceful unfurling of the petals of a blossom and the relentless energy of a dancing dervish. For each of these artists, the work of art begins with the thoughtful and experienced selection of the raw material and with the embracing of the flawed, the imperfect, to create an object of stunning visual presence.

While this first group of artists seduces the viewer's eye with the poetic suggestion of nature, other artists use a more direct and pictorial route in their depiction of nature. Importantly, these artists also look outside the nature of wood itself for forms and patterns that reverberate with the essential character of the medium. Jacques Vesery (see plate 3) is internationally known for his exceptionally skilled carving of feather motifs on the surfaces of his vessels and other forms.

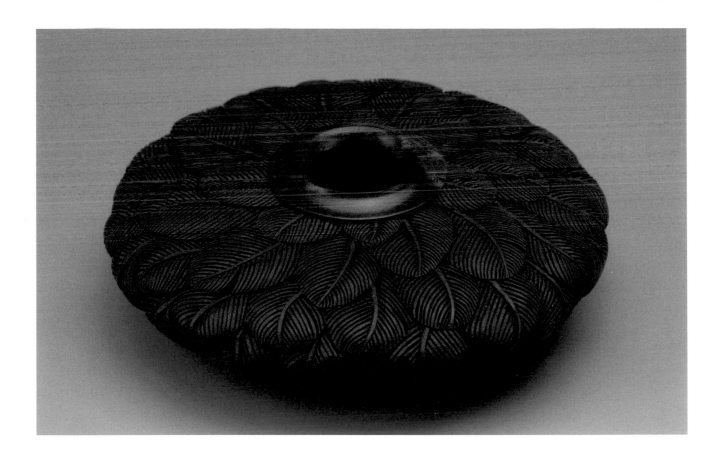

3 JACQUES VESERY
Easy Winds, 2001
Cherry, cherry burl, 2⅛ × 6 × 6 in.

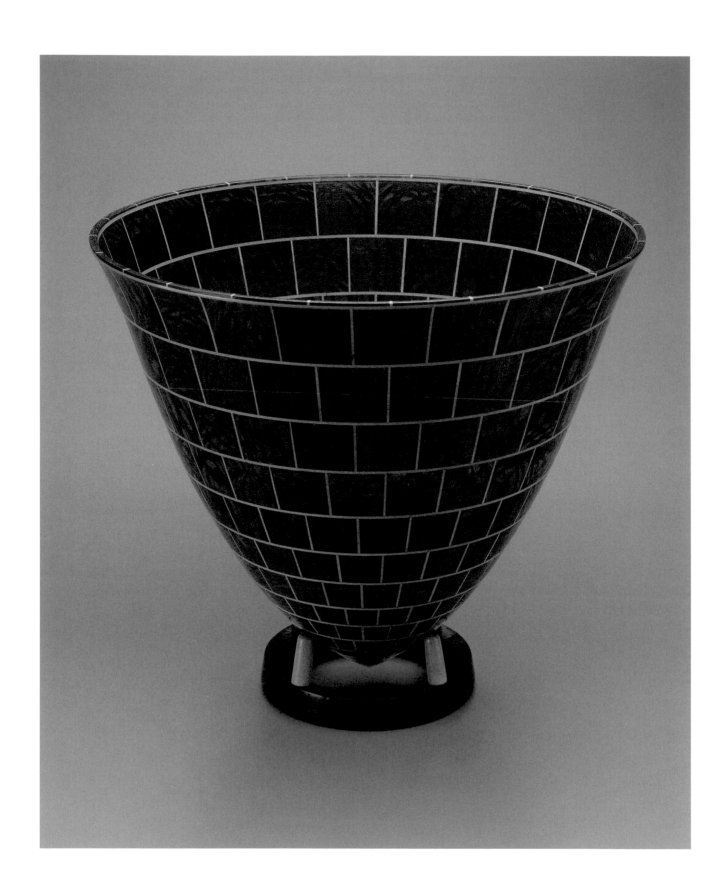

4 MICHAEL MODE
Holding the Honey, 2003
Lacewood, holly, 13 × 15¼ × 15¼ in.

Each detail of each feather is painstakingly engraved on the surface, suggesting that the basic wooden structure has been enveloped in feathers. The search for natural forms that echo the patterns of growth, change, and evolution we appreciate in nature has led an artist like Ron Fleming (*Pegasus,* 1999; plate 116) to create a multilayered container of overlapping leaves. The leaves are not static but seem to swirl and move to their own rhythm. This effect of movement—of dance, if you will— is achieved with stunning visual power in Fleming's *Ling Chih* (1997; plate 117), which invokes the flexible muscularity of tree ear mushrooms but also evokes a stairway that connects earth to heaven. Simulation and evocation of natural forms can range from the subtle abstractions of Fleming to the theatrical trompe l'oeil of Frank Sudol and C. R. Merkle's exceptional "feather" vase (see plate 126). Here the wood has been used with the delicacy of an india ink pen, providing the foundation for the impeccably painted feathers. The trompe l'oeil effect of the painting is reiterated by the unusual thinness of the carved feathers; both structure and surface seem to be animated by even the most subtle of breezes.

A third group of objects from the Bohlen collection is dedicated to virtuosity, a passionate involvement with detail that borders on the obsessive. Certain artists, such as Michael Mode (see plates 4, 47), create bold graphic patterns on their works by juxtaposing colors and designs with such perfect control that they approach op-art painterliness. A similar intensity of vision pervades the works of Michael Shuler (see plate 49), one of America's most respected craftsmen and an admired artist. Shuler's Mondrian-like staccato rhythms are achieved through careful planning and flawless execution. Like Mode's, Shuler's simple forms become the focus of relentless visual movement, giving the vessels their life and recognizable personality. Pattern-making

on a flat surface has also been used extensively by Alan Stirt (see plate 5), whose essays in monochrome pigment on wood are so familiar. The effect that Stirt achieves is only possible through obsessive repetition of movements that modulate the surface; if one were to compare his work to those by practitioners in other mediums, it would have to be with bead or embroidery artists.

The ultimate extension of such intensely focused procedures has kept the "virtuoso" traditions of wood turning alive. For a Renaissance prince, learning to turn wood, ivory, or amber on the spinning lathe was as expected as learning the arts of war and statesmanship.[4] While it is the skilled work of the hands that gives virtuoso works their visual power, the sheer perfection of the work suggests that it was made with divine, and not earthly, hands. First and foremost among this group of virtuosi who have reiterated that the aesthetics of technique cannot be divorced from the final product is Hans Weissflog, whose mind-boggling multiaxis turnings would be as at home in a royal cabinet of curiosities as in a twenty-first century home or museum. Weissflog's work (plates 22, 87, 93) reminds us that the origins of the word "virtuoso" are to be found in the word "virtue," meaning rigorous and admirable strength and power. Alongside Weissflog's ever-changing moiré patterns in wood can be placed Jean-François Escoulen's Dr. Seuss–like turnings that defy gravity as well as belief. Without obsessive perfection, these works would not hold our attention, something that artist William Hunter (plates 21, 63) has fully absorbed. Hunter's cyclonic spirals engage the viewer's eye on a journey across and through space. While fully resolved as a form, the tumescent ribs of Hunter's bowl shapes produce a state of unresolved tension in movement that draws the viewer back and forth from the surface to the interior. With equal finesse, Stuart Mortimer

5 ALAN STIRT
Spiral Ceratite, 1997

Mahogany, 24 × 24 × 1½ in.

6 STUART MORTIMER

Untitled, 2002

Sycamore, ebony, bronze flakes
and dust, lacquer, 18 × 9 × 9 in.

(see plates 6, 20, 141) pierces his forms in complex patterns that make them appear lacelike and weightless. Perfection has its own justification as a form of beauty, and these artists have never veered from their commitment to it.

The merging of art, craft, and design in our time has been documented in works by a broad and diverse range of artists in all media who question the validity of categorization. For example, the sculptor Jim Dine has recently completed a series of painted porcelain vases at the Manufacture Nationale de Sèvres, and photographer Sandy Skoglund learned the art of flameworked glass to create hundreds of animated glass dragonflies for *Breathing Glass,* an installation work and photograph created for the American Craft Museum in 2000.

These artists often transgress the boundaries intentionally, provoke discussion and argument about today's definition of art, and confound our expectations about a material and its "proper" treatment. In the Bohlen collection are a number of artists who have chosen to paint the surfaces of their forms, often entirely. For traditional collectors of wood, such treatment is sometimes seen as sacrilege; for others, it is the logical extension of the medium into the wider sphere of the arts of today. The boldly painted vessels and sculptures of Giles Gilson (see plates 28–31, 65, 143) are shocking in their color combinations and patterns. Legendary among this group of painters on wood is David Ellsworth (see plate 62), whose delicately abstract patterns respond to the subtle forms he has achieved on the lathe, but also to the organic surface quality of wood itself. Visual drama is accomplished by Stephen Hughes and Margaret Salt in their massive *Eruption Shield #3* (see plate 76) panel of 1998. Rippling with color that is further reflected on gold leaf, this ceremonial

shield marries wood and paint to spectacular effect. And a more abstract use of color is seen in the monochrome palm vessels of Dewey Garrett (see plate 7), in which color and texture are played against each other in works that seem to glow from within.

The major shift in the field has, of course, been the development of a new sculptural vocabulary by artists whose chosen material is wood. The power and compressed strength of works by Todd Hoyer (see plate 64) demand our attention from multiple points of view. Likewise, the calmly understated poetry of Virginia Dotson is achieved by carefully balancing the nature of the medium with the nature of her art. The transformation of wood as a craft medium into wood as a valid medium for artists is underscored in numerous works in the Bohlen collection, particularly in sculptures by Stony Lamar and Robyn Horn (see plate 69), to mention only two. There is one multipiece work, however, that describes the contemporary scene with special clarity. Hugh McKay has created a family of works based on the same form but using radically different materials (plate 8). From carved wood to cast glass to bronze, the works beautifully capture the nuance of expression and meaning that can be achieved in mediums that either absorb, reflect, or transmit light.

With artists such as these at the forefront of the field, wood will continue to reveal our fascination with nature, our interest in narrative and depiction, our appreciation of virtuosity, and our respect for the endless possibilities seen in a single medium. The field of wood art will continue to flourish, grow, and astonish. The Bohlen collection gives us the unique opportunity to witness these changes in works of beauty and lasting significance.

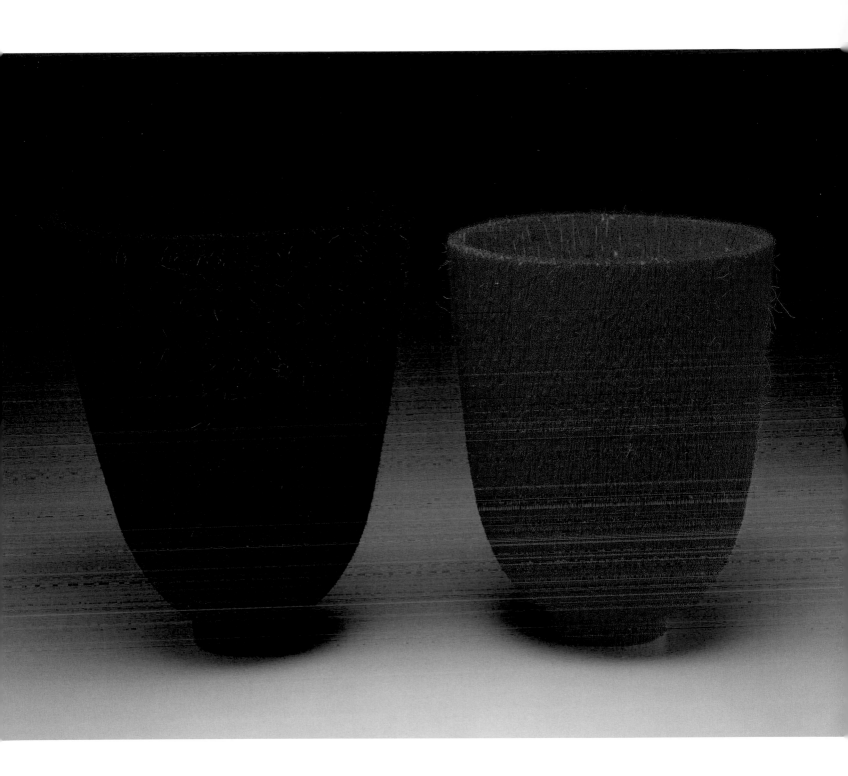

7 DEWEY GARRETT
Tosca, 2000
Palm, dye, 13½ × 10½ × 10½ in.

Aida, 2000
Palm, dye, 12¼ × 9½ × 9½ in.

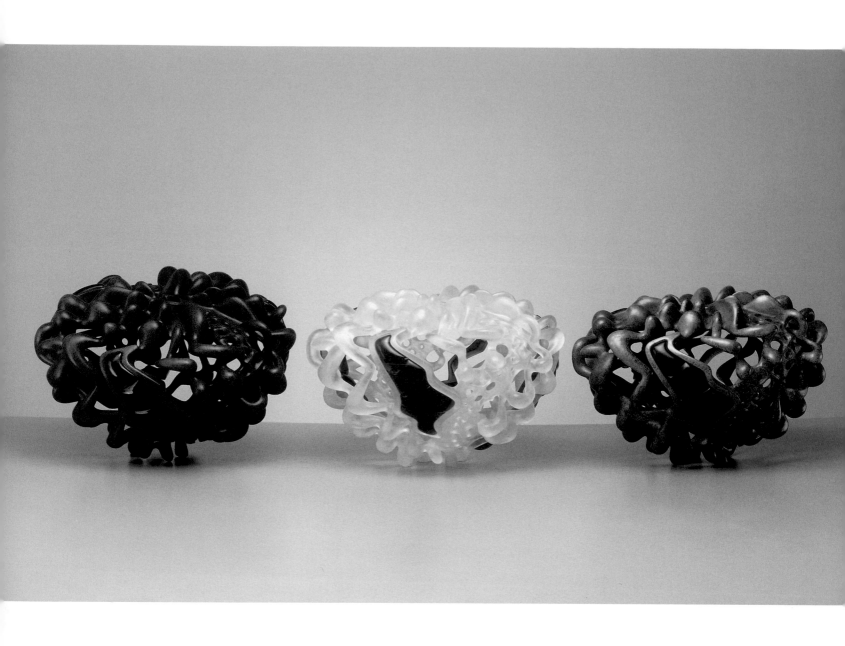

8 HUGH McKAY

Ruach, 1998

Madrone burl, cast glass, cast bronze,
each: 12 × 18 × 18 in.

NOTES

1. The Japanese tradition, in contrast to that of the West, was to place all materials on a level playing ground, rather than pigeon-holing them as art, craft, or design. In Japan, weaving and dyeing, or the making of ceramics, were on a parallel level with painting, sculpture, and architecture. This was due, in part, to the powerful cultural traditions embedded in specific materials. For example, the specialized techniques and aesthetics of lacquerwork are entirely merged. Likewise, clay has its own "personality"; it is the artist who reveals the character of the materials through creative intervention.

2. One of the most dramatic and impressive collections of turnings by members of a royal family can be seen today at Rosenborg Palace in Copenhagen. This unusually intact and well-documented collection highlights work by multiple generations of royalty, made by both male and female family members.

3. Folk and cultural history museums throughout Europe, and particularly in England, contain documents of always rural, primarily anonymous, sometimes itinerant, woodturners who made a range of useful items from bowls and table accoutrements to stair balusters and other ornamental enrichments.

4. Turning as a princely discipline was the subject of a lecture given at the American Craft Museum in 1998 by Dr. Mogens Bencard, director emeritus of the Danish Royal Collections.

FOR FURTHER READING

The renaissance of interest in wood as an art medium is reflected in the impressive number of recent exhibitions on the subject and the growing body of literature surrounding it.

Burgard, Timothy A. *The Art of Craft: Contemporary Works from the Saxe Collection.* San Francisco, Boston, New York, and London: Fine Arts Museums of San Francisco and Bulfinch Press/Little, Brown & Co., 1999.

DuBois, Alan, et al. *Moving Beyond Tradition: A Turned Wood Invitational.* Little Rock: The Arkansas Art Center Decorative Arts Museum, 1997.

Fike, Bonita, and Mike Mendelson. *The Fine Art of Wood: The Bohlen Collection.* New York: Abbeville Press, 2000.

Hogbin, Stephen, et al. *Curator's Focus: Turning in Context: Physical, Emotional, Spiritual, and Intellectual.* Philadelphia: The Wood Turning Center, 1997.

Kangas, Matthew, John Perreault, and Edward S. Cooke, Jr. *Expressions in Wood: Masterworks from The Wornick Collection.* Oakland: Oakland Museum of California in association with University of Washington Press, 1996.

Out of the Woods: Turned Wood by American Craftsmen. Mobile, AL: The Fine Arts Museum of the South, 1992.

Perreault, John, and Heather Sealy Lineberry. *Turned Wood Now: Redefining the Lathe-Turned Object, IV.* Tempe: Arizona State University, 1997.

Ramjlak, Suzanne, and Michael W. Monroe. *Turning Wood into Art: The Jane and Arthur Mason Collection.* New York: Harry N. Abrams, Inc., Publishers, in association with The Mint Museum of Craft & Design, 2000.

Wood Turning in North America Since 1930. Philadelphia and New Haven, CT: Wood Turning Center and Yale University Art Gallery, 2001.

Today's turned wood art goes well beyond beautiful wooden
salad bowls, vases, candlesticks, spoons, and containers to
encompass objects that may retain some semblance of the
vessel form but are more sculptural than functional. Whether
turned on a variety of axes, or turned and carved, or painted, or
inlayed with other materials, these "new vessels" pay homage
to their predecessors but move in new directions, constantly
pushing traditional definitions. These objects, some of which
were created using recently invented wood turning techniques,
prompt new ways of thinking about wood art.

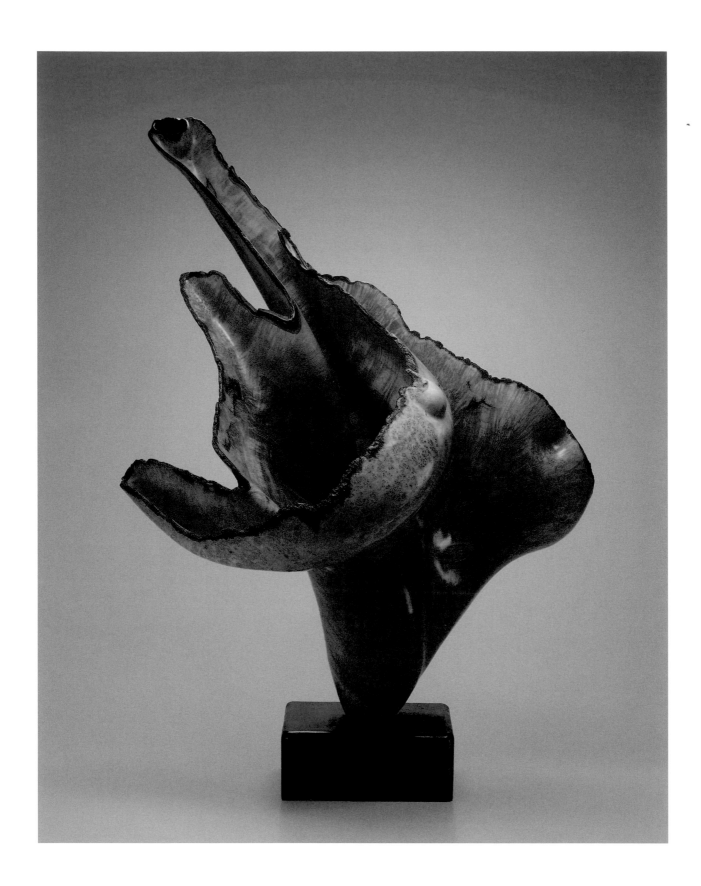

9 BRAD SELLS
Helio, 2003
Maple, 33 × 27 × 24 in.

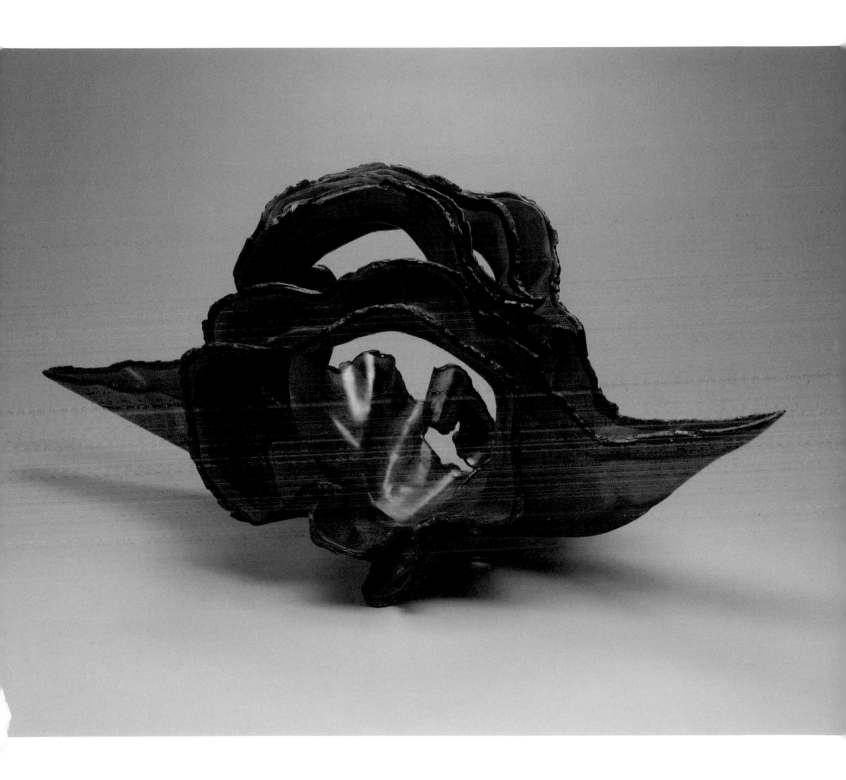

10 BRAD SELLS
Tres Bastardos (Bridge Series Number One), 2001
Spalted maple burl, 15 × 39½ × 17 in.

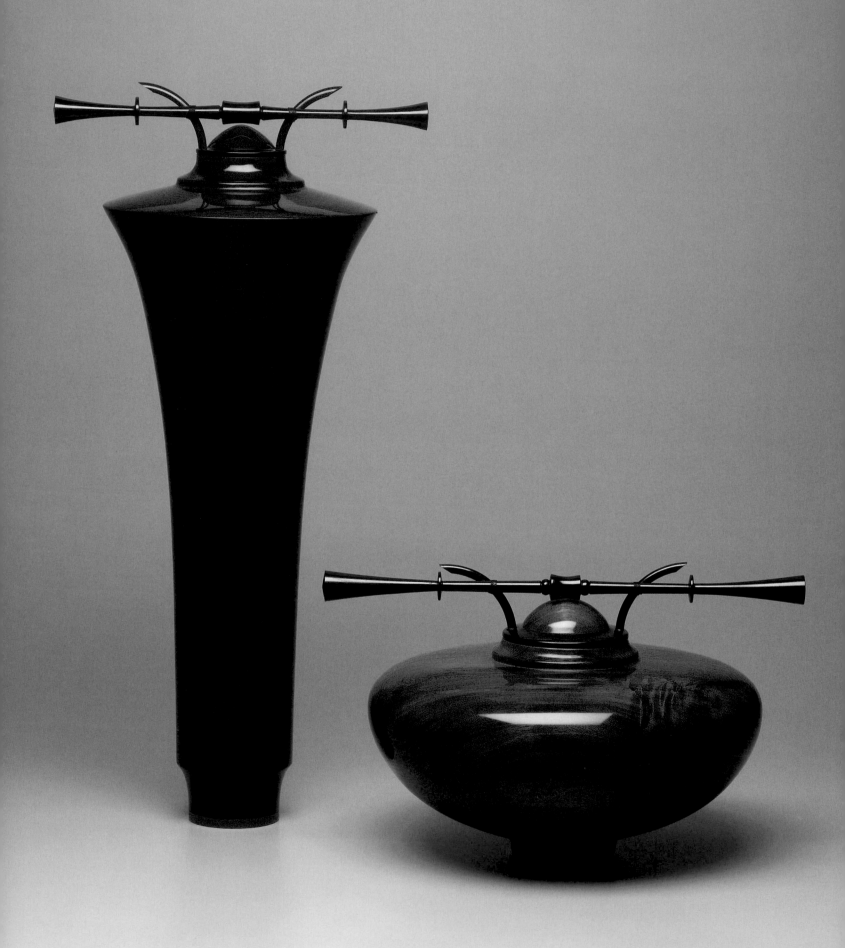

29

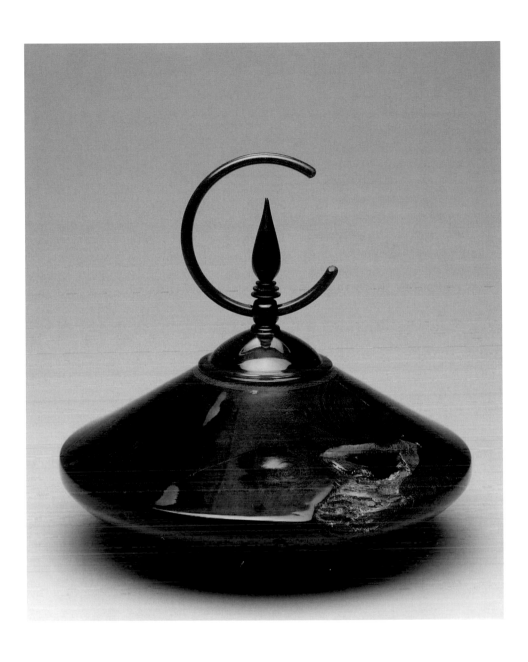

11 MATTHEW HATALA
Left: *sentinel, in the shadow of uluru*, 2003
Australian grasstree, 23¼ × 11⅜ × 8½ in.

Right: *aina o waipio*, 2003
Hawaiian koa, 8⅞ × 14⅜ × 11½ in.

12 MATTHEW HATALA
Untitled, 2000

Desert ironwood, Osage orange, ebony,
bloodwood, 9 × 10 × 10 in.

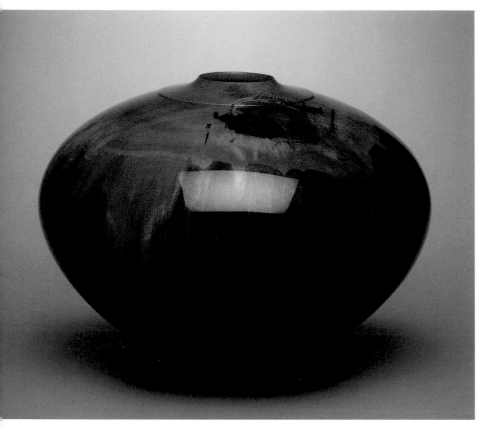

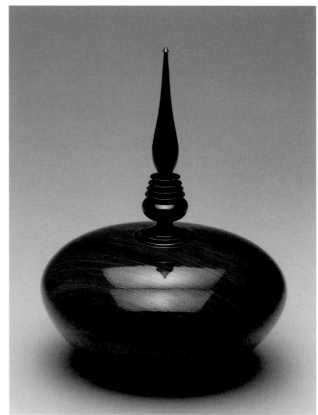

13 TED KNIGHT
Untitled, 1998

Ponderosa pine, 20 × 28 × 28 in.

14 BARRY T. MACDONALD
Bottle, 1999

Cocobolo, 12½ × 9 × 9 in.

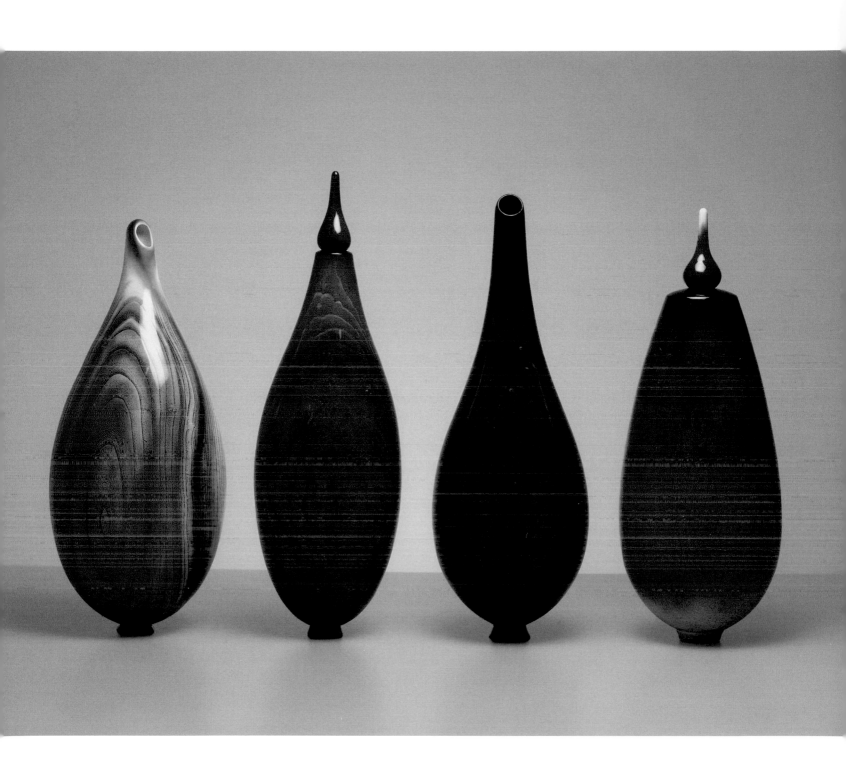

15 DONALD DERRY

Untitled, 1999

Elm, lacquer, 23 × 9½ × 9½ in.; 26 × 8 × 8 in.;
24 × 8½ × 8½ in.; 23 × 8½ × 8½ in.

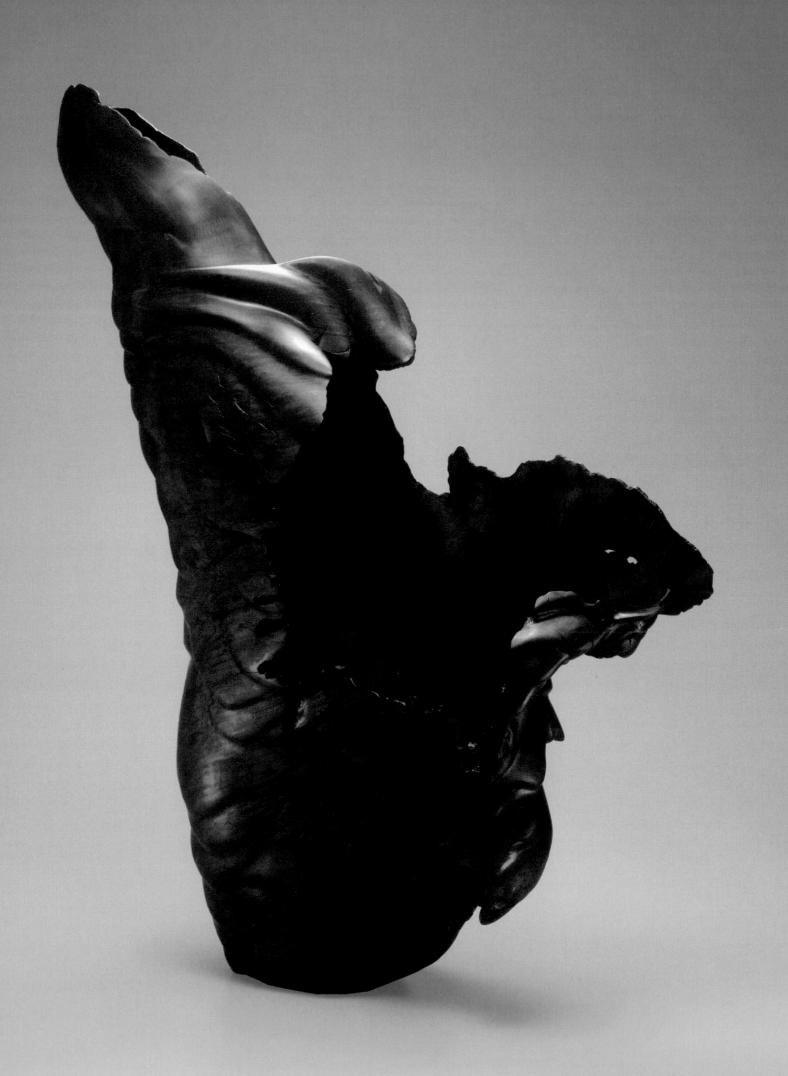

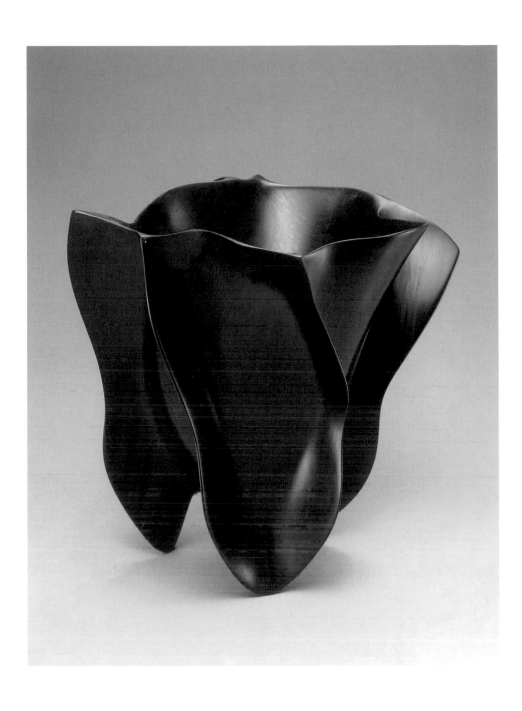

16 MARK BRESSLER
Spirit Dancer, 2002
Madrone burl, 35 × 34 × 12 in.

17 DEREK BENCOMO
Come to Dancing, 2000
Macassar ebony, 11½ × 12¾ × 12 in.

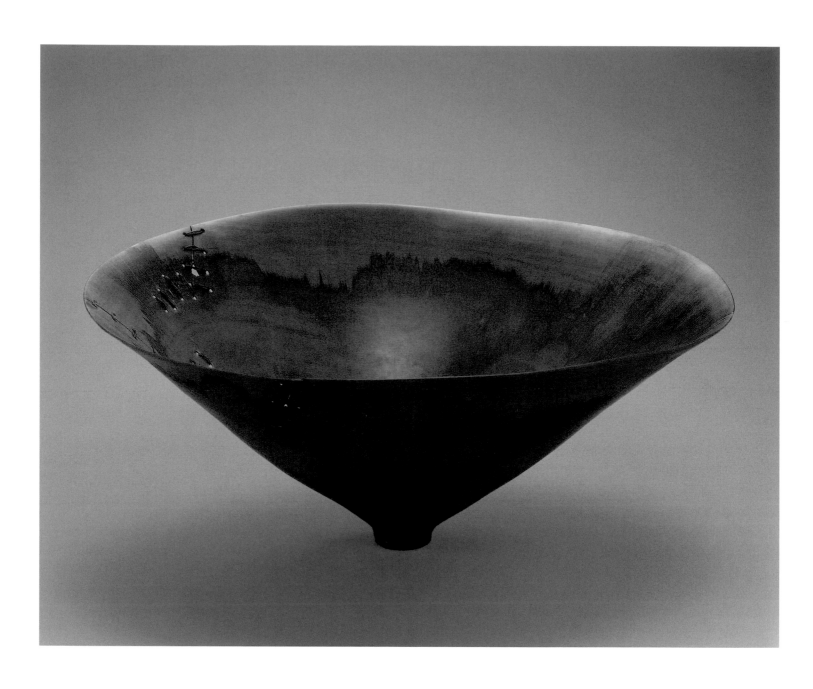

18 RON KENT

Translucent Norfolk Pine Vessel, 1998

Norfolk pine, copper braid, 14 × 20½ × 15 in.

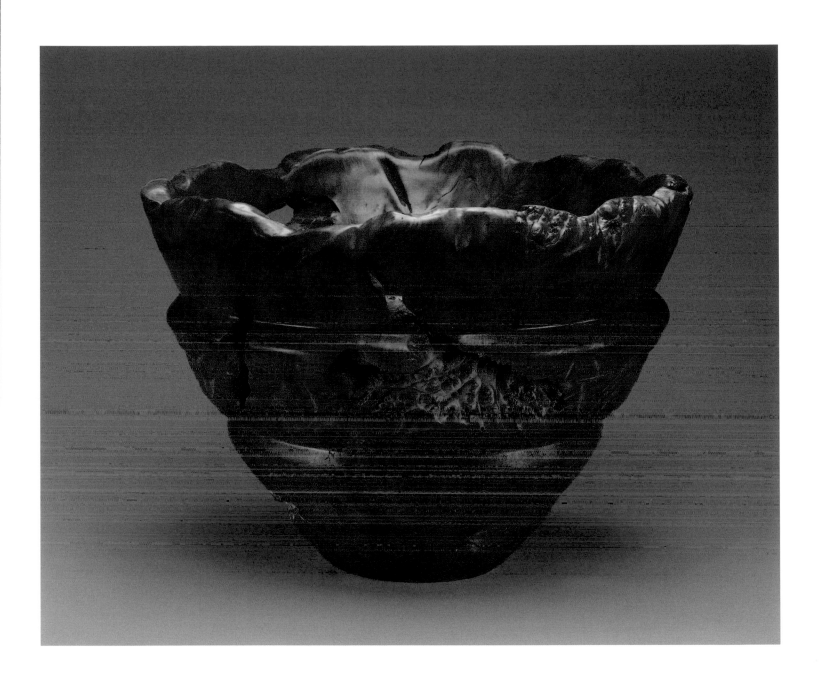

19 DENNIS ELLIOTT
B2116 Perigee II, 1999

Big leaf maple burl, 16½ × 23¾ × 23 in.

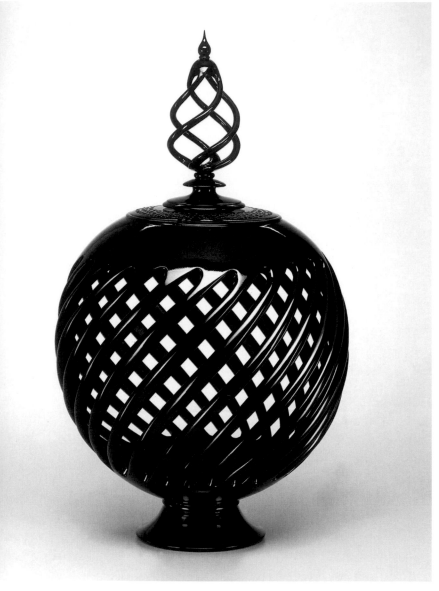

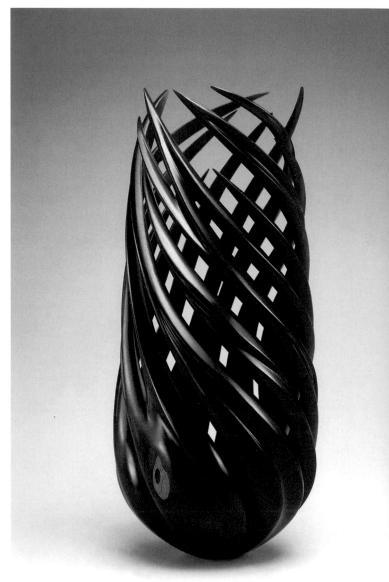

20 STUART MORTIMER
Untitled from *Twisted Pink Ivory* series, 2002
Pink ivory, ebony, 17 × 9½ × 9½ in.

21 WILLIAM HUNTER
Ahab's Garden, 1997
Cocobolo, 13 × 5½ × 5½ in.

22 HANS WEISSFLOG
Star Bowl, 2002
Walnut, 5 × 15½ × 15½ in.

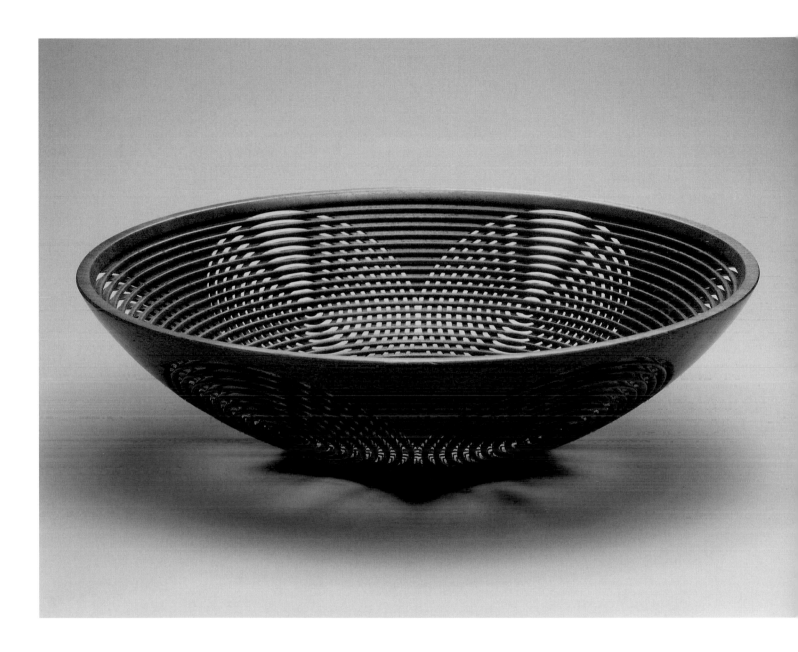

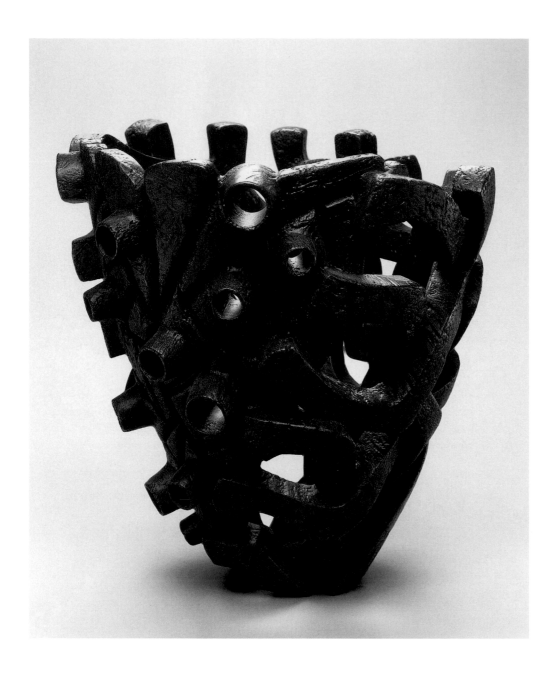

23 HUGH McKAY
Warfed, 2002

Maple burl, stain, 16 × 16 × 16 in.

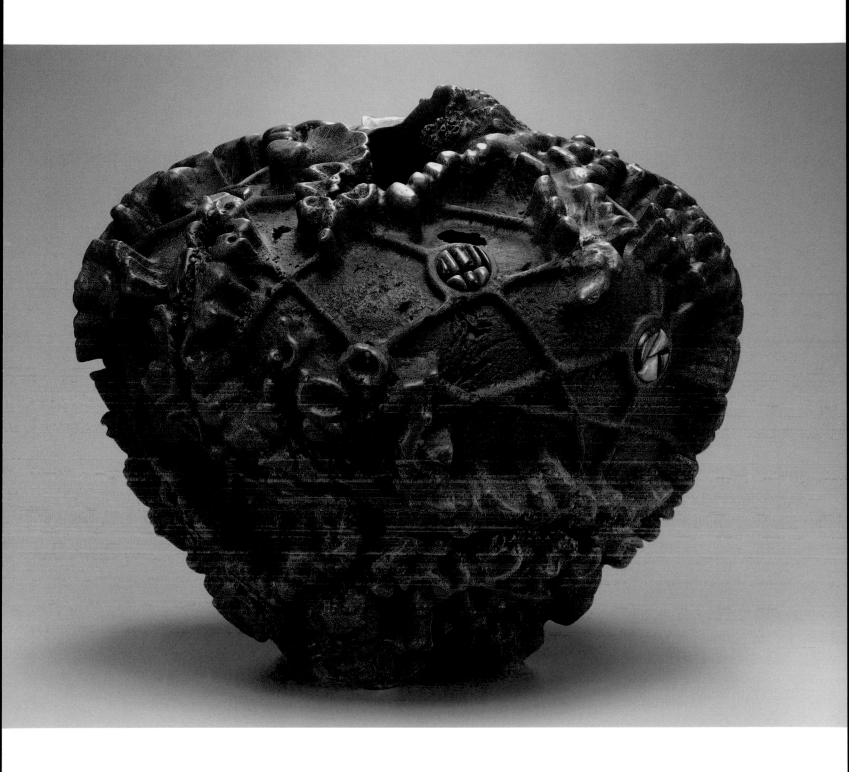

24 HUGH McKAY
Asteroid, 1993

Maple burl, soapstone, stain, 21 × 24 × 24 in.

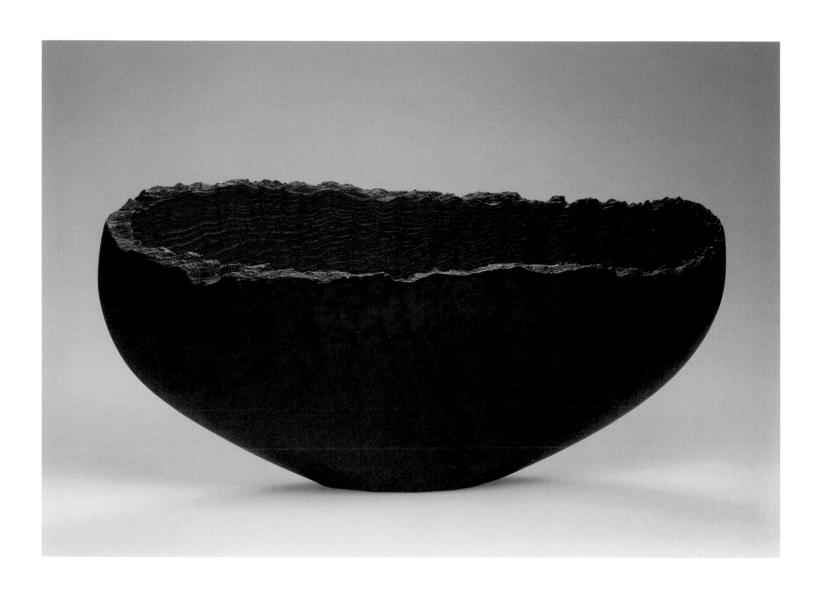

25 MARK BRESSLER

Bodega Fury, 2001

Redwood lace burl, wax, 14 × 22 × 6 in.

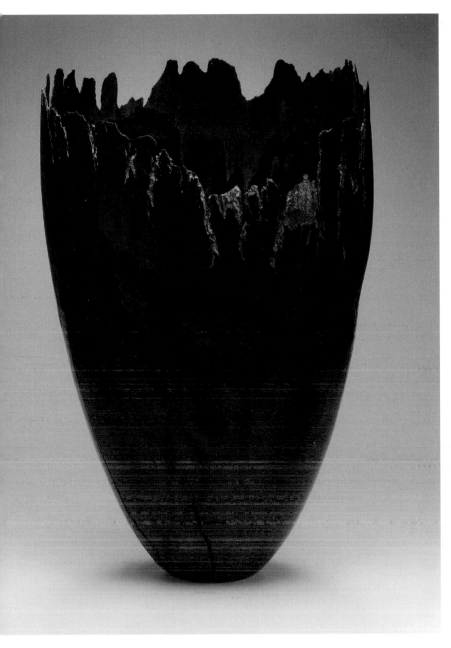

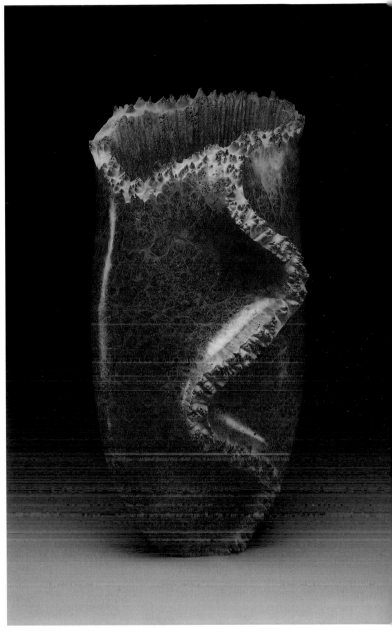

26 MIKE IROLLA
Hemlock Canyons, 2001
Hemlock, 25 × 16 × 16 in.

27 BOB WOMACK
Capital Reef, 1998
Big leaf maple burl, 14½ × 7½ × 5 in.

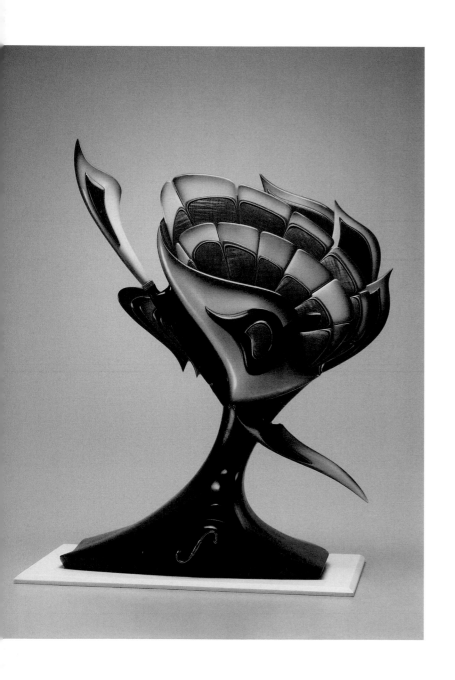

28 GILES GILSON

Early Autumn, 2000

Padauk, basswood, lacewood, walnut, cherry, figured maple, ebony, holly, purpleheart, brass, stainless steel, lacquer, 25¾ × 18 × 10 in.

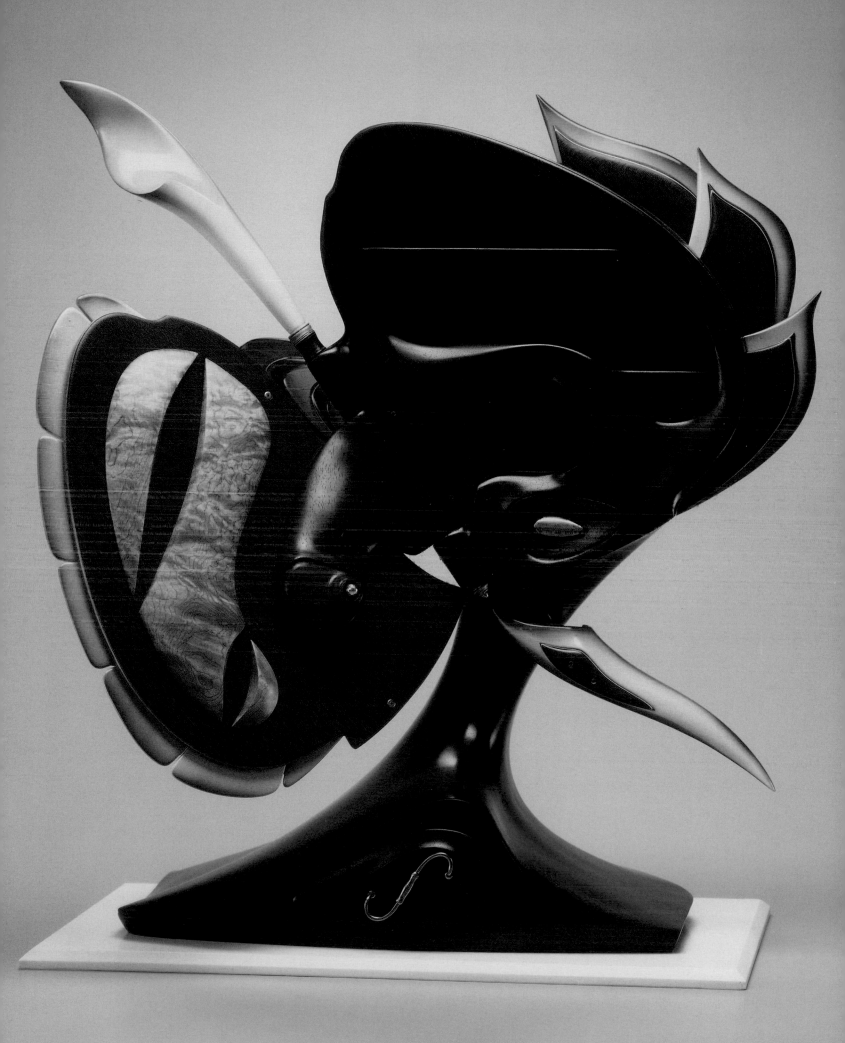

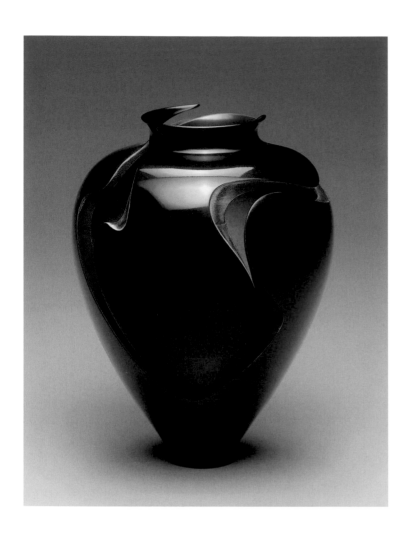

29 GILES GILSON
Black Ribbon Vase, 1984
Birch, lacquer, 9 × 6¾ × 6¾ in.

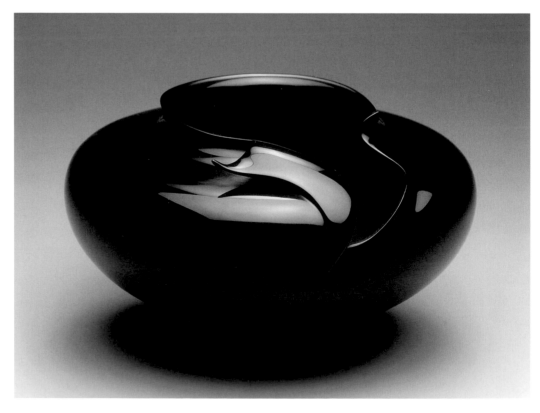

30 GILES GILSON
Cammy-Oh 1, 2001
Basswood, pakkawood, pigment,
lacquer, 6½ × 11¼ × 11¼ in.

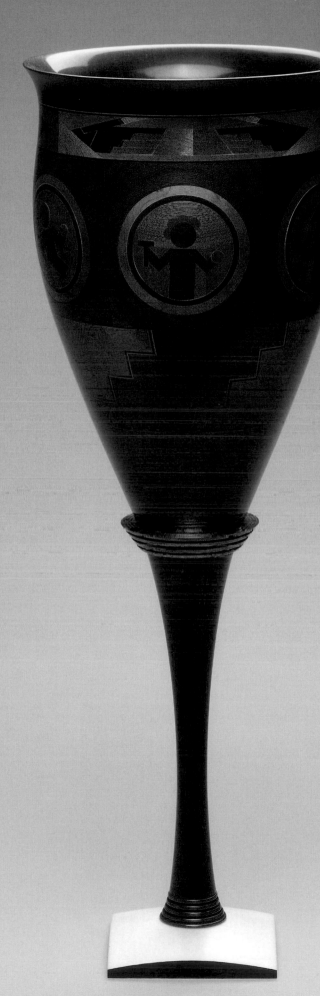

31 GILES GILSON

Archetype: Hero, 1996

East India rosewood, ebony, padauk,
purpleheart, cocobolo, birch, walnut,
lacquer, brass, 19 × 6¾ × 6¾ in.

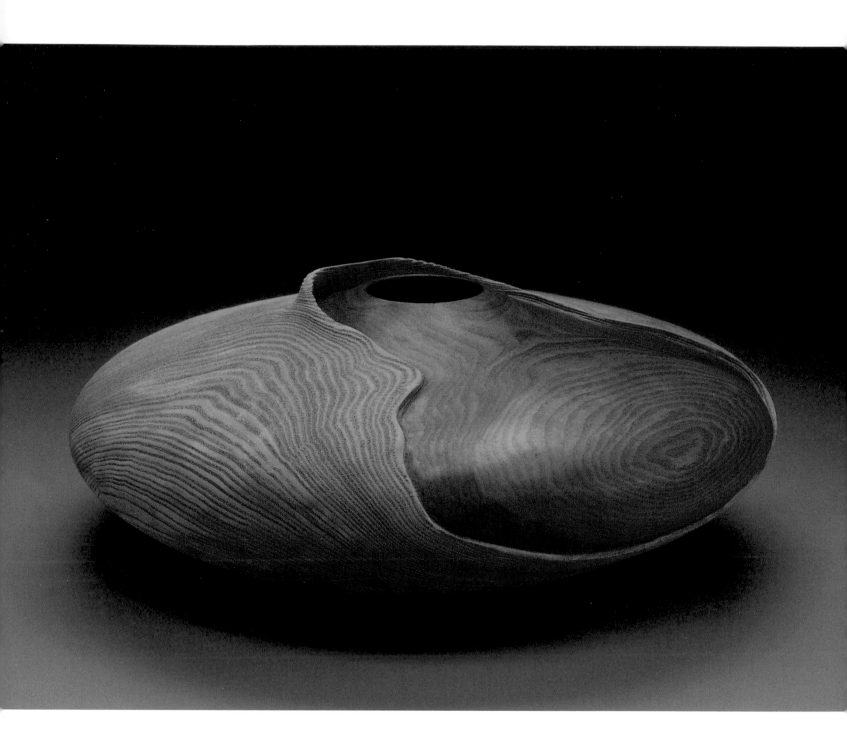

32 TRENT BOSCH
Sienna Series, 1999

White ash, 5¾ × 15 × 15 in.

33 ROBERT CHATELAIN
Untitled, 2002

Black cherry burl, scarlet and
gold resin, gold leaf, 7 × 11 × 11 in.

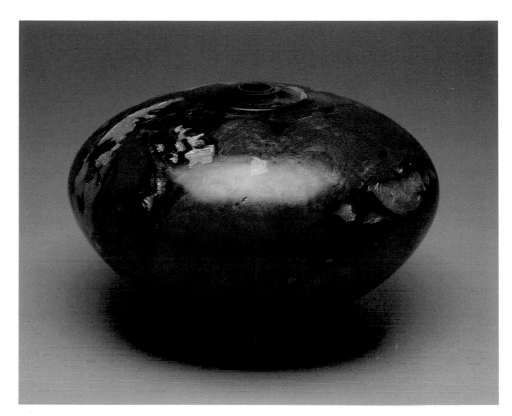

34 ROBERT CHATELAIN
Untitled, 1999

Vermont red maple, black cherry,
box elder burl, colored epoxy
resin, gold leaf, 11 × 12½ ×
12½ in.

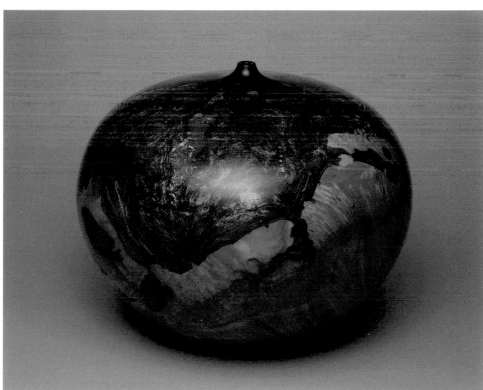

36 DALE NISH
Untitled, 1984

Wormy ash, 12 × 8 × 8 in.

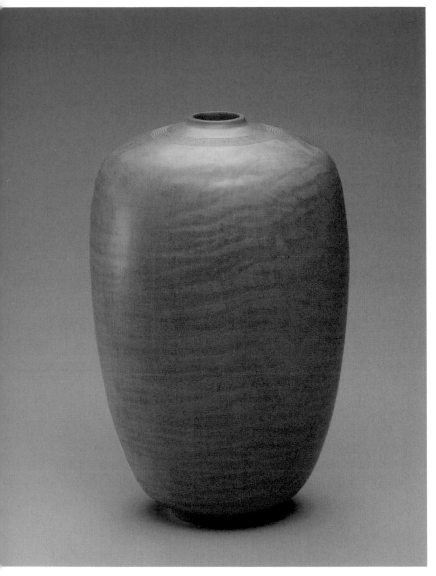

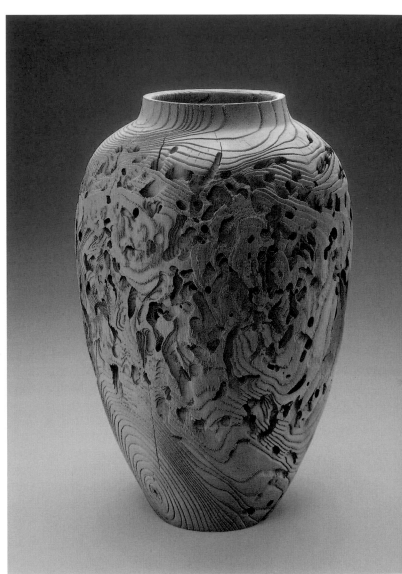

35 J. PAUL FENNELL
Untitled, 1995

Curly maple, 7 × 4 × 4 in.

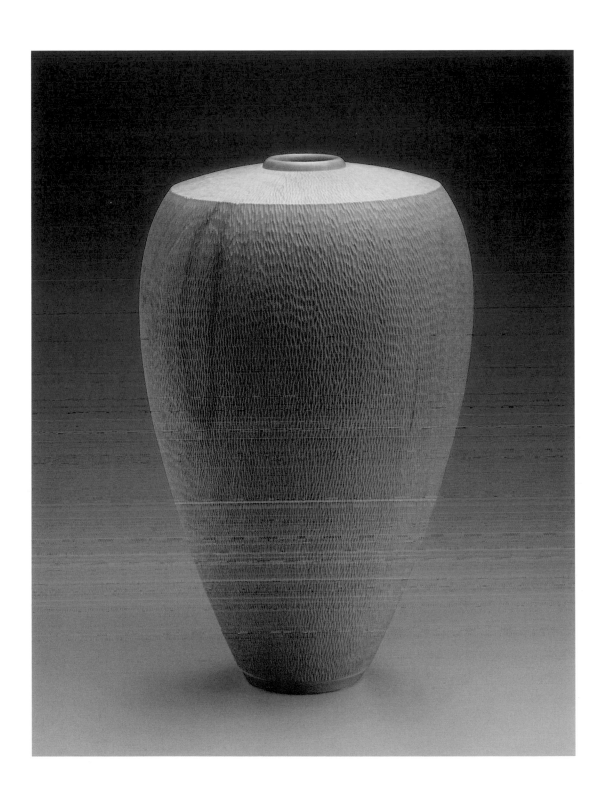

37 JOHN JORDAN
Boxelder Vessel, 1996

Box elder, 14¼ × 9 × 9 in.

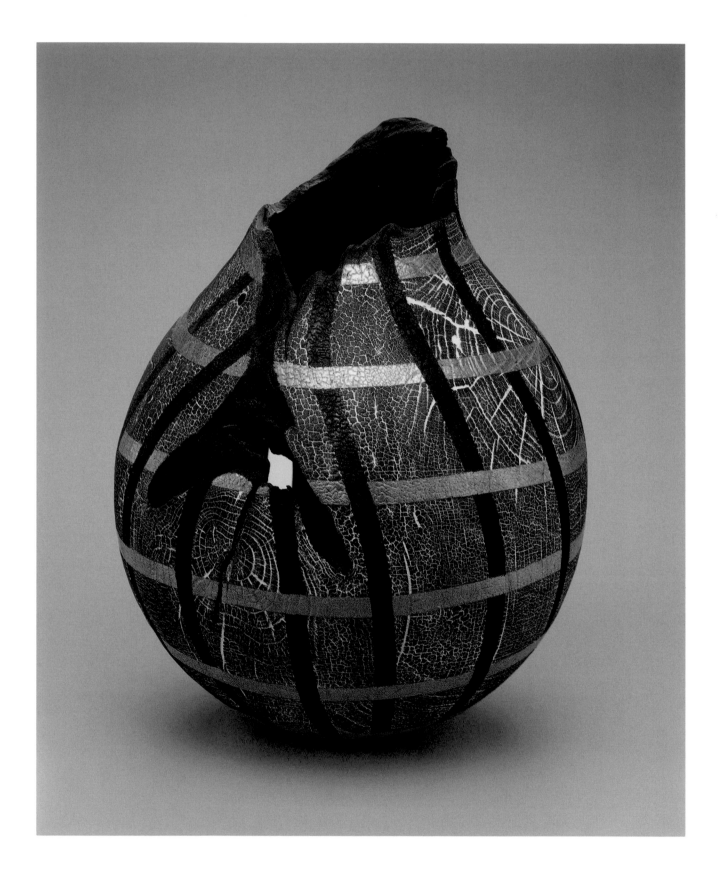

38 TODD HOYER

Moving On, 1993

Arizona cedar, ink, imitation gold leaf,
20¼ × 11¼ × 11¼ in.

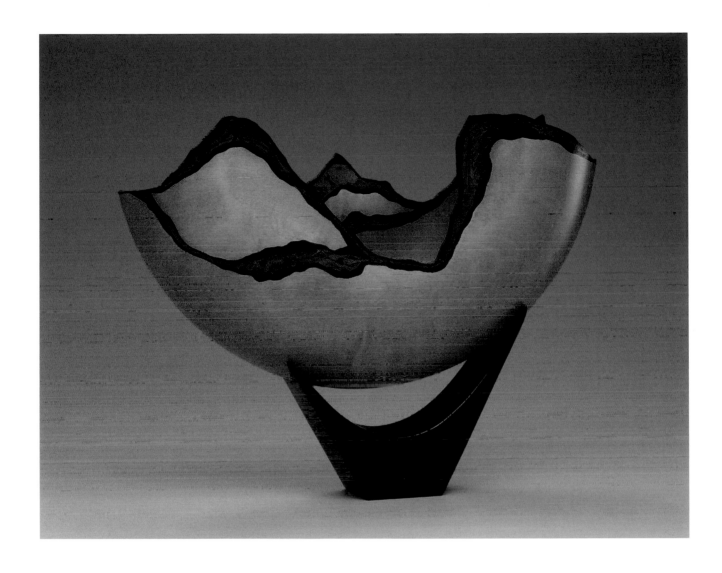

39 MARILYN CAMPBELL
Igneous Series #3, 'Rare Elements,' 1999
Holly, pigmented epoxy, 9½ × 11⅞ × 2 in.

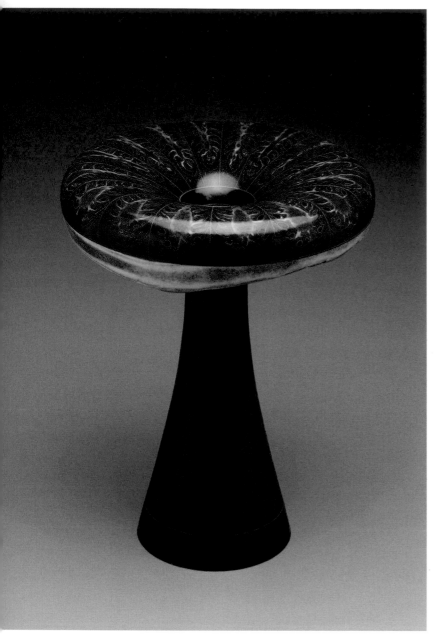

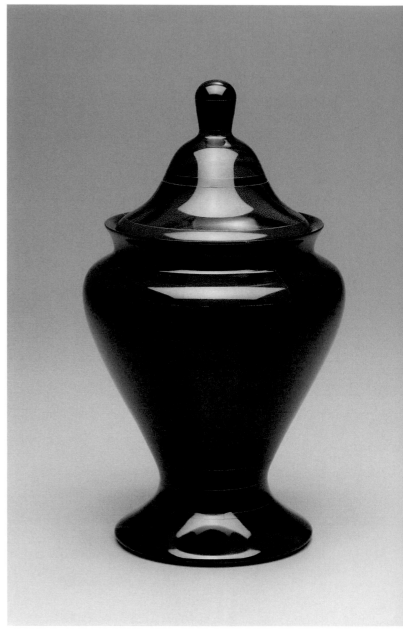

40 GALEN CARPENTER

01-1, 2001

Pine cones, antler, padauk, maple, royal palm,
black palm, 10⅛ × 7¾ × 7¾ in.

41 MARK PARISH

Macassar Grace, 1999

Macassar ebony, 11½ × 6½ × 6½ in.

42 TERRY EVANS

Tapered Urn #7, 2002

Ebony, ash, blondwood, canary wood, imbuia,
sassafras, hackberry, 23 × 7½ × 6 in.

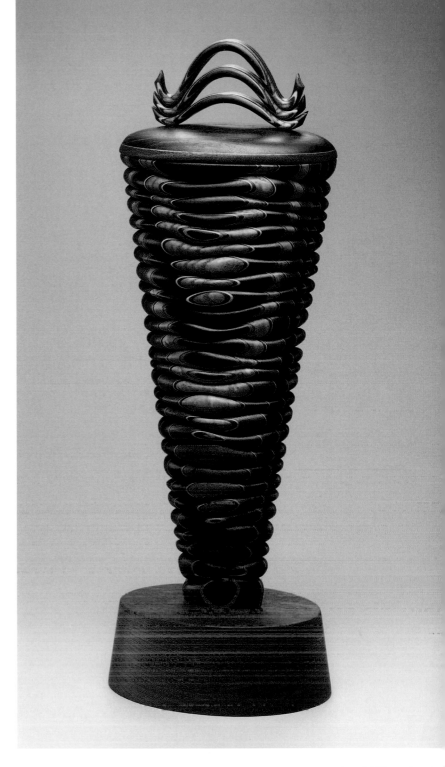

43 PHILIP MOULTHROP

White Pine Mosaic Bowl #8940, c. 1996

White pine, resin, carbon black, 8½ × 10½ × 10½ in.

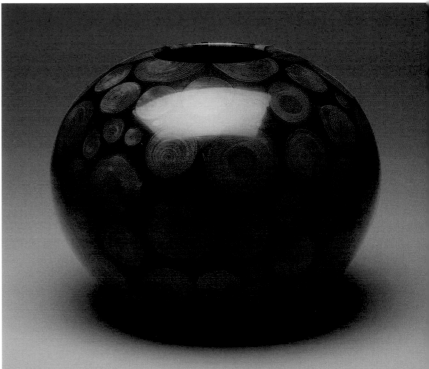

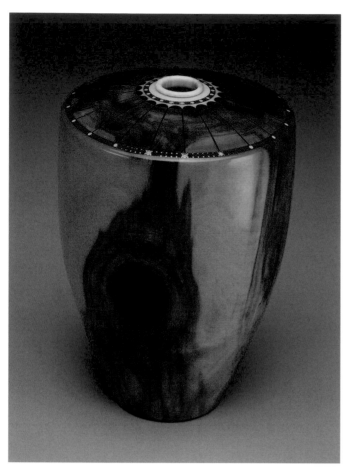

44 ROBERT J. CUTLER
And Bullet, 1997

Mahogany, Alaska aspen, fossil walrus, mammoth ivory, brass, copper, silver, 9 × 5½ × 5½ in.

45 ROBERT J. CUTLER
Aurora Borealis, 1997

Alaskan masur birch burl, brass, copper, curly mahogany, fossil bone, fossil mammoth ivory, fossil walrus ivory, moose antler, silver, tagua nut, 4½ × 19 × 19 in.

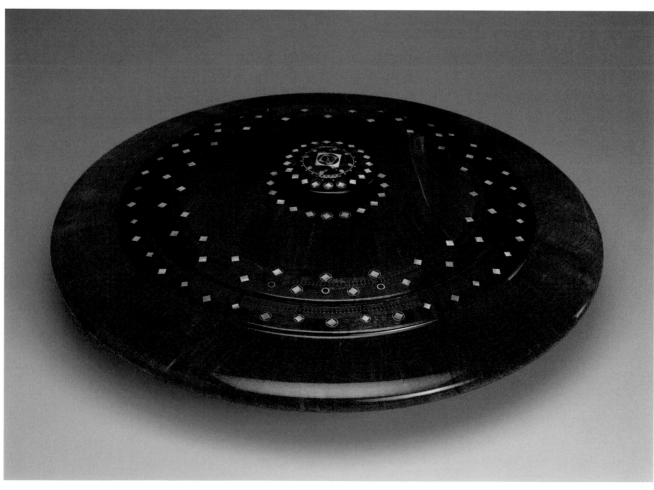

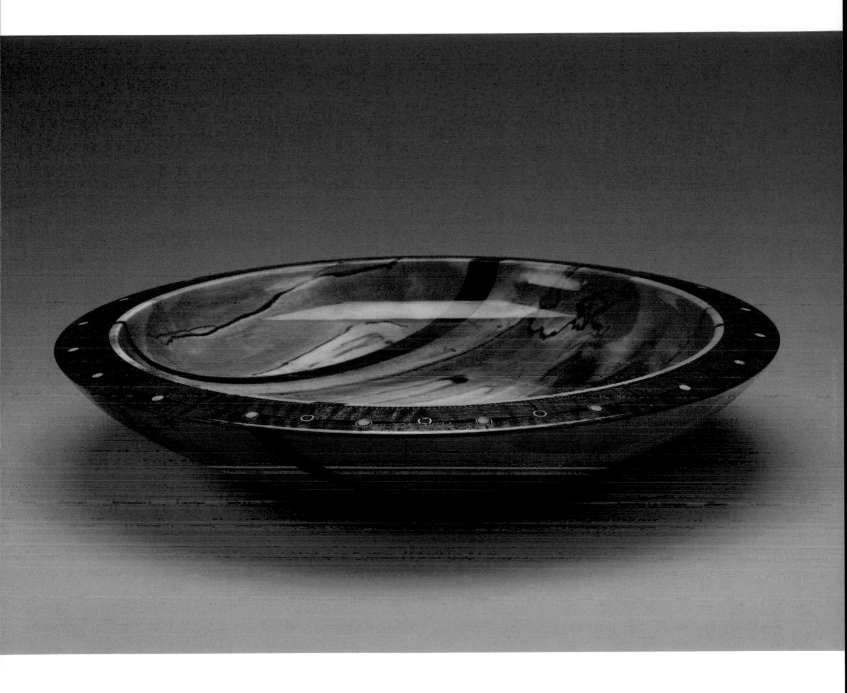

46 ROBERT J. CUTLER
Essence, 2002

Spalted Alaska aspen, curly mahogany,
moose antler, prehistoric bone, copper,
brass, 3½ × 19 × 19 in.

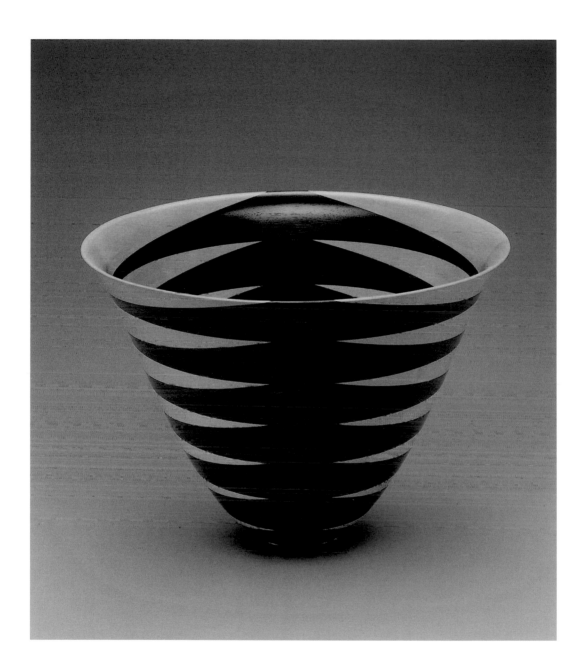

47 MICHAEL MODE

Ask No Questions, 2000

Wenge, holly, bloodwood, 11 × 14 × 14 in.

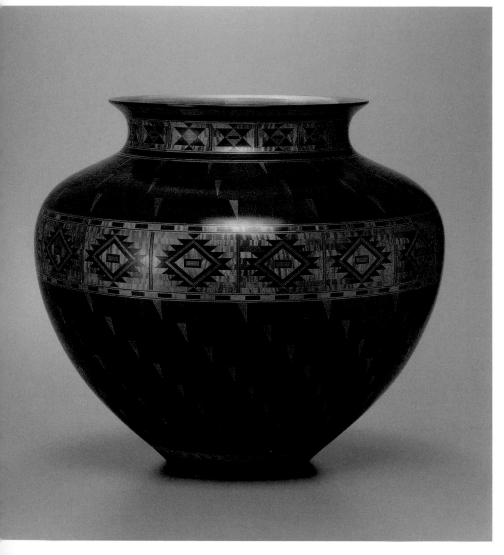

48 RAY ALLEN
Untitled, 1995

Mesquite, satinwood, bloodwood, rosewood, curly maple, ebony, dyed veneer, 27 × 30 × 30 in.

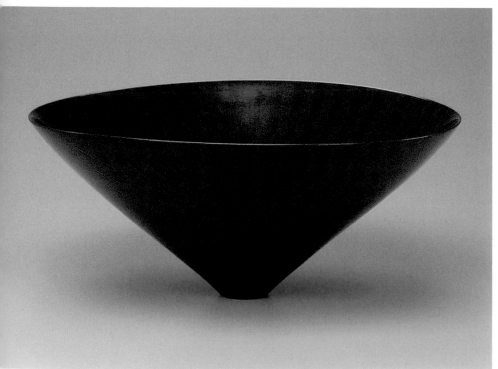

49 MICHAEL SHULER
#729, 1994

Pink ivory, Gabon ebony, 5½ × 12 × 12 in.

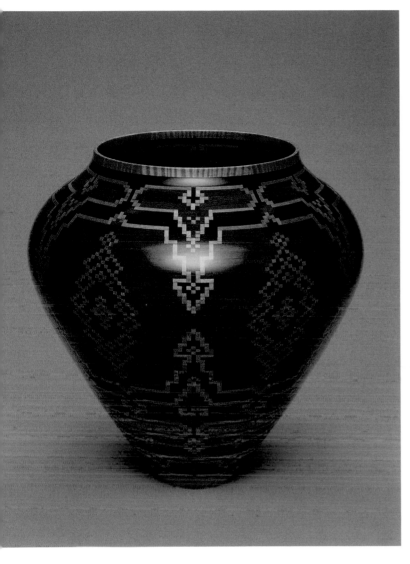

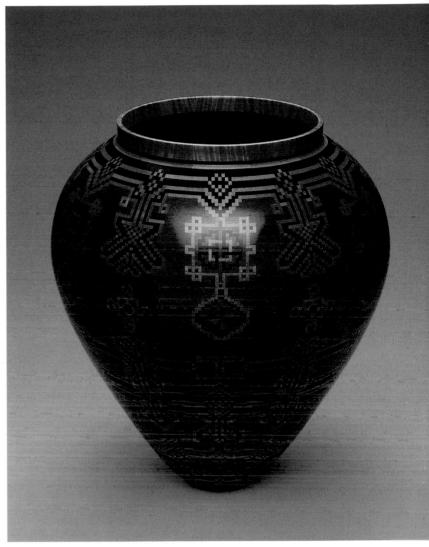

50 EUCLED MOORE
Untitled, 1998

Bubinga, maple, wenge, 16 × 16 × 16 in.

51 EUCLED MOORE
Untitled, 1999

Mahogany, maple, padauk, wenge, 19 × 17½ × 17½ in.

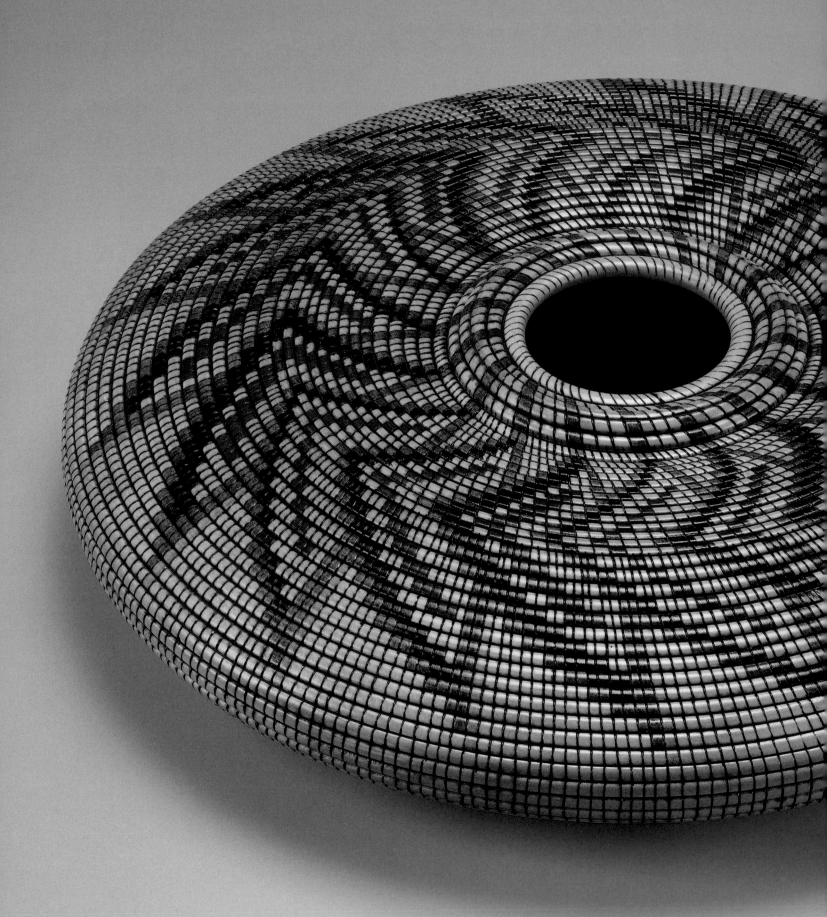

52 DAVID NITTMANN
Shamrock V from *"Bodydrum" Basket Illusion*
series, 2001

American holly, 3 × 15 × 15 in.

53 BINH PHO
Kimono #3, 2001

Olive, ash, bamboo, acrylic paint, 10¼ × 8½ × 6¾ in.

54 BINH PHO

King and I, 2001

Ebonized oak, box elder, pink ivory, acrylic paint,
dye, 22-karat gold leaf, King: 17½ × 7¾ × 7¾ in.;
And I: 17 × 7¾ × 7¾ in.

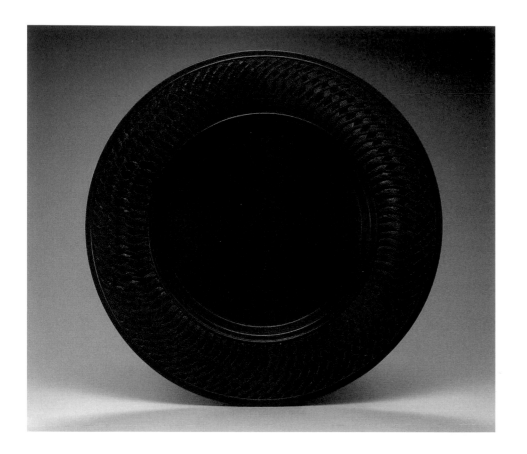

55 CHARLES AND TAMI KEGLEY
Dr. Lipton's Basket Platter, 1995
Honduran mahogany, 26½ × 26½ × 2 in.

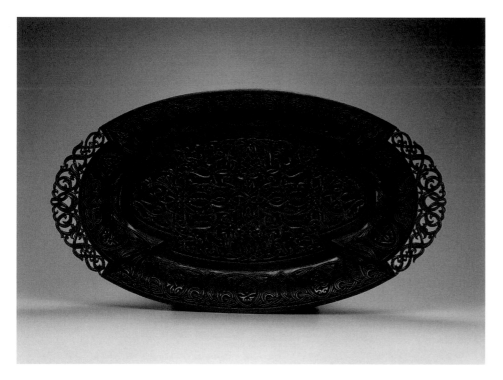

56 MELSIK YEGHIAZARYAN
Lusy, 1995
Mahogany, 20 × 37 × 6 in.

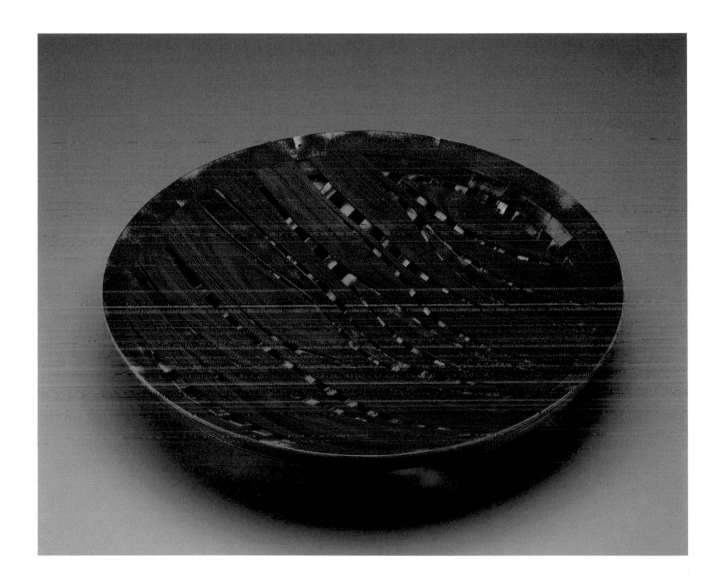

57 GIANFRANCO ANGELINO
Ribbed Birch Plywood, Sumac Plate, 1994

Birch plywood, sumac branch, ebony pins,
3 × 14¼ × 14¼ in.

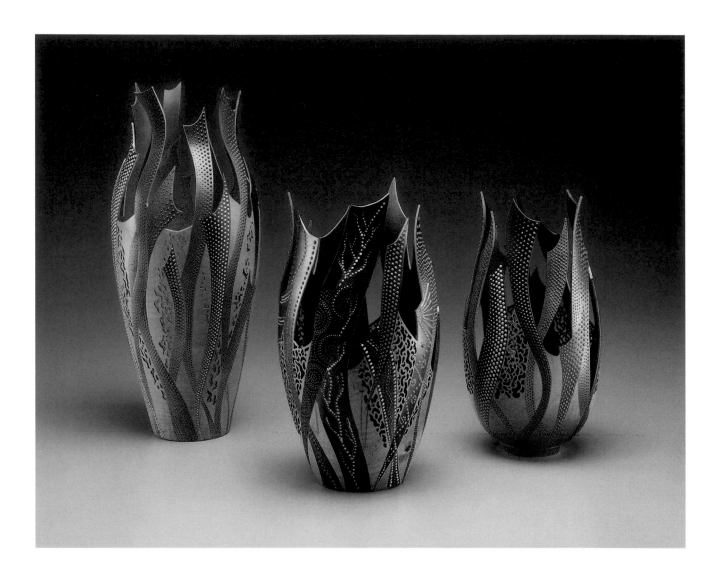

58 FRANK SUDOL

Ribbon series, left to right: 1998, 2002, 2000

Birch, lacquer, dye, fabric paint, left to right: 13¾ × 5½ × 5½ in.;
10½ × 5½ × 5½ in.; 9¾ × 5 × 5 in.

59 FRANK SUDOL

Giant Ribbons I, 2002

Birch, acrylic, fabric paint,
43¼ × 15 × 15 in.

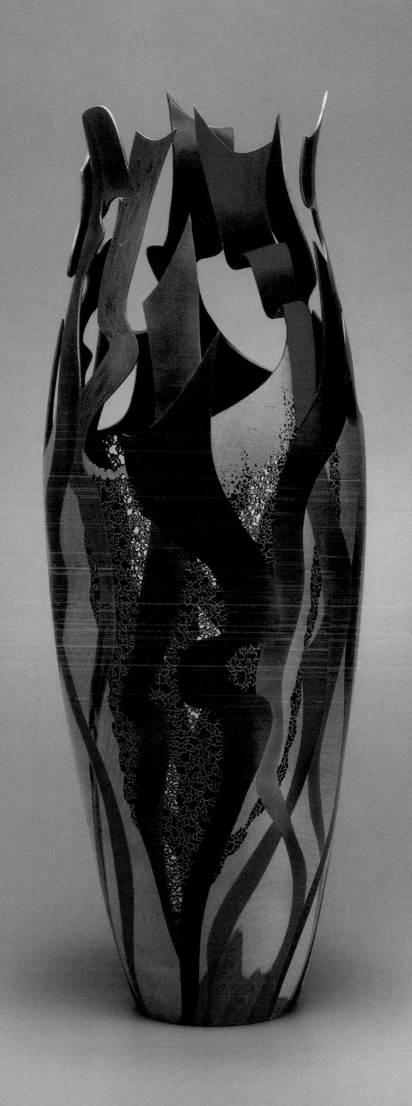

60　MARK BRESSLER

Cherry Bomb, 2001

Fiddleback maple, fractured-lacquer finish,
63 × 15 × 15 in.

61 MARK BRESSLER

Berry Bomb, 1999

Redwood burl, fractured-lacquer
finish, aluminum twisted fuse,
24 × 8½ × 14 in.

WOOD ART] TERRY MARTIN

[THE ALIGNMENT OF INTENT WITH NATURE'S BOUNTY

For thousands of years wood has been one of the most utilized materials. More workable than stone, more readily obtainable than metal, less likely to shatter than clay, and more sympathetic to the touch than glass, wood has been a part of human culture from the beginning of time. It has been the impetus for much of human endeavor—providing shelter, fuel, bridges, vessels, and much more.

Woodworkers of the past have often been production workers, repetitively making the same design to provide goods for daily use. The village artisan adzing a water trough, the bodger turning chair parts with his foot-powered lathe, the carpenter planing boards for simple tables, the shipwright bending the strakes of a fishing boat—all of these, as they hand down techniques and slowly acquired wisdom, are the ancestors of the modern woodworker.

In technically developed societies, wood has lost its place as a prime material for daily use. Woodwork was once valued for its speed and economy—taken for granted in fact—but now wood is prized as a material for contemplation. It has become a source of pride to own a handmade table or a well-formed bowl. In a reversal of the old values, wooden objects are nowadays often valued for how difficult they are to make and the amount of time required to produce them. Now that computer technology has removed all possibility of failure from production processes, it is reassuring to know that some woodworkers can still produce beautiful things through their knowledge of the material and their own dexterity.

The wood art phenomenon is largely a product of the wood-turning revival, even though turning, of all the wood crafts, was historically most associated with mass production. By placing a piece of wood on a lathe, it could be spun and shaped into chair legs, salt shakers, doorknobs, and other functional products based on circular cutting. Fast and efficient, wood turning was perfect for repetitive production. This was also why it was one of the first wood crafts to decline when fashions and production methods quickly changed. But just as it was on the verge of dropping out of sight altogether, wood turning experienced a renaissance when a few key individuals, such as David Ellsworth and Todd Hoyer, started to turn with creative intent. The curvilinear processes of the lathe proved to be more adaptable than anyone had previously thought. It is pure serendipity that wood turning, so ideal for manufacturing common items, should be so adaptable to the exploration of wood in uncommon ways. Just as with the potter's wheel, a seductive curve is best made on a machine that moves in circles. By the 1970s a new generation of rebellious makers started to express themselves freely, and it was their willingness to ignore convention and break rules that became a jumping-off

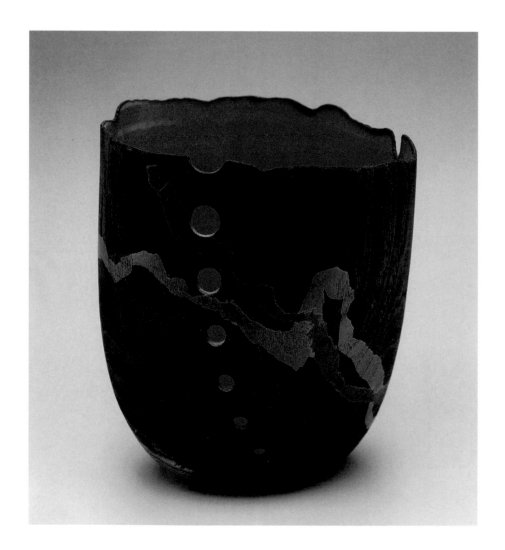

62 DAVID ELLSWORTH
Fo, 1991
Ash, pigment, 7¼ × 6½ × 6 in.

point for a whole new art form. In 2001, at the launch of the exhibition *Wood Turning in North America Since 1930*, Mark Lindquist, himself an influential pioneer of wood art, said of these new turners: "They simply disregarded, with the nonchalance typical of their generation and turbulent times, the dictums and taboos of traditional woodworking that were very much a part of the industrial arts and furniture making heritage of mainstream woodturning."[1]

A whole generation of woodworkers embraced this new genre through the latter part of the century. As turning rushed headlong into an auspicious future, generally uninfluenced by the academy, other woodworkers looked on, sometimes in dismay. As Dona Meilach says in *Wood Art Today,* "The turner has become a sculptor and may also make furniture. The furniture maker may turn wood for legs, and details, and sculpt portions of furniture that are already three-dimensional items. The sculptor may use all the techniques. No longer is there a great divide between the artists. They are all versatile and, seemingly, never run out of ideas."[2]

In this heady rush of recent success, it would be easy to get the impression that art created in wood is a new phenomenon, but in fact wood has been one of the most common materials in figurative sculpture and decorative art through the ages, particularly among first-people societies with animist traditions in Africa, the Americas, Polynesia, and Melanesia. European and Asian cultures also have ancient carving traditions. There has always been a strong religious element in woodcarving, and it is still hard to ignore the seductive image of the tree as spirit—the Tree of Life—which nurtures and provides. This same element of respect permeates much wood art today, acknowledging and paying homage to the tree and, by association, nature itself.

Wood artists work on all scales, from monumental to miniature. Enormous blocks of wood can be cut with

Snow Gum
Photo: Krista Welk

a screaming chain saw that bucks and vibrates like a living thing, or tiny portions of the most valuable timbers might be delicately cut with the finest hand saws. In every case the first creative decisions are taken with the first cuts. Grain direction, condition, and dryness are all carefully considered. Only years of experience permit the artist to fully judge what is possible. The next stage of cutting may be with the band saw, table saw, or handsaw. The wood can be drilled, turned, chiseled, or power-carved, and the final cuts may remove only infinitesimal shavings, bringing the form to the desired degree of perfection. The choice of tools is extensive, but they are only a means to an end, and it is the process that satisfies. The British environmental sculptor David Nash beautifully describes the feeling of cutting with a six-foot handsaw: "You don't

just use your arms—you can go right down to your toes to get the rhythm going. I could saw for half-an-hour to an hour at a time, and it would be like a meditation."[3] Even non-woodworkers tend to appreciate the risks involved in working wood to the limit. It can be an unforgiving material, and a piece that has been worked during several days of intense concentration can, in a moment, become splintered shards suitable only for firewood. Much of wood art is a triumph of carefully calculated deliberation combined with fingers-crossed risk.

Wood art is a genre that has been dominated by the vessel form—the archetypal human artifact. The vessel as symbol has existed for thousands of years. In any museum you will find cherished ceramic bowls, ceremonial stone vessels, gold chalices, but almost no wood, most significantly because wooden vessels were rarely considered valuable enough to be elevated to the status of art. All that has changed.

The collection shown in this book reflects almost everything that is being done in wood art today, from strictly formal vessels to in-your-face erotic sculpture. It also reveals the increasing international reach of the field, with work sourced from England to Australia, Indianapolis to Italy, Maine to New Zealand—uniting

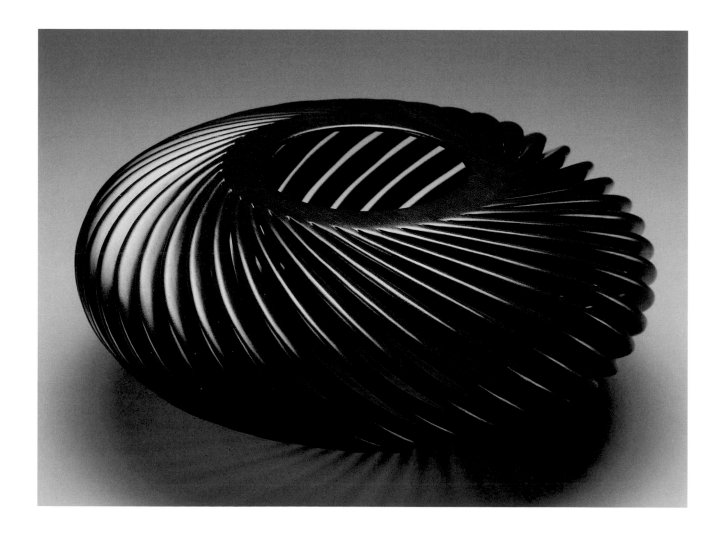

63 WILLIAM HUNTER
Contemplating Rhythms, 1998
Cocobolo, 6½ × 14 × 14 in.

the international community of artists who share an understanding of wood and its potential. Viewers and wood art enthusiasts have strong reactions to the work and the material. It is as if some tribal memory is triggered when encountering it, and this empathy makes wood art accessible to many who do not feel confident with more esoteric art forms.

Some of the pieces in this collection echo the craft world from which wood art partly evolved. *Ribbed Birch Plywood, Sumac Plate* (plate 57) by Gianfranco Angelino reminds us of woven baskets, while William Hunter's spiral vessel *Contemplating Rhythms* (plate 63) unmistakably resembles the work of the native potters in the American Southwest. The works by David Nittmann, Ray Allen, and Eucled Moore (see plates 52, 48, 50, 51) echo the pattern and texture of woven Native American baskets. The surprise comes in the fact that these artists have chosen to apply these traditional designs to wood, a medium they were never intended for and which is not easily adapted to such work.

During the early days of wood art some makers claimed they were only responsible for uncovering the beauty hidden within the tree. Nowadays few artists try to take credit for something that was already there, but there was a kernel of truth in the notion. Many of the works in this collection have an essential sense of "treeness." One example is Ronald Gerton's *A Tree Runs Through It* (plate 131), which spectacularly reminds us of the origins of the material. Mark Bressler's work is often a homage to the tree, as shown in his *Spirit Dancer* (plate 16), which resembles nothing so much as a lightning-blasted tree. The voided vessel invites us to peer within, offering a glimpse both into the tree and into the mind of the artist. Brad Sells (see plates 9–10, 94–95) is another artist who invites us to explore the hidden secrets within the tree. In many of these pieces a natural bark edge is retained. This is

always an intriguing reminder of the outside of the tree, a delineation of its worldly form before the artist took us into its otherworldly interior. Quintessential wood artist Todd Hoyer has for decades been changing our perceptions of what can be done with wood. In his *Suspended Sphere* series (plate 64) he explores not only the heart of the tree but also what we do and why we do it. By leaving evidence of the creative process on the work, he teases us into believing that we know how it was made. Closer examination, however, shows that what appears to be turned may not have been turned at all. Of course the most important question is not how he did it, but why.

Sometimes the artist celebrates the natural beauty of the wood in quietly respectful ways. Marilyn Campbell's *Igneous Series #3* (plate 39) would be a superb design in glass or clay, but that it is made from wood adds another dimension. This is no accident; Campbell cut away the wood and added epoxy to the rim to create a vessel that perfectly aligns intent with nature's bounty. Many other artists use the palette of wood grain and color to create simple vessels of stunning beauty. J. Paul Fennell's *Untitled* (plate 35) is a wonderfully austere example, designed to display the unadorned splendor of the wood.

The natural environment is a driving force for many wood artists, including Derek Bencomo, whose carved vessels such as *Ocean Harmony* (see plate 110) twist and flow like the Hawaiian seascape that inspired them. Another Hawaiian artist, Mike Lee, creates animorphic vessels that appear to have just crawled from the sea (see plate 144). It seems the Pacific is a powerful stimulus. Rolly Munro of New Zealand also interprets the detritus of the seashore near his home to create vessels with a powerful sense of place (see plates 80, 138).

Wood artists who apply concealing finishes, such as paint or gold leaf, are included in the wood art field

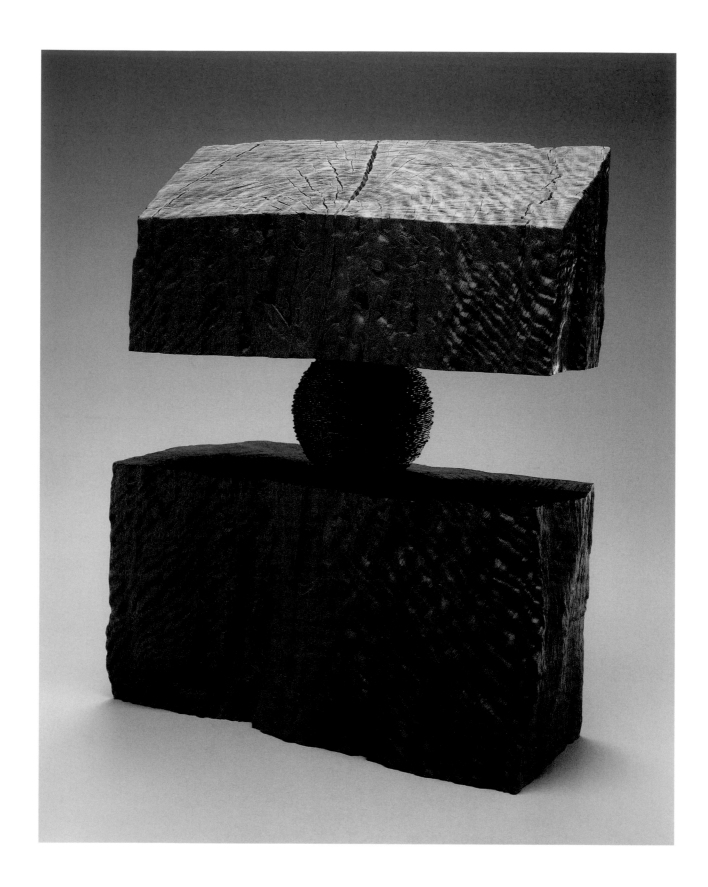

64 TODD HOYER

Untitled from *Suspended Sphere* series, 2000

Eucalyptus, wire, 20¼ × 17½ × 8¼ in.

either because they started out working with natural wood, or because they could not produce such work without an equal understanding of how to manipulate the material. These rebels have often paved the way for others to break even more rules and create new ideas. Perhaps the best known of these is Giles Gilson (see plate 65), who has always challenged the common preconceptions about what can be done with wood. Ron Fleming is another artist who has traveled from wood to painted finishes. His *Pegasus* (plate 116) is a wonderful evocation of nature with its carved leaves twining upon themselves, forming a delicate vessel. More recently, in *Yama Yuri* (plate 118), Fleming painted two-dimensional images on raw wood. This work owes nothing to wood and everything to nature. The question of whether such pieces constitute "wood art"—or whether the question should be asked at all—will be debated for years to come. Arthur Jones is an excellent example of the new innovative wood artist. His skeletal forms such as *Exhibitionist* (plate 132) could owe much to the turning process, but any turning becomes incidental when the work is cut, recut, joined,

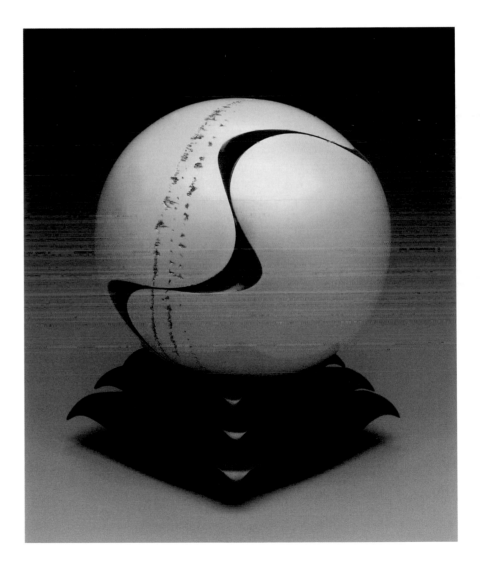

65 GILES GILSON
Snowball from Atlantis, 1997
Basswood, walnut, lacquer, 9 × 7 × 7 in.

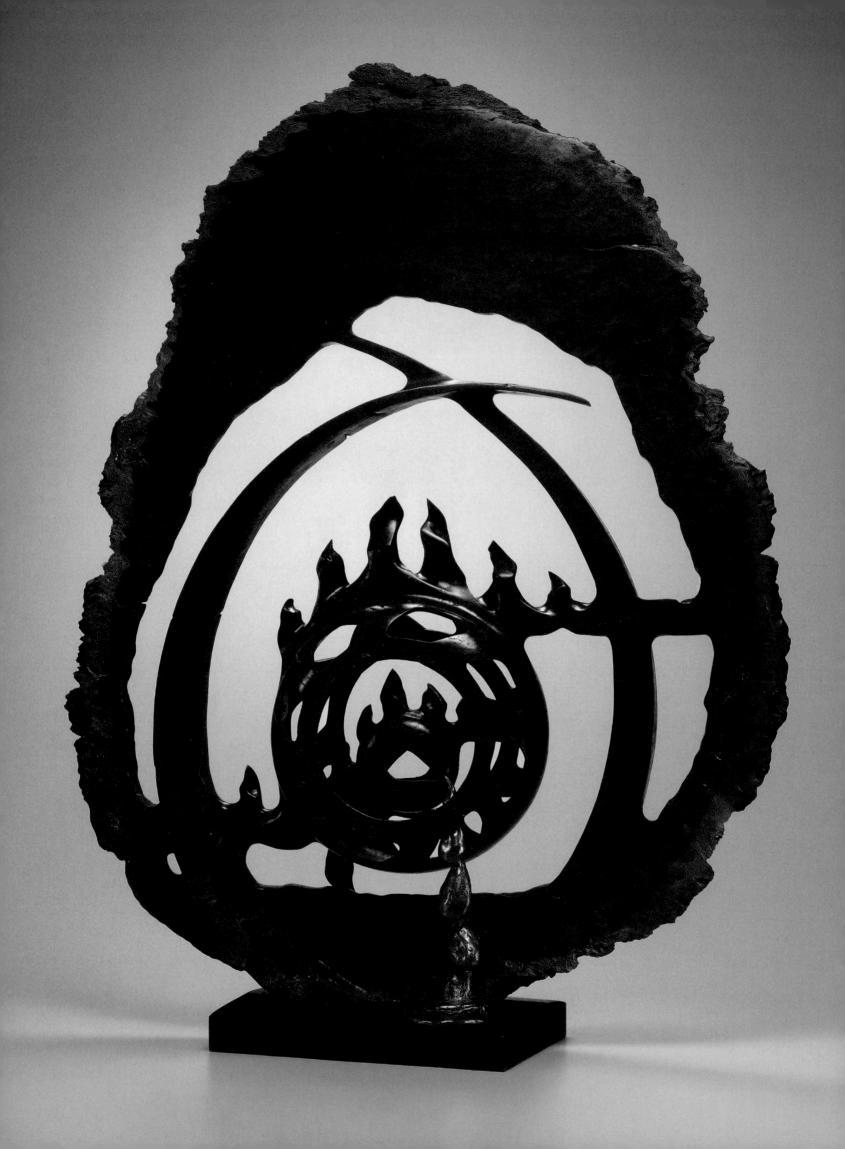

and elevated to his wonderful fantasies in wood. The complexity of his voluptuous vessel *Clam Pitcher* (plate 134) defies understanding.

An element of amazement is not unusual in wood art. For example, although made from one solid piece of wood, each of the tiny vessels in *The Stone Eater* by Alain Mailland (plate 145) is individually turned on different axes on the lathe; even other turners are stunned. Stoney Lamar's pure sculpture (plate 69) is also amazing because it was largely turned on the lathe, as was the pioneering work of John Wooller (see plate 66). This element of wonder extends to the use of wood to create such improbable objects as William Kent's *Crushed Boot* (plate 103)—unlikely because of both its size and its material.

Wood is a tactile material, and it is often possible to sense this about a piece without even touching it. Dewey Garrett's vessels in palm wood (see plate 7) look just as fibrous as they must feel. You can almost visually caress the tool marks on the early and seminal *Double Totemic Sculpture* (plate 1) by Mark Lindquist. Michael Hosaluk's *Spineback* (plate 67) and David Sengel's *The Kiss* (plate 135) both send a clear message: touch at your own risk. These two artists are masters of whimsy in wood.

All these examples only hint at the diversity of the field. Just when we think we have the measure of it, a truly astonishing artist like John Morris will arrive with his *Denim Girl* or *Head* (plates 82, 81) and challenge all our preconceptions anew. In all its permutations, wood art is both reassuring and challenging: reassuring, because it confirms that sympathetic materials worked by skilled artists still have a place in our lives; challenging, because it breaks all the old rules

and defies convention. Wood art is, above all, loved for its material and for the devotion of the artists to this material. Jody Clowes, former curator of decorative arts at the Milwaukee Museum of Art, put it beautifully when she said, "I've found my heart pounds loudest for things that speak of work, and pulse with the energy of their creation."[4] Wood art speaks of the trees and of the artists who work their bounty.

NOTES

1. Mark Lindquist, "Reinventing Sculpture" (keynote speech given at the launch of *Wood Turning in America Since 1930* at the Minneapolis Institute of Arts on Oct. 26, 2001). From the archives of the Wood Turning Center, 501 Vine St., Philadelphia, PA 19106.

2. Dona Z. Meilach, *Wood Art Today: Furniture, Vessels, Sculpture* (Atglen, PA: Schiffer Publishing, 2003), p. 9.

3. Julian Andrews, *The Sculpture of David Nash* (London: Henry Moore Foundation and Lund Humphries; Berkeley: University of California Press, 1999), p. 68.

4. Jody Clowes, "The Sound of One Heart Pounding," in *Object Lessons: Beauty and Meaning in Art* (Madison, WI: Guild Publishing, 2001), p. 49.

66 JOHN WOOLLER
The Wheel of Fire, ca. 1993
Jarrah burl, bronze, 42 × 32½ × 9½ in.

67 MICHAEL HOSALUK
Spineback, 1996
Ivory, porcupine quills, 5½ × 24½ × 5½ in.

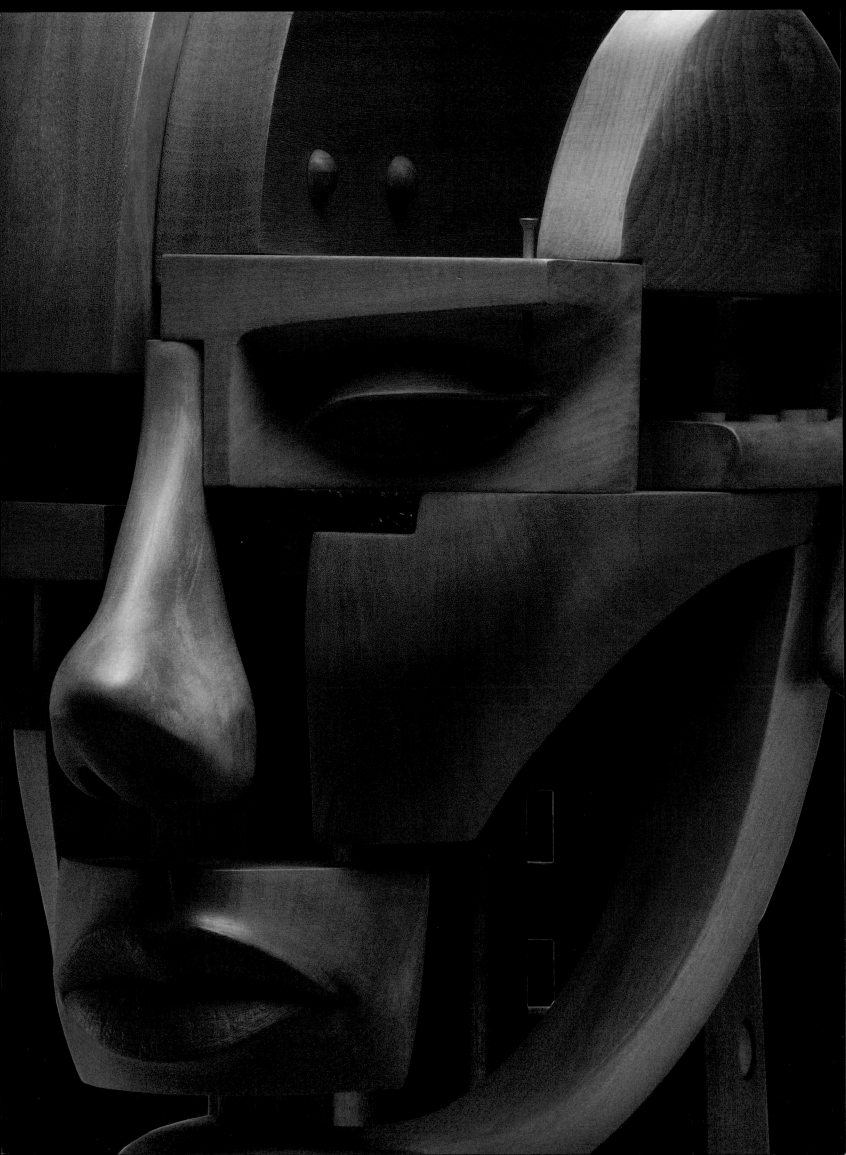

SCULPTURAL TENDENCIES

In moving completely away from the vessel form, some artists have created a body of work that is purely sculptural. Joining a time-honored tradition of fashioning sculpture from wood, these artists produce art that is richly varied but linked by an appreciation for the medium and the opportunities it offers for exploration and creativity.

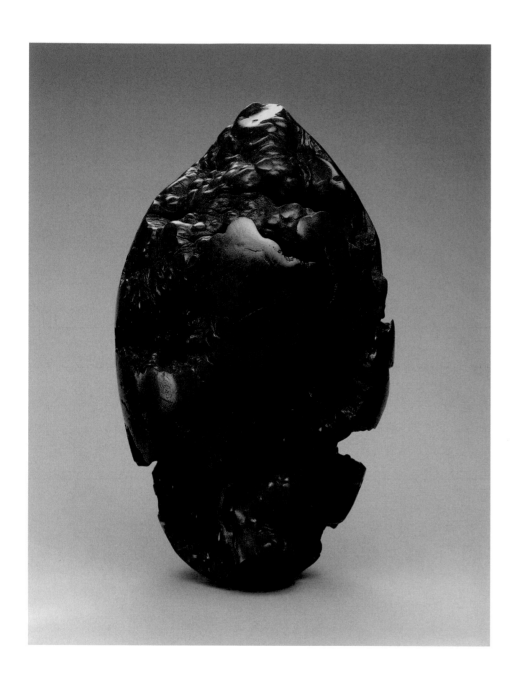

68 GEOFFREY WILKES
Emergence, 1998

Manzanita, 11¾ × 7 × 7 in.

69 STONEY LAMAR
Untitled, 1996

Madrone, 26 × 16 × 6 in.

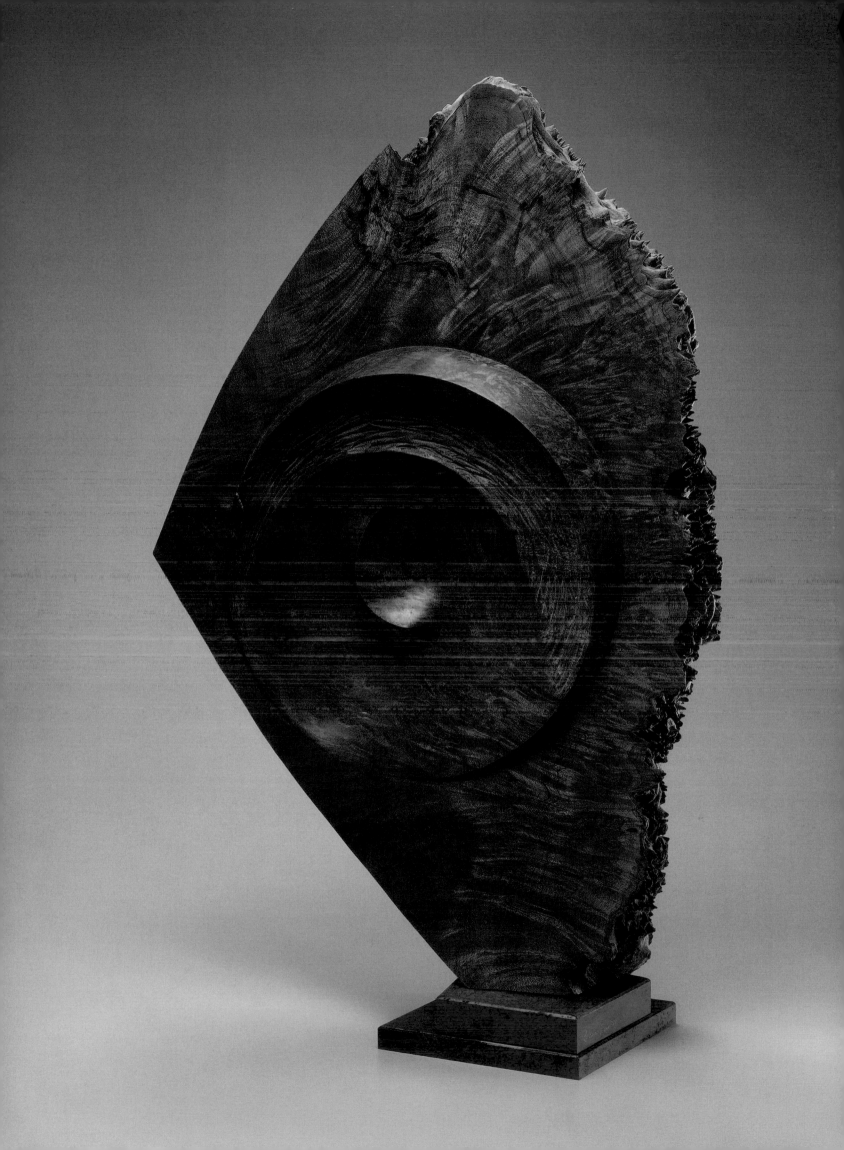

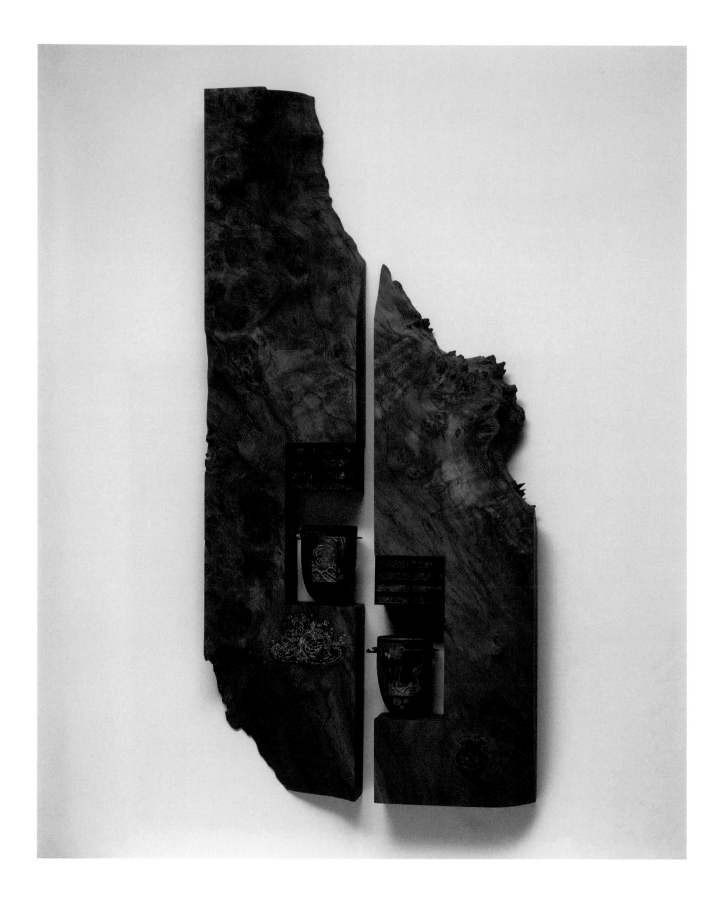

70 BINH PHO

Otomine and Urashima, 2002

Willow burl, carob, maple, acrylic paint, 45 × 20½ × 3½ in.

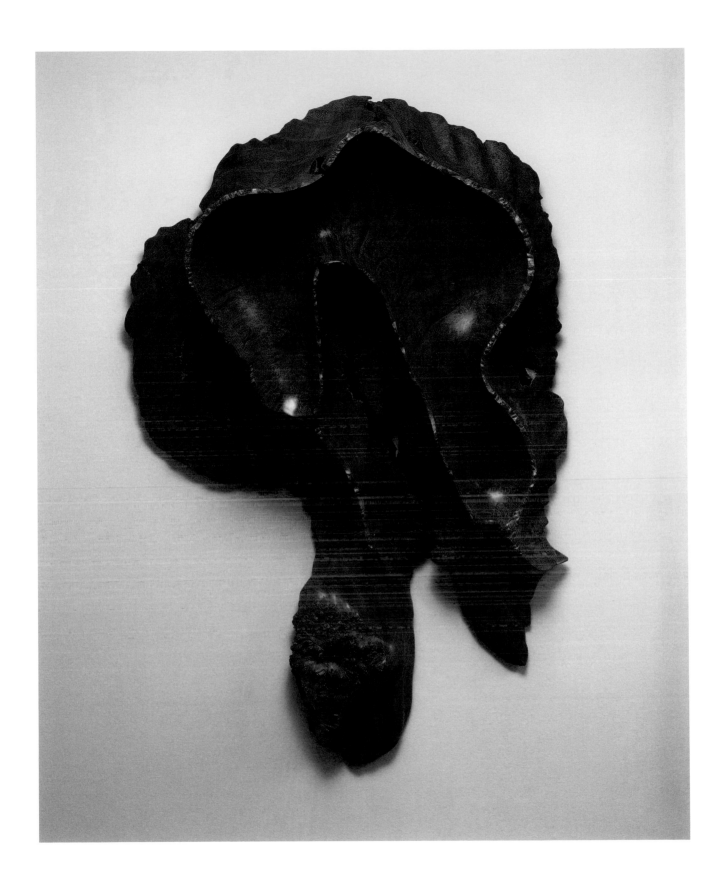

71 MARK BRESSLER
Emotional Sojourn, 1999
Maple burl cap, 42 × 30 × 12 in.

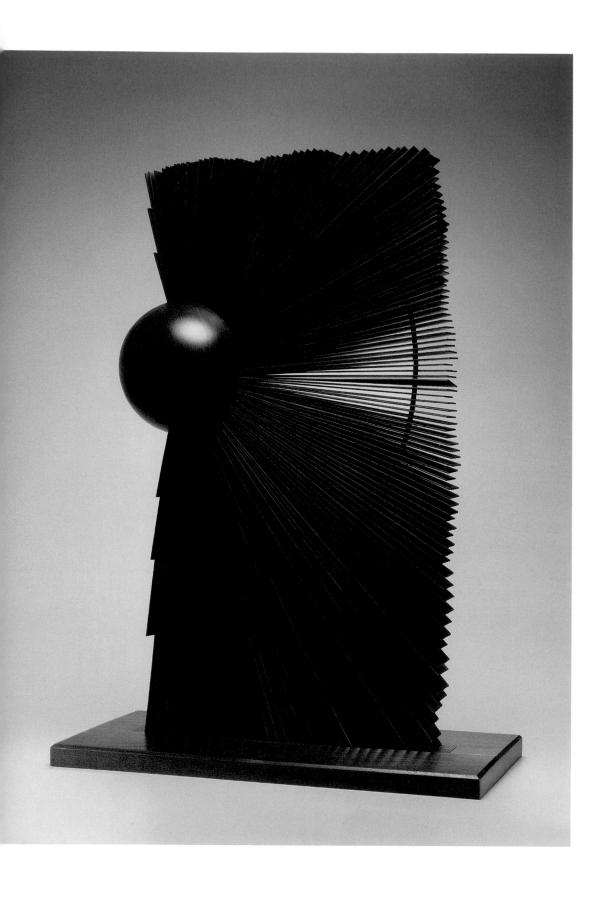

72 ARTHUR JONES
Dusk Star, 2002
Walnut, 31 × 17 × 7 in.

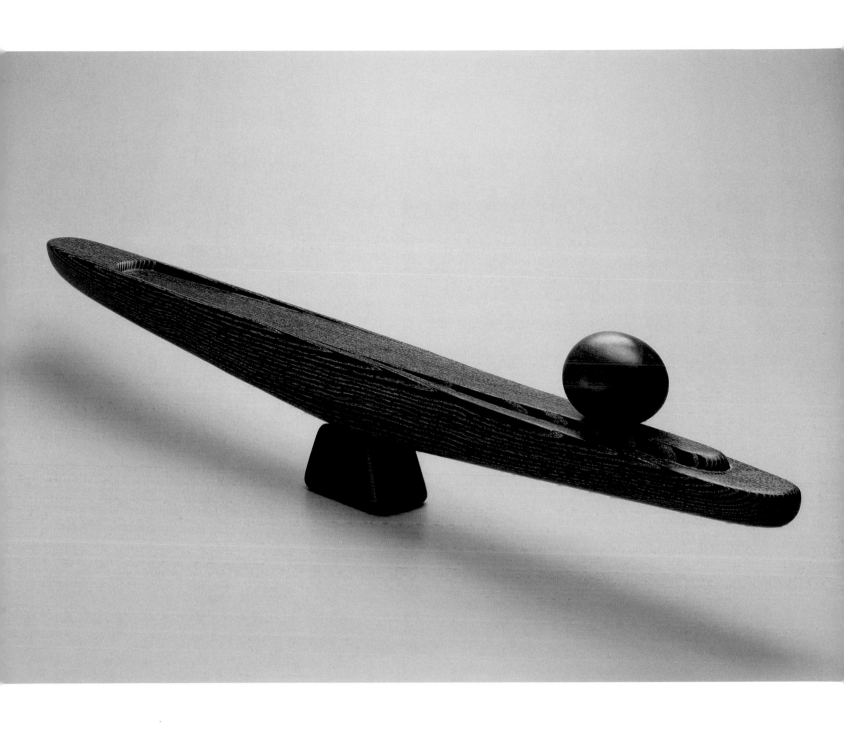

73 BETTY J. SCARPINO
Launched, 2002

Ash wood, stained, filled with liming wax; egg: poplar,
milk paint, 6 × 44 × 3 in. (egg: 4 in. diam.)

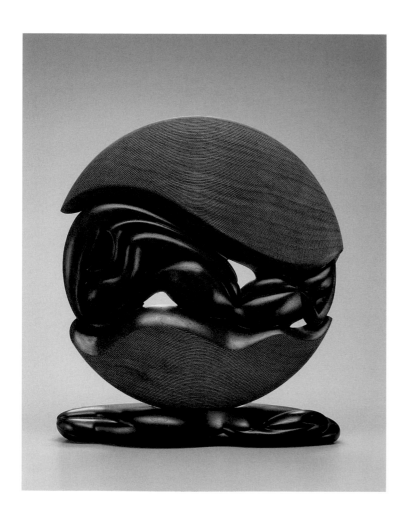

74 BETTY J. SCARPINO
Unbound, 2002

Walnut, stain, 17 × 17 × 2½ in.

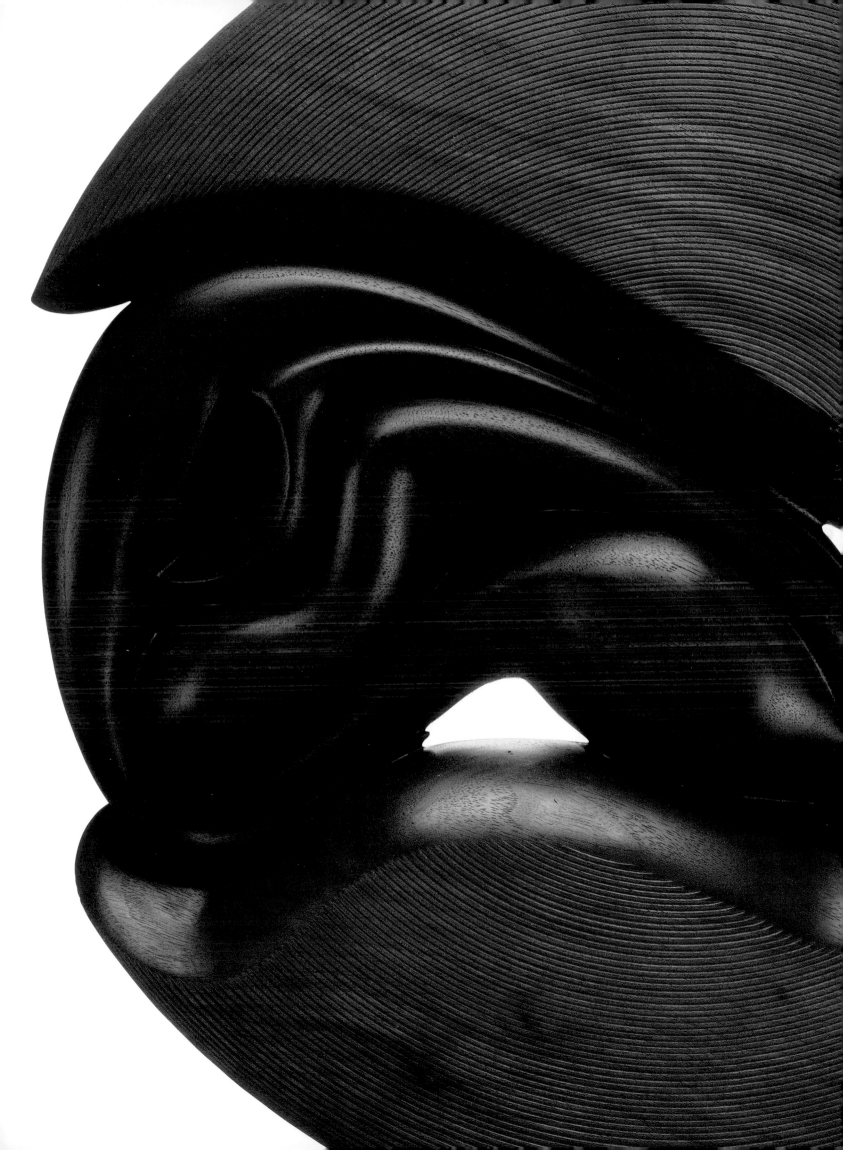

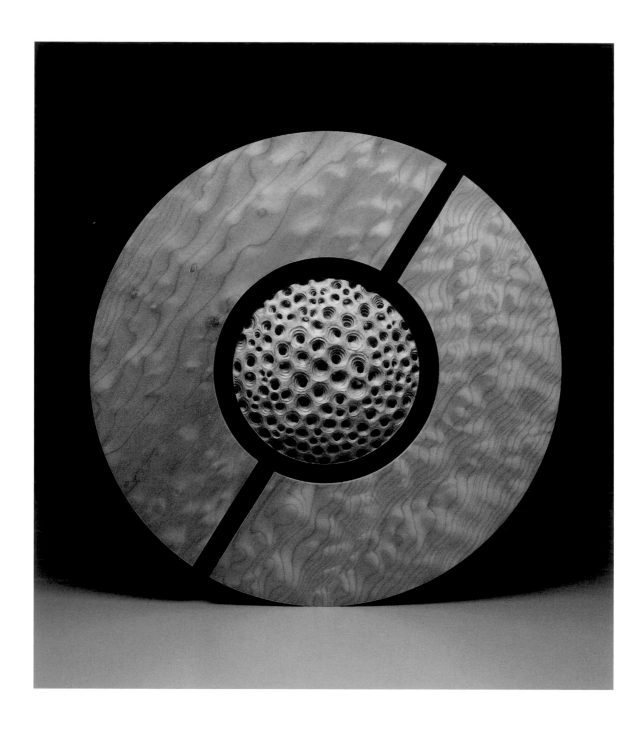

75 HAYLEY SMITH
Wall Piece #1/01, 2001
Maple, 17¾ × 17¾ × 2 in.

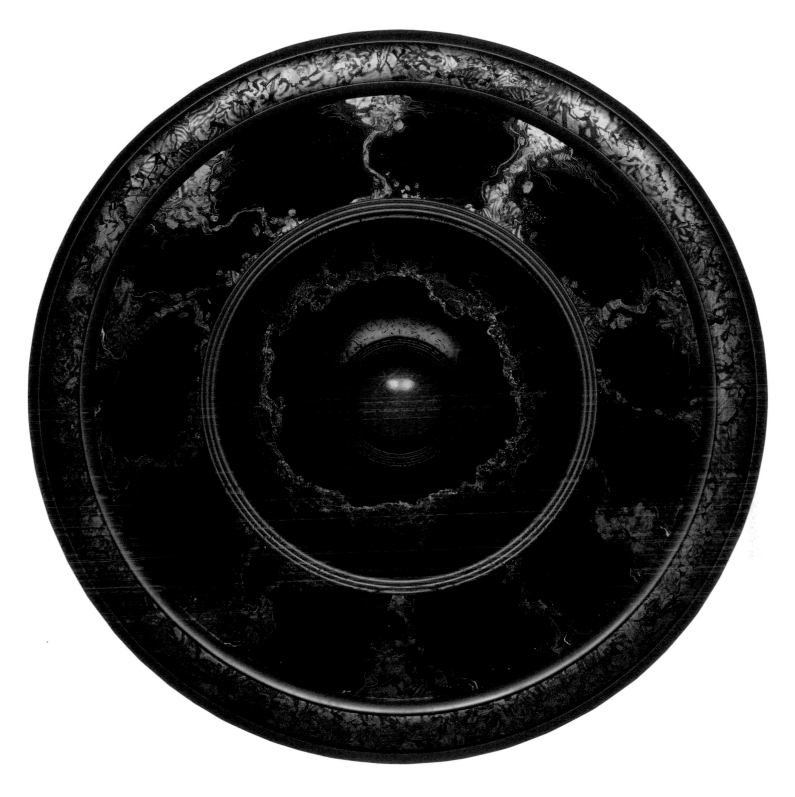

76 STEPHEN HUGHES AND MARGARET SALT
Eruption Shield #3, 1998
Jarrah burl, acrylic paint, gold leaf, 49 × 49 × 6 in.

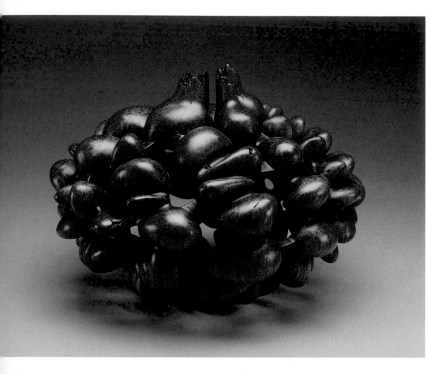

77 HUGH McKAY
Tsaar, 2002
Maple burl, 10 × 14 × 14 in.

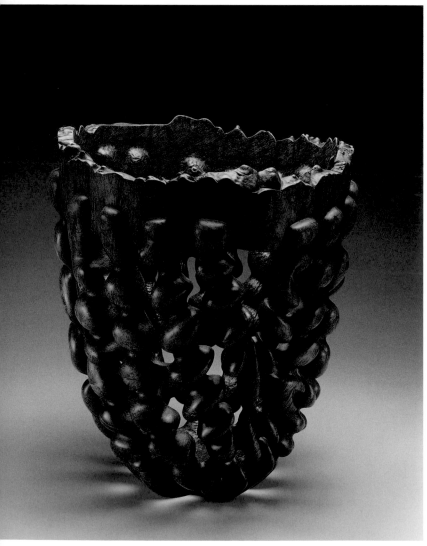

78 HUGH McKAY
Suash, 2002
Maple burl, 15 × 14 × 14 in.

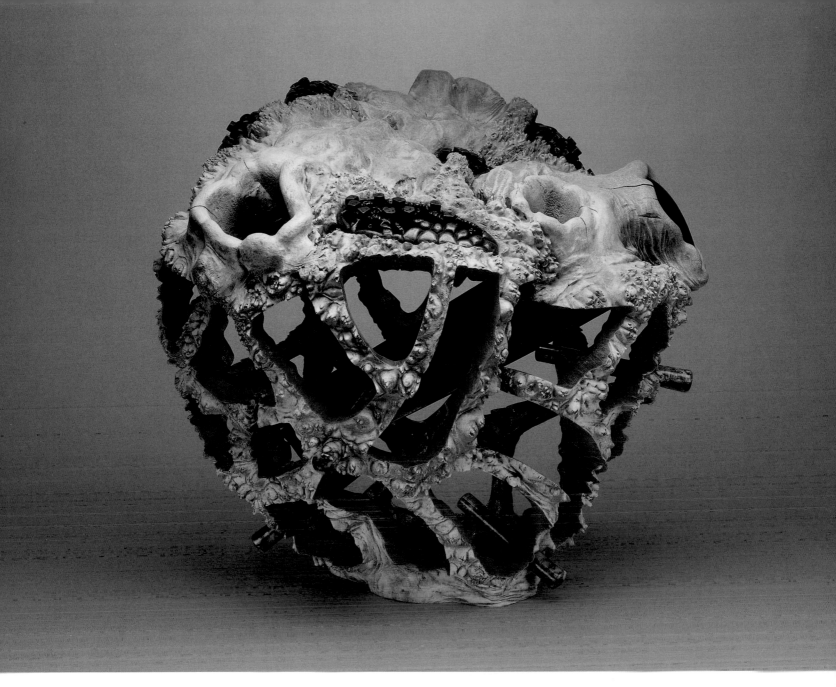

79 HUGH McKAY
Burl Cult, 2002

Maple burl, cast glass, cast lead,
alabaster, 30 × 32 × 30 in.

80 ROLLY MUNRO
Shell Form IV, 1995–98

Puriri wood, pigment, 8½ × 11 × 11 in.

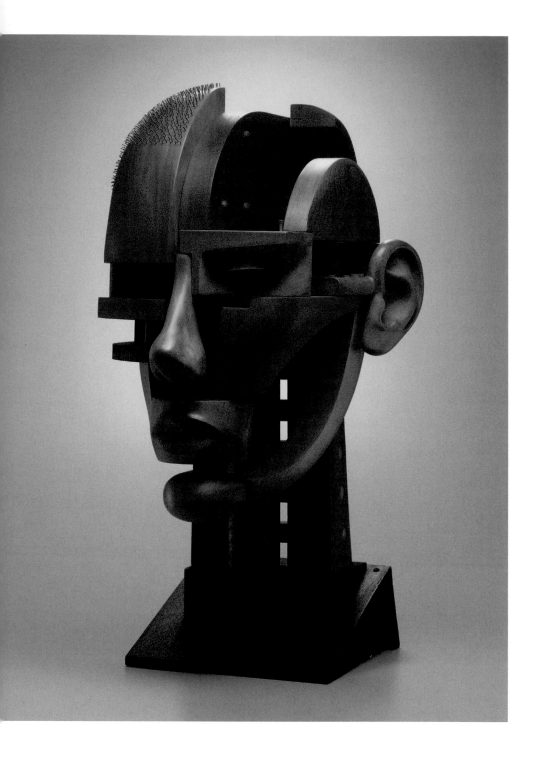

81 JOHN MORRIS
Head, 1999

Hoop pine, Tasmanian oak, linden, jarrah, mahogany, New Guinea rosewood, qwila, nails, 32½ × 23 × 16 in.

82 JOHN MORRIS
Denim Girl, 2002

Tasmanian myrtle, milky pine, purpleheart, 36¼ × 13½ × 7 in.

83 JOHN MORRIS
White Lady, 1996

Assorted hardwoods, metal, 29 × 7½ × 6½ in.

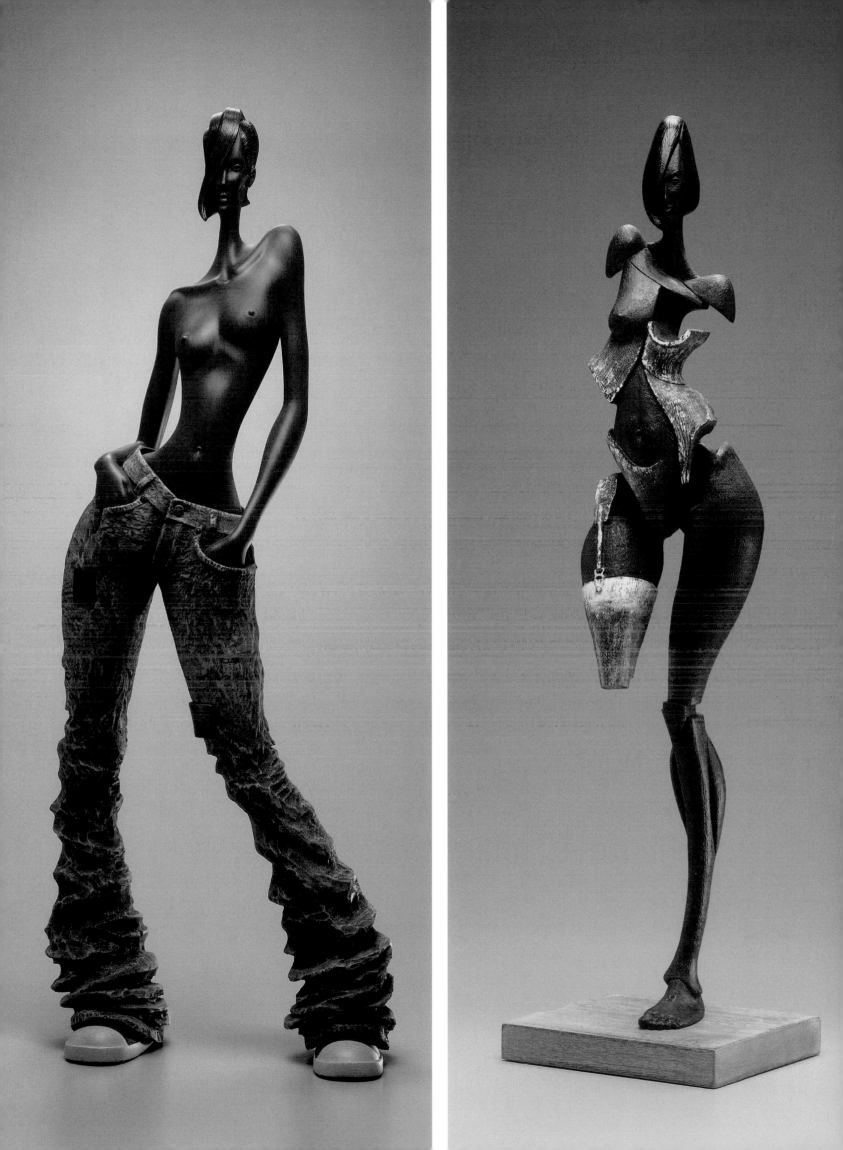

84 ALAIN MAILLAND
Eclosion, 1998–2001
Elm burl, 13¾ × 13¾ × 13¾ in.

85 TERRY MARTIN
Bigclops, 2000
Red gum burl, 23½ × 16½ × 5½ in.

86 MELVYN FIRMAGER AND CORIANDER FIRMAGER
Blue Infinity Vessel from *Risen from the Ashes* series, 1999
English yew, copper oxide, acrylic, wax, 20¼ × 5½ × 5½ in.

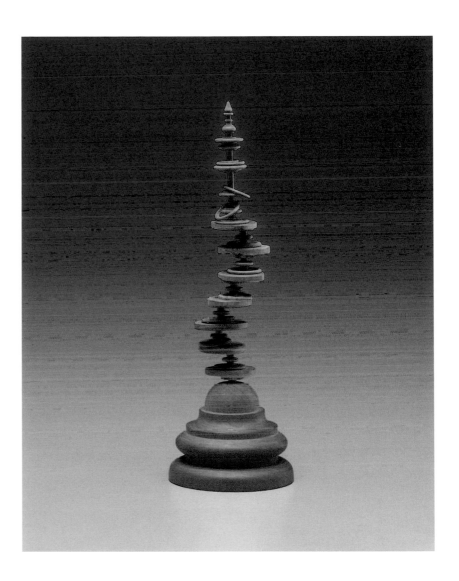

87 HANS WEISSFLOG
Classical Piece, 1996
European boxwood, 5¼ × 2 × 2 in.

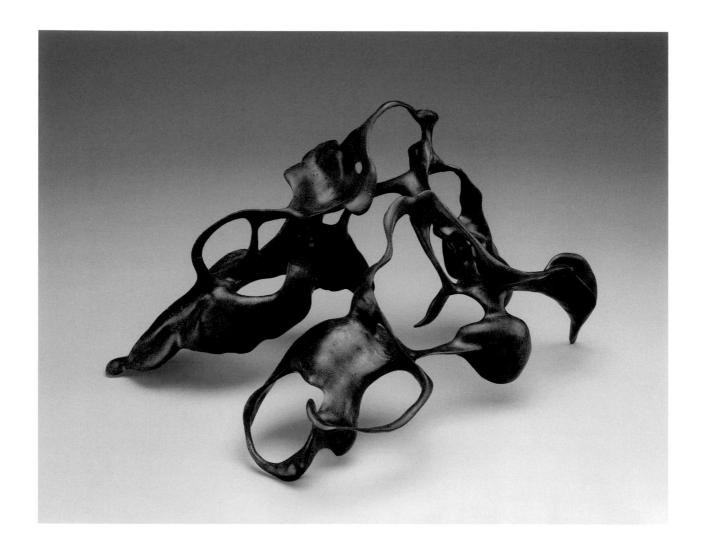

88 ELISABETH MEZIERES
Vegetal Dream, 2001

Pistachio root, 7 × 12⅝ × 10 in.

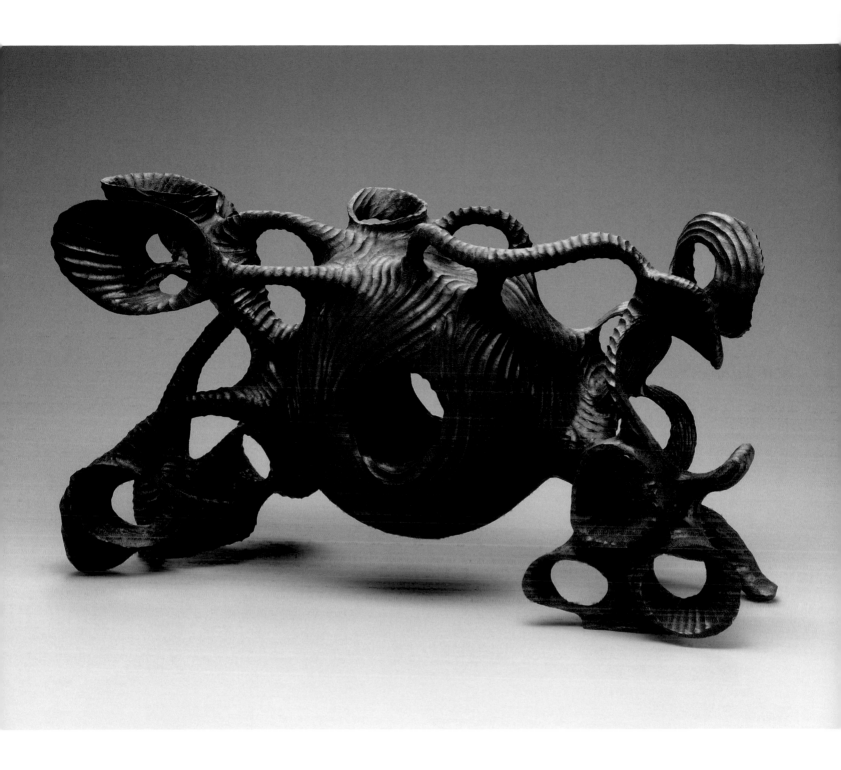

89 TERRY MARTIN
Walnut Cyclops (also known as *Mother cut your toenails, you're tearing all the sheets*), 1999
Walnut, 11¾ × 22½ × 7 in.

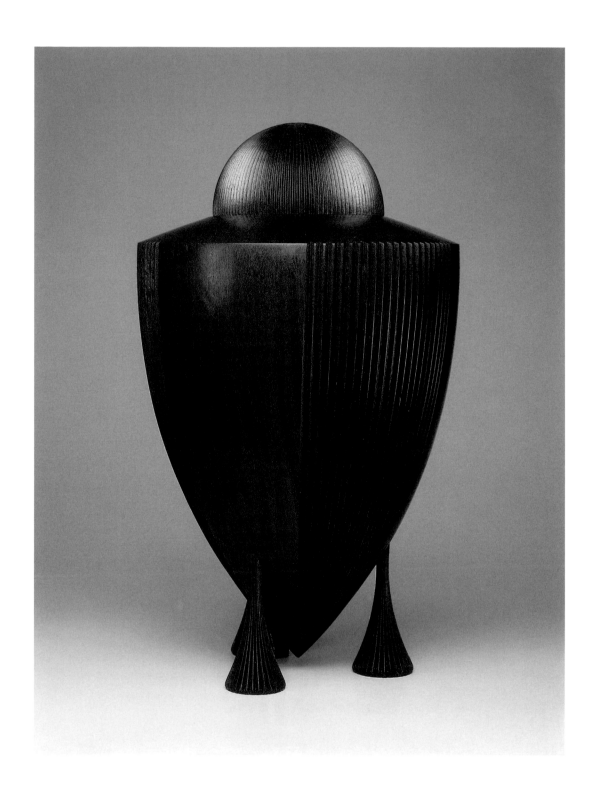

90 DEAN MALCOLM
Sentry Jarrah, 1997
Jarrah, 19 × 12 × 12 in.

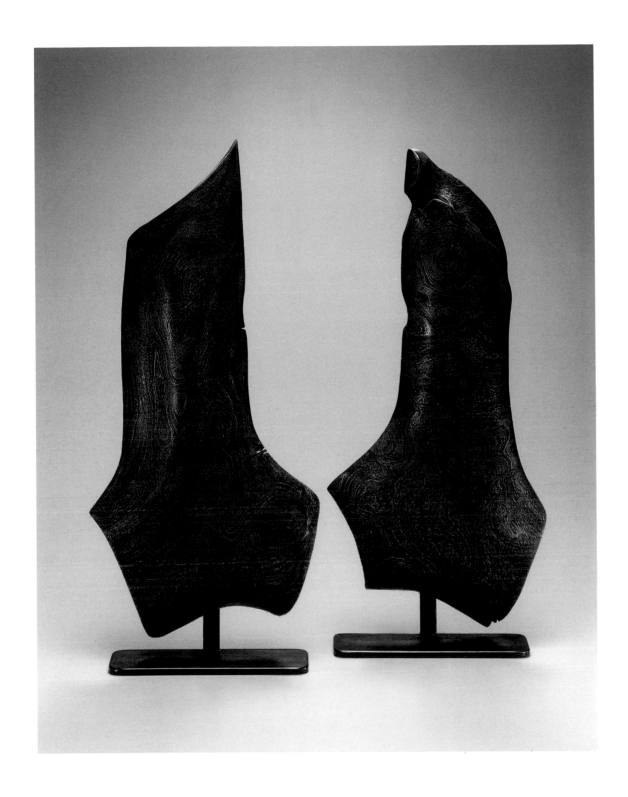

91 MICHAEL JAMES PETERSON
Coastal Objects, 1999
Carob, india ink, 23 × 10¼ × 3½ in.; 22½ × 10 × 3 in.

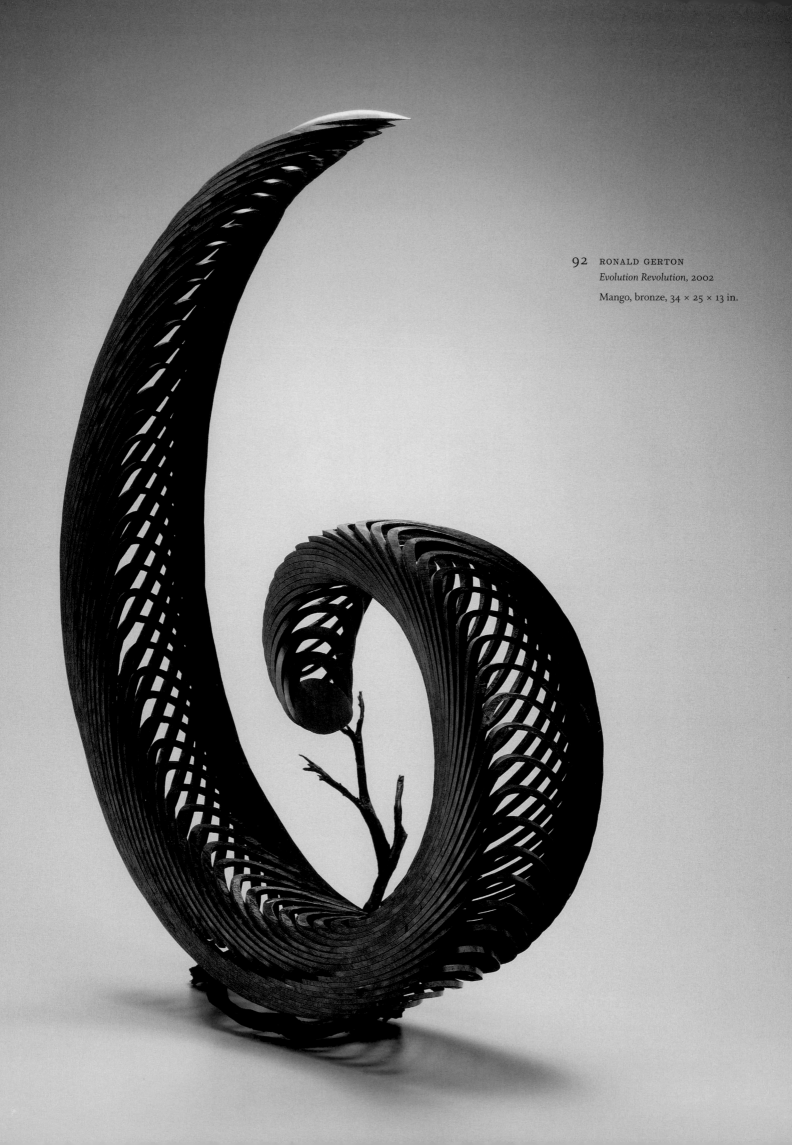

92 RONALD GERTON
Evolution Revolution, 2002
Mango, bronze, 34 × 25 × 13 in.

93 HANS WEISSFLOG
Ball Box, 2002

Amazon rosewood, monkey puzzle, 12½ × 9 × 8½ in.

94 BRAD SELLS
Spine, 2000

Red oak, 32 × 24 × 13 in.

95 BRAD SELLS
Traveler's Bridge, 2001

Maple burl, 96 × 24 × 16 in.

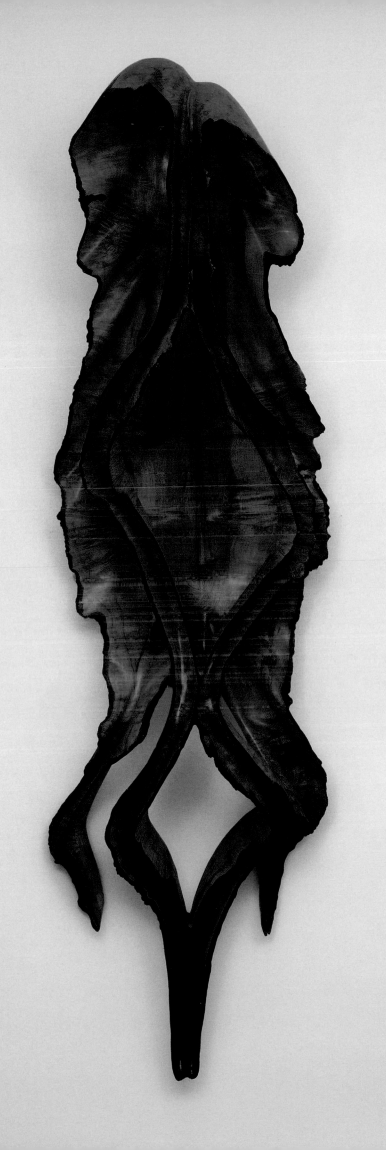

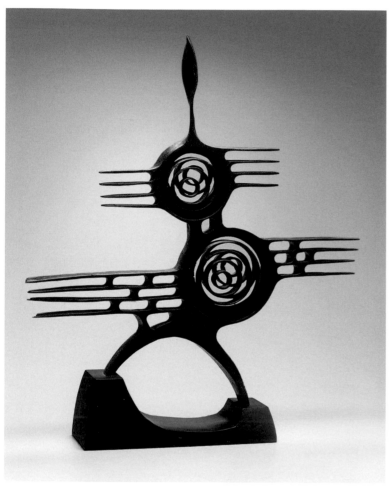

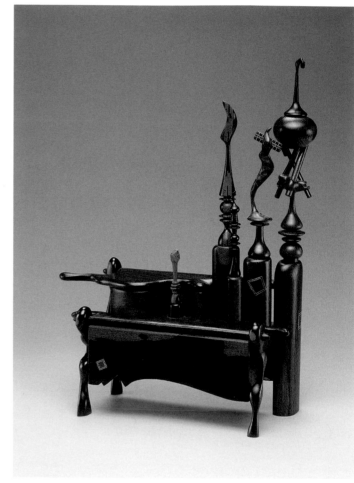

96 JOHN WOOLLER

In My Intricate Image, ca. 1993

Jarrah burl, 33¼ × 28¼ × 7⅛ in.

97 CHRISTOPHER CANTWELL

Wonderland a.k.a. Imagination Box, 1996

Ziricote, cocobolo, curly narra, bocote, Mexican kingwood, Honduras rosewood, walnut, granadillo, lignum vitae, pink ivorywood, ebony, satinwood, Brazilian kingwood, maple, koa, osage orange, chakte kok, purpleheart, gold leaf, 14¾ × 10½ × 5¼ in.

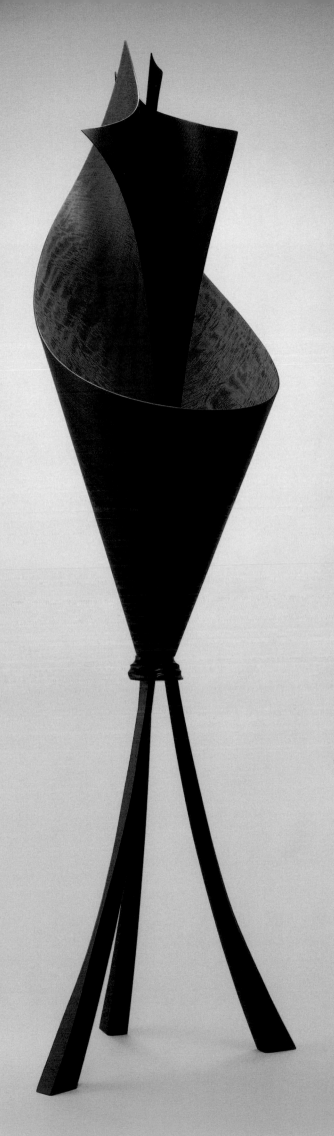

98 PETER SCHLECH
Phoenix Series #7, 2000
Anegre, padauk, 82 × 20 × 20 in.

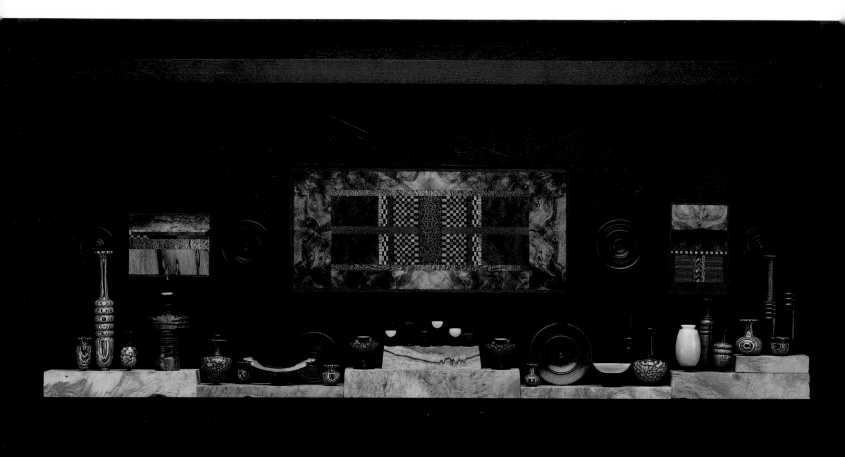

99 STEPHEN PAULSEN

*The Most Recently Exposed Annex to Dr. Marquard's Notorious Clandestine
Museum on the Third Planet, with Two Landscapes, a Classic Sky Quilt
and Thirty-Three Artifacts Illegally Imported by Marquard and Crew from
the Void, in Clear Violation of the Compact,* 1999

Arariba, bimblebox burl, boxwood, buckeye burl, canary wood,
cercocarpus, coconut palm, ebony, jacaranda, kingwood, lauan,
leopard palm, lyonothaminus, makamong burl, maple, oreocallis,
oysterwood, pernambuco, pink ivory, poinciana, purpleheart, royal
palm, satinwood, thuya burl, vegetable ivory, wenge, wild lilac burl,
17½ × 31½ × 2¼ in.

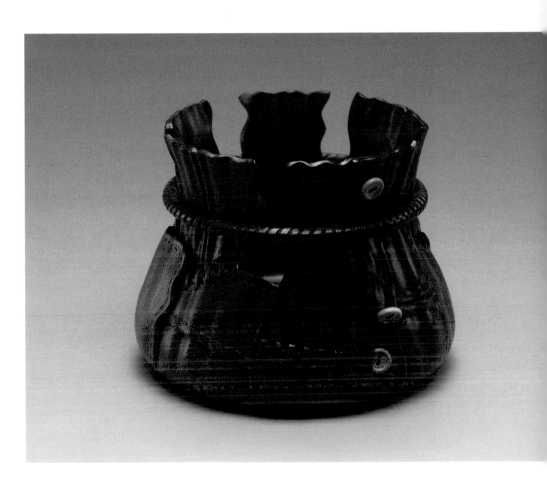

100 NIKOLAI OSSIPOV

Fabric Bowl, 2002

Sycamore, maple, 5½ × 6½ × 6½ in.

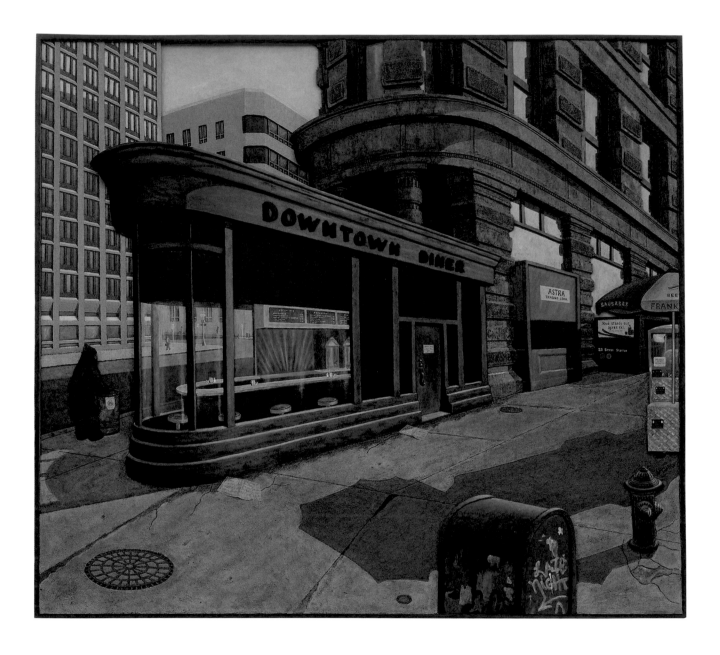

101 STEVEN MacGOWAN

Downtown Diner, 1988

Butternut, oil paint, 47½ × 53 × 3 in.

102 STEVEN MacGOWAN

Prairie Avenue, 1998

Butternut, oil paint, 57 × 48 × 4½ in.

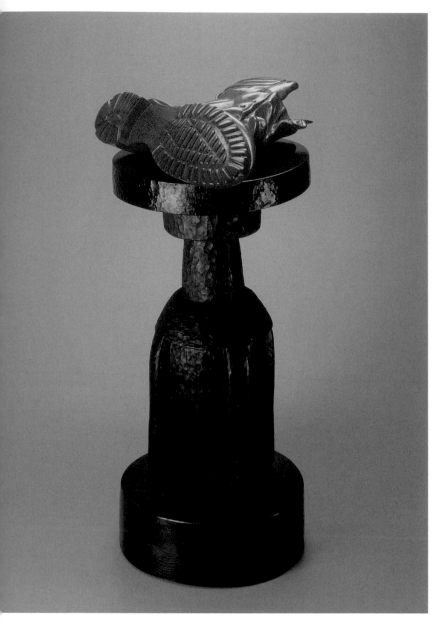

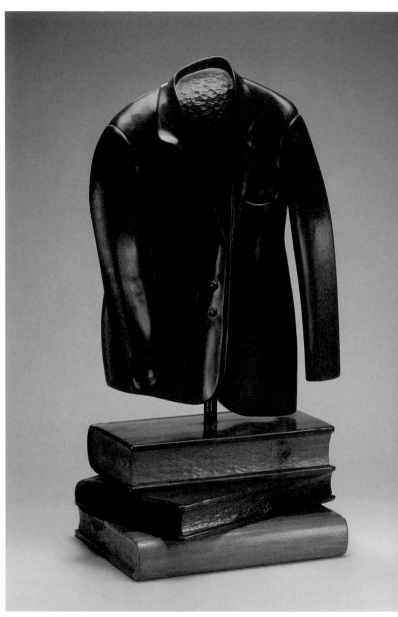

103 WILLIAM KENT
Crushed Boot, 1991

Maple, found wood, 46 × 26 × 23 in.

104 WILLIAM KENT
Jacket, 1995

Mahogany, pine, 47 × 23½ × 21 in.

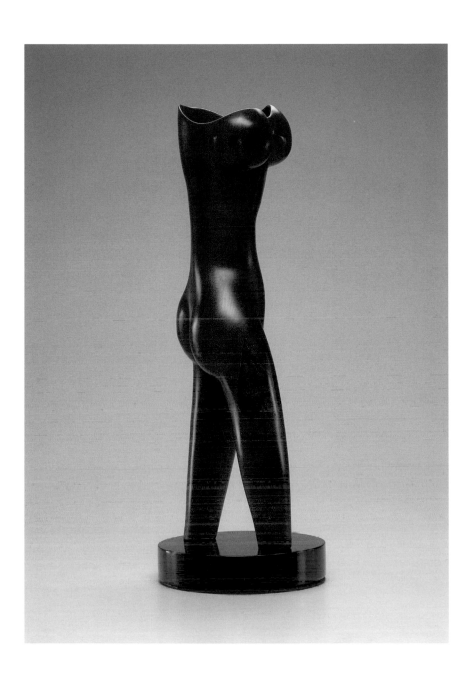

105 LYLE JAMIESON
Sassy, 1998
Wild black cherry, 22 × 7½ × 7½ in.

TURNING TO WOOD] JANICE BLACKBURN

[A CURATOR RESPONDS TO THE ART FORM

My first reaction when invited to contribute an essay to this catalogue was to ask, Why me? Although I have worked in quite a rarefied area of the contemporary art world for many years (as the assistant curator of the Saatchi Collection from the time it opened in London in 1985 until 1994; then, since 1997, as founding curator of the Sotheby's Contemporary Decorative Arts Exhibitions and as a writer on contemporary art), I knew very little about the world of turned wood. Wasn't it too decorative, too resolved and finished for my taste? I smugly questioned.

Even though I believe that fresh and innovative work that truly combines the highest artistic merits with all the labor, intensity, and skill of craftsmanship has, over the years, won many converts, I too had prejudices to overcome. Basketry, for example, had no place in my art vocabulary (it was fine, I condescended, for bread, logs, shopping, or waste, but reeking of rusticity along the lines of macramé). Then I saw the work of California-based artist Gyöngy Laky. Here before me were hard-edged, bold, gutsy, provocative sculptures, combining all manner of unusual woods—apricot- and apple-tree twigs and branches—with rather brutal and ugly nails, plastic or rubber tubing, and wire. The results were so unusual, compelling, and above all, non-basketlike that I started to hunt out other "basket makers" of Laky's caliber and created an exhibition with ten equally extraordinary and powerful artists. One of the artists, Valerie Pragnell, now has a piece in the collection of the Metropolitan Museum of Art.

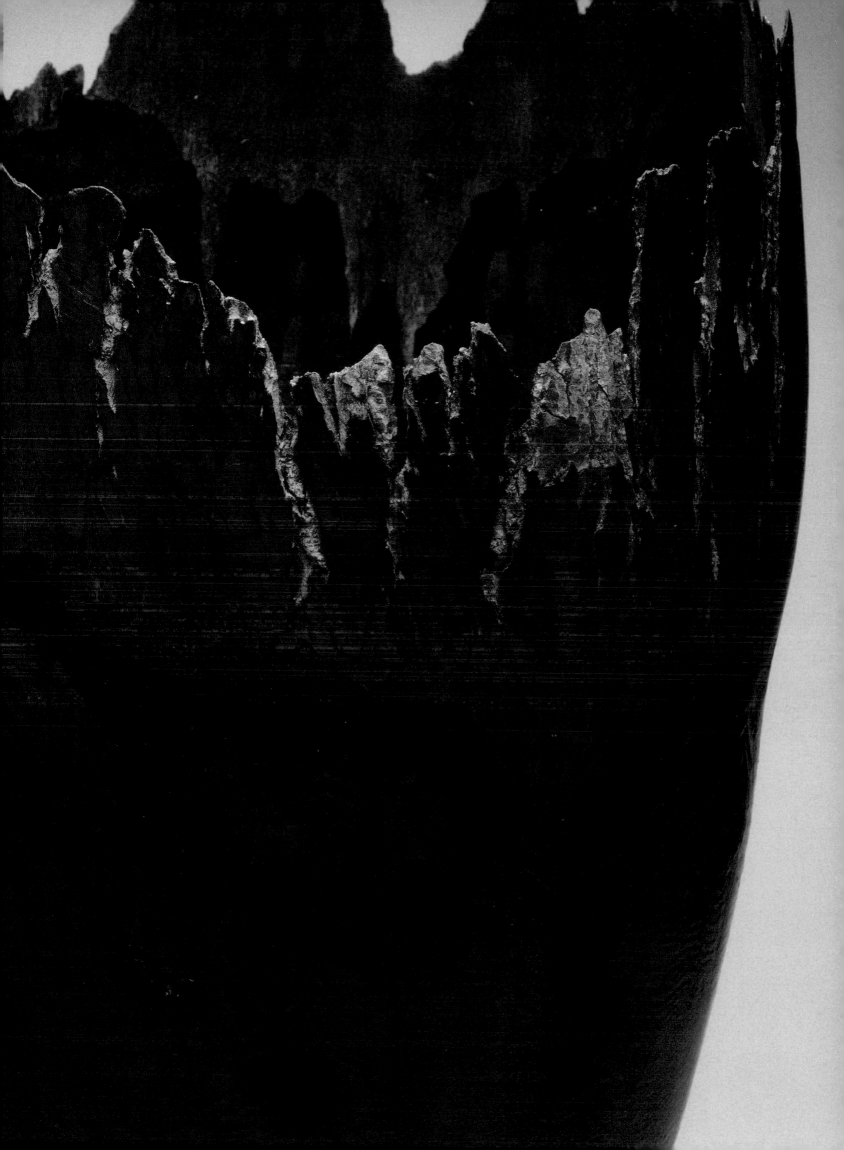

Most of the contemporary craftspeople I have selected over the years for Sotheby's shows share a distinctive aesthetic that hovers on the edge of what is normally regarded as craft. It certainly isn't "crafty" in the traditional sense and can be quite conceptual, quite at home with the most cutting-edge examples of art and sculpture. In my somewhat particular style of presenting modern craft, I select work by a careful process of thoughtful elimination after looking and seeing as much work as possible. I visit studios, art college degree shows, and gallery exhibitions, and of course, a huge amount of work is sent directly to me in the form of slides. I would feel I was not doing my job properly if I didn't seriously consider work just because it didn't appeal to me on the basis of personal taste. Personal taste should not be an issue; as a curator, I must make choices comprehensively and on behalf of a wide audience.

On the grounds, therefore, that I must practice what I preach and not dismiss anything as "unworthy" of my attention out of pure ignorance, I asked for more

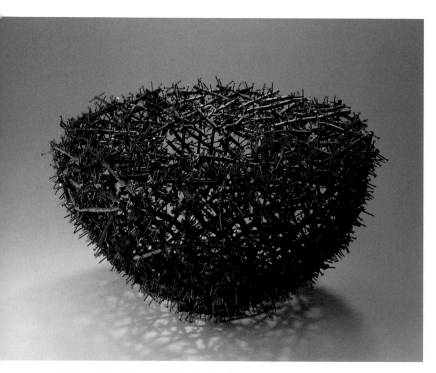

Gyöngy Laky, *Spike*, 1998. Doweled apple prunings, vinyl-coated steel nails, 13 × 21 in. Collection of the Renwick Gallery of the Smithsonian American Art Museum, Gift of Eleanor Friedman and Jonathan Cohen

information about the Bohlen collection; I wanted to carefully study the pieces illustrated there. Could these wide-ranging and often stunning works of art really be made of wood? They were all so distinctive; what they had in common, apart from workmanship that defies description, was that they couldn't be easily categorized. They are what they are, and that is exactly what intrigued me. But does that necessarily make them fine art, in the same league as work collected and shown by leading galleries? Barbara Hepworth, for instance, worked a great deal with wood, and though she was never considered a "craft" artist, works by Bohlen collection artists Dan Kvitka, Andrew Gittoes, Todd Hoyer, and Dwayne Rohachuk seem to share many features of her rigorous aesthetic.

There is also a younger generation of artists working in wood. Stephan Balkenhol, from Germany, carves ordinary-looking men and women in simple, peasant clothing—the figures integral with their pedestals. They appear to be rooted in Grimm's fairy tales, and it is their very "woodiness" that gives a feeling of unease, like characters in a nightmare. David Nash is known for his "ongoing dialogue with wood" and uses wood from trees that have been cut down for clearing or have fallen naturally. He and Jim Partridge (who only shows his work in craft, rather than fine art, galleries) share many similarities in the burning and charring of the wood they work with.

The early shows I assisted in curating at the Saatchi Gallery featured what have since become contemporary classics, ranging from the works of familiar artists like Andy Warhol and Lucian Freud, to minimalists such as Robert Ryman, Brice Marden, and Donald Judd—with all of whom, at the time, I was little acquainted. Since then life has been a continuous (and sometimes challenging) learning experience. One thing I have discovered in my journey through the intriguing but confusing world of contemporary art is that things

rarely are what they seem. Making an instant assessment or judgment frequently proves to be a mistake.

At times I would look, see (or thought I saw), and be unconvinced by a particular work's merits, only to later change my opinion. Sometimes a good initial response turned negative after I was able to really see the work and reflect deeply on its lack of substance, instead of being seduced by its, oftentimes, shallow surface. With the arrival in the collection of the group referred to as Young British Artists (YBAs)—Damien Hirst, Tracey Emin, and a host of others—the learning process had to start all over again. New rules were being imposed; "conceptual" became the buzz word in the hip art vocabulary, and now it was not so much what you saw as what the artist was telling you to see. There seemed to be a new restricted club; you were "in" if you got it, "out" if you didn't. Was I missing something? I still can't answer that question—maybe history will—but I always harbored doubts about the merits of the pickled shark, the medicine bottles, and the unmade bed. I was even less convinced by Tracy Emin's bold borrowing of Marcel Duchamp's slogan "It's art if I say it is."

This direction in contemporary conceptual art felt cynical to me. There was a detached aloofness that I found hard to respond to. The artists seemed to be intent on making an impression and an impact that, to me, lacked depth. In reaction I started to develop an interest in what I call the "art of the handmade": glass, ceramics, functional wood, metalwork, and fiber. All these materials had, to my mind, the potential for being fashioned into art of exceptional integrity. I felt engaged emotionally in a way I never had been with the art of my Saatchi days—as if there were an intimate dialogue between the maker and myself, though in many cases we had never met. This work had much of the excitement and "edge" of the YBAs, but it seemed to be more thought out and self-assured. With many of the works

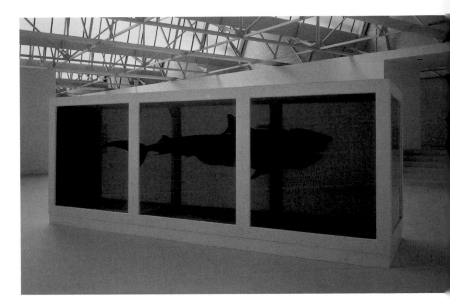

Damien Hirst, *The Physical Impossibility of Death in the Mind of Someone Living,* 1991. Glass, steel, silicone, shark, and 5% formaldehyde solution, 84 × 252 × 84 in. Courtesy of the artist and Jay Jopling/White Cube (London)

in the YBA movement, the concepts just weren't significant enough to last beyond their initial powerful debuts. We live in such a swiftly changing world, do we want even the art around us to have only momentary appeal? For me the answer was no.

The ceramics of Edmund de Waal or James Makins with their pure, unaffected, very modern Japanese aesthetic—de Waal's cool celadon and white glazes and regal forms and Makins's extraordinary, delicious sherbet-candy-colored palette and "misshapen" shapes—could be classified as minimal art. Yet because they had clearly been lovingly handmade in a studio and one is aware of the practical risks involved, the work was, maddeningly, being categorized as craft. There is no certainty that the labor involved in creating the pots, often of huge dimensions, necessarily promises a happy result or will prevent work from cracking or breaking in the firing and simply being lost. I had a similar reaction to the work of several Bohlen collection artists, particularly Hugh McKay's *Melisma* (like conjoined triplets), David

Ellsworth's *Fo* (plate 62), Andrew Gittoes's smooth as silk *Gourd* (plate 147), and Betty Scarpino's wonderful wood sculptures (see plates 73, 74). Together they share, along with Makins and de Waal, a similar presence and a promise of continuing and evolving experimentation—perfection achieved in a quiet, confident way.

It was in 1997, when I started to curate the Contemporary Decorative Arts Exhibitions at Sotheby's (first in London and later in New York), that I had the distinct opportunity to introduce to the public work that defied classification. The pieces I included weren't crafty or rustic or even, at times, easy to understand, as in the cases of the fiber works of Caroline Broadhead (who was short-listed for the prestigious Jerwood Prize in Applied Art) and Lucy Brown. I had the privilege of a freedom made possible by working outside the sometimes restrictive museum system. I was able to exhibit

Grayson Perry, *Posh Bastard's House,* 1999. Earthenware, 21⅝ × 9⅝ × 9⅝ in. Courtesy Victoria Miro Gallery, London

what I wanted and lure my audience into thinking about the works without the old stigmas and prejudices suggested by the craft label. The pieces I showed were art, with a capital A, and deserved equal time and as much respect as any piece of "fine" art.

Interestingly enough, around the same time, Charles Saatchi had put on an exhibition titled *New Labour* (a pun on the recently rebranded British Labour Party) that featured artists working with their hands. Grayson Perry, controversial, "subversive" ceramist and winner of the 2003 Turner Prize, was included. The Turner Prize has always courted publicity and controversy, and in recent years it has been awarded primarily to artists working in video art or the most extreme realms of conceptual art. Painters rarely win the coveted prize, even when they are nominated. The inclusion of a ceramist among the nominees seems even more out of character for the Prize committee. I would not, however, herald the panel's choice of Perry as a change in their aesthetic direction. It is more likely that Perry was nominated in equal parts for the scalding narratives on consumerism and society he paints on his traditionally shaped ceramics as for his habit of turning up at events dressed as Little Bo Peep, complete with blonde wig and full makeup.

I have had many personal responses to the works in the Bohlen collection. The first was an overwhelming compulsion to get up as close as I could, to touch and scrutinize every complex detail of everything in sight. Then there was the challenge of absorbing what I was seeing and the fun of letting my imagination run away with itself. Dick Codding's vessel (plate 106), for instance, might remind me of a luminously colored sea urchin, but it might convey something entirely different to someone else—a bunch of thistles, a porcupine, or maybe nothing more than the beautifully elegant, tactile work of art that it is.

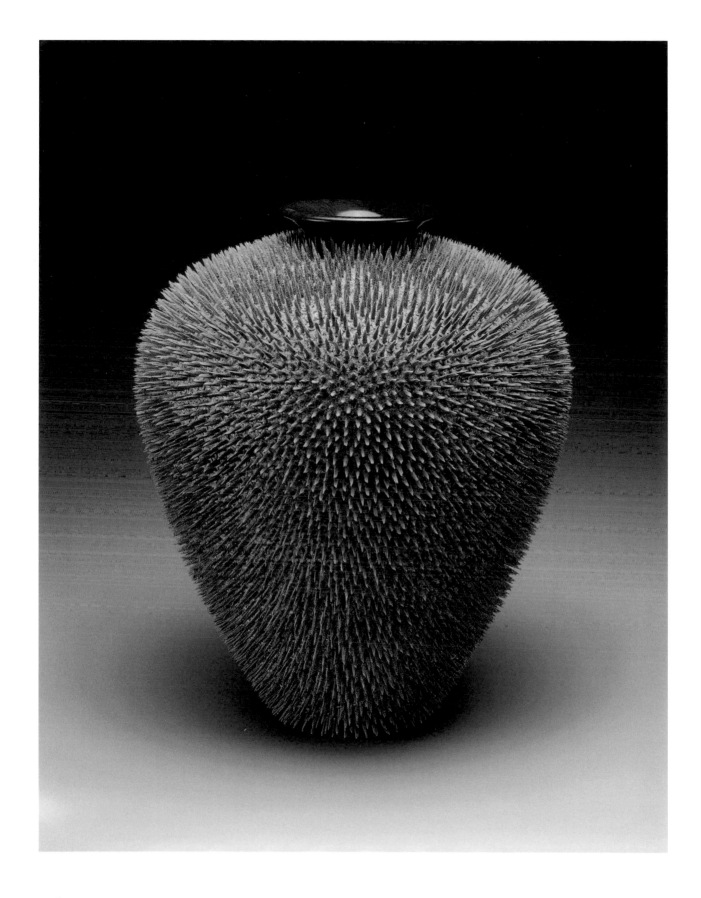

106 DICK CODDING

Untitled, 2000

Norfolk Island pine, mahogany, oxidized
copper tacks, 12 × 9½ × 9½ in.

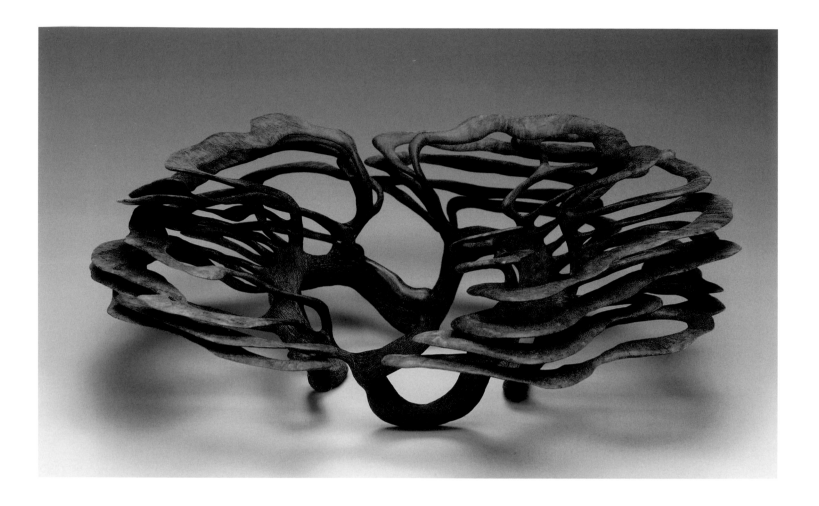

107 ALAIN MAILLAND
The Awakening of the Snake Bird, 1996
Heather root, 5½ × 14 × 11½ in.

The wonderful thing about these objects is that an individual is able to respond in a personal way and with an imagination that can be almost childlike in its interpretation. Alain Mailland's work is a good example: the title of *Mother Fish* clearly has aquatic connotations, but before reading the wall text what I saw was something that resembled the dry, eerie animal skulls in a New Mexican desert. *Touch of Zen* (so ephemeral you would believe it might break if a gust of wind touched it) did indeed convey the Zen-like peace and magic of a rare bonsai tree, as did *The Awakening of the Snake Bird* (plate 107).

Other artists are quite literal with their subject matter. Dan Kvitka's *Stones from the River* (plate 108) look so shiny and smooth that restraint is required to keep from picking them up to skim over the surface of the water. Then there are pieces so realistic that I find myself comparing them with the work of artists like Roy Lichtenstein, Andy Warhol, or the new breed of photo realists. Ron Fleming's *Palisades* cactus plant, William Kent's giant *Crushed Boot* (plate 103), and John Morris's very hip young-girl-with-attitude in her low-slung jeans, with a saucily direct gaze and super model pose (plate 82), are all accurate in every detail.

There are uplifting impacts of color—the rich vibrancy of Gauguin's yellow and red in Dewey Garrett's marvelously textural vessels, or the subtlety of Mike Irolla and David Ellsworth's equally assured

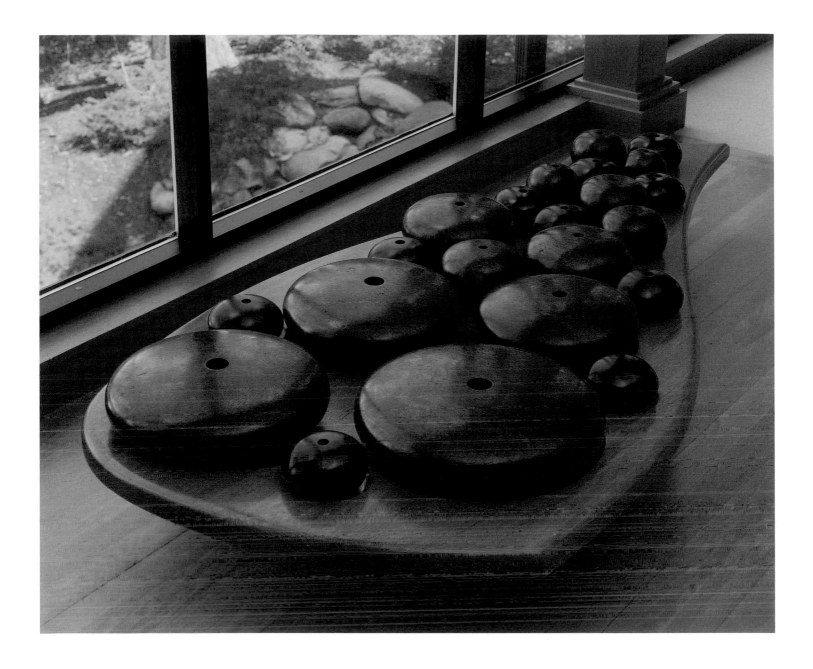

108 DAN KVITKA
Stones from the River, 2000
Burmese afzelia burl, Nigerian black ebony,
10½ × 85 × 39½ in.

and painterly pieces (plates 7, 26, 62). Color seems to have an important place in Robert Bohlen's life. The art collection in his home zings with energy and vitality. Like a successful orchestra the wood objects, skillfully arranged, harmonize with both the paintings on the wall and the natural landscape outside—a magnificent backdrop changing mood with the colors of the changing seasons—everything completely in tune.

As a curator of applied arts across numerous disciplines and media, I am always eager to make connections. Obvious themes and categories conventionally serve as a good formula for showing work, but sometimes blending artworks together like a patchwork of

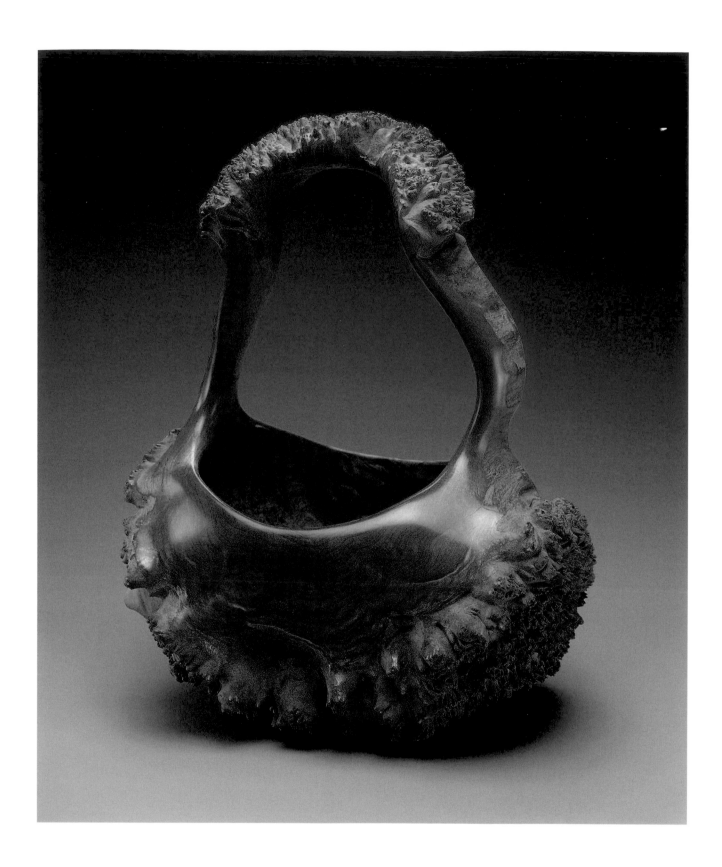

109 BOB WOMACK

Basket Bowl, 1999

Big leaf maple burl, 14½ × 11 × 7 in.

different materials, disciplines, and aesthetics is more exciting and rewarding for viewers than simply arranging objects in a more predictable manner. The goal in this approach is to achieve a logical and pleasing organic flow. Harmony can take many forms.

Bob Womack's and Hugh McKay's vessels or many pieces by Terry Martin and Arthur Jones would sit very comfortably alongside the work of artists whose achievements are in totally different materials. Giorgio Vigna— a sculptor and glass maker who lives in Milan, works with the esteemed Venetian glass company Venini, and whose work includes stunning glass flowers with stems of copper tubing and "families" of cool, rock crystal stones in a variety of shapes and sizes—is one complementary artist that springs to mind. Neil Wilkin—a British glass maker who designs and makes extraordinary bold glass sculptures, mainly in crystal and often combined with steel or concrete as part of spectacular outdoor installations—is another.

Sotheby's always has a varied patronage coming to view particular items that are to be auctioned. Often, people wander into the galleries hoping to look at an oriental rug or a piece of eighteenth-century furniture. They are somewhat perplexed to find galleries vibrant and alive with displays of the very unexpected. Many want explanations: What is it? Why is Sotheby's showing it? Frequently, not only is a sale made but more than a few converts made, of viewers who see work they like and respond to for the first time. Facilitating these conversions was one of the most gratifying aspects of my job.

My personal collection has also become more eclectic and varied with my expanding appreciation. In the same way that I introduce new artists to visitors in my shows, I am frequently introducing them to myself. I always encourage pushing the artistic boundaries. Better for an artist to make a mistake than to pursue the same tried and tested formula for life and go nowhere new artistically. As a result I get many surprises when work is delivered, and sometimes, once an exhibition has ended, a piece ends up in my own home.

In my introduction I admitted that until I was invited to write this essay I was unfamiliar with the sophistication of the turned-wood art form. I would go further and say I probably had a prejudiced view against it, which makes discovering this form through the Bohlen collection even more rewarding. I am confident that, like me, readers who look in awe at the remarkable pieces in the Bohlen collection will respond as I have. They will recognize the refinement of the work and the natural impact of the pieces. In turn, they will keep their eyes and minds open to looking at and seeing things in a fresh way, to discovering the high-quality workmanship, great individuality, excitement, and in many instances, the gentle irony and wit of this diverse collection.

Neil Wilkin, *Tridrop Bush*, 2003. Glass, stainless steel, 48 × 35 × 30 in. Photo: the artist

Whether working in vessel form or in a more thoroughly sculptural vein, many wood artists reference nature in their work. With its vastly varied colors, textures, and grain patterns, wood embodies and symbolizes the diversity found in nature. Some artists shape the material to evoke natural forms explicitly, while others paint images inspired by nature or their surroundings directly onto their work. In many different ways, this group of artists finds inspiration in nature and its abundant forms.

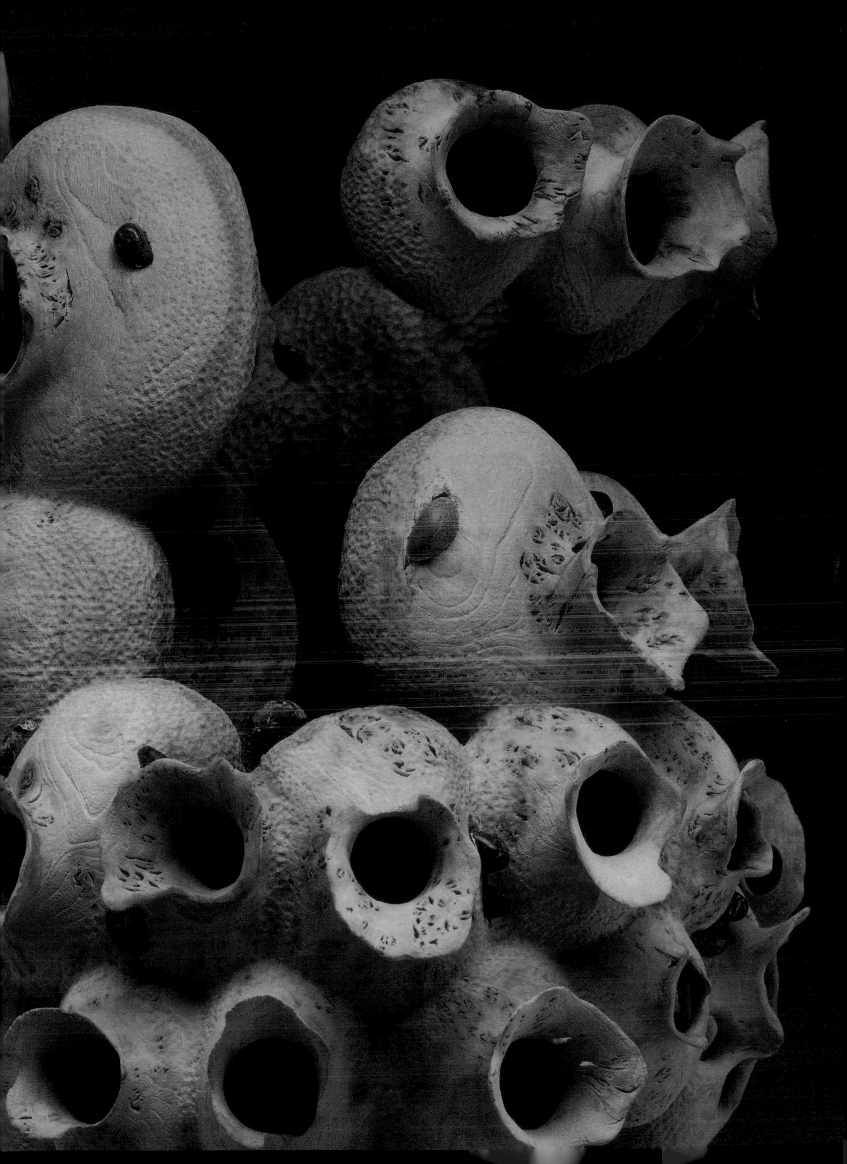

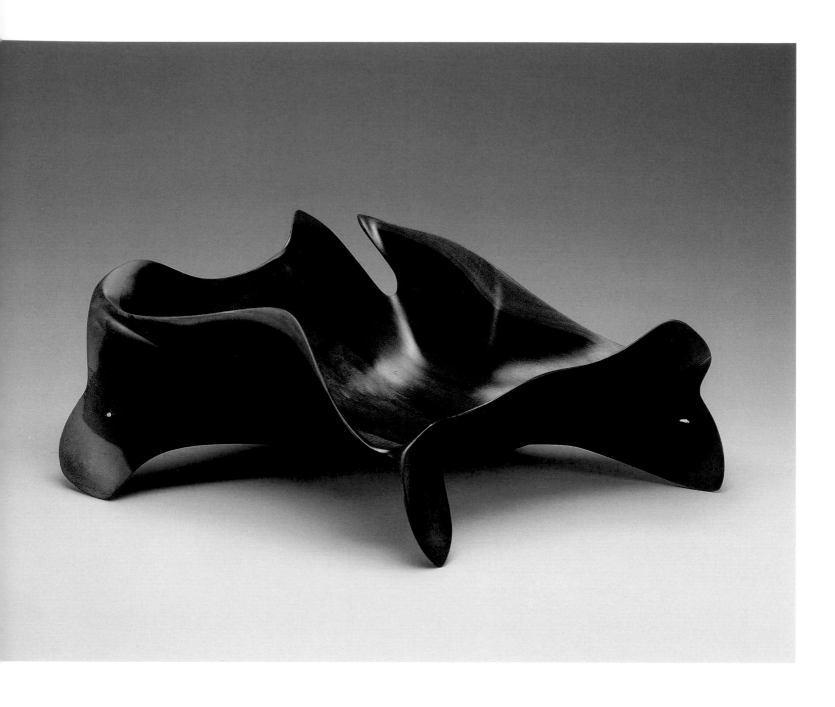

110 DEREK BENCOMO

Ocean Harmony, 1998

Maui milo wood, 5½ × 16 × 16½ in.

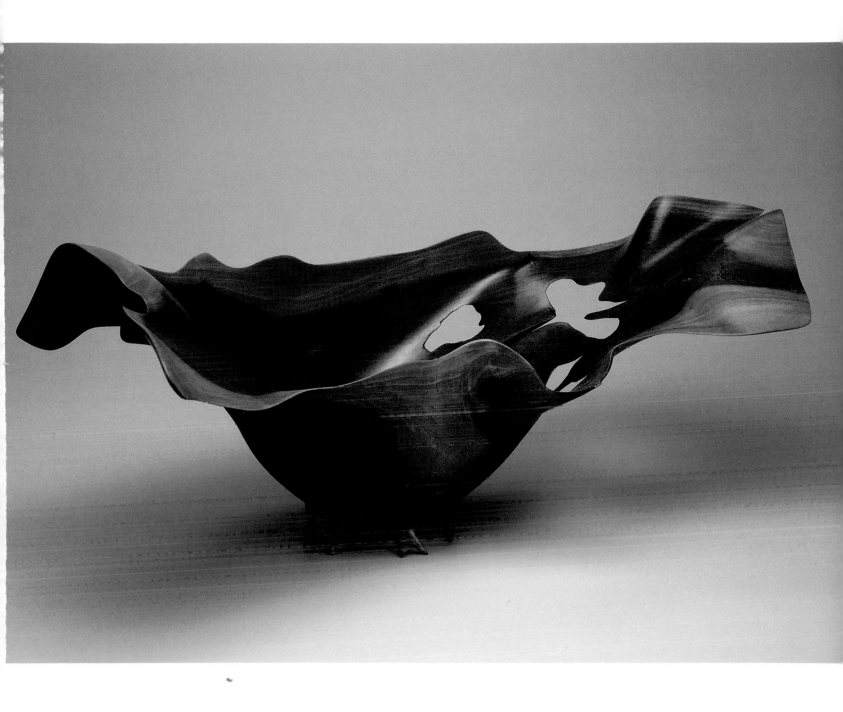

111 DEREK BENCOMO

Paia Valley, 1997

Maui milo wood, 11¾ × 26 × 13 in.

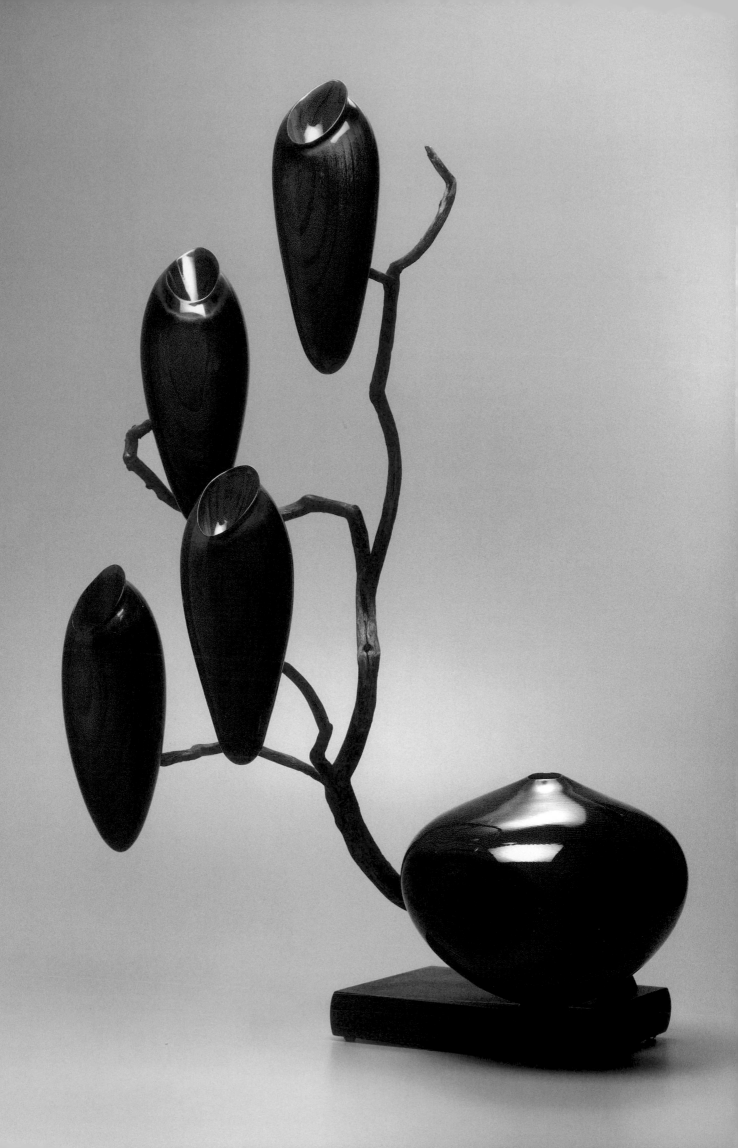

113 DONALD DERRY
 Mother and Daughters, 2002

 Western big leaf maple, dye,
 lacquer, 17 × 12 × 7 in.

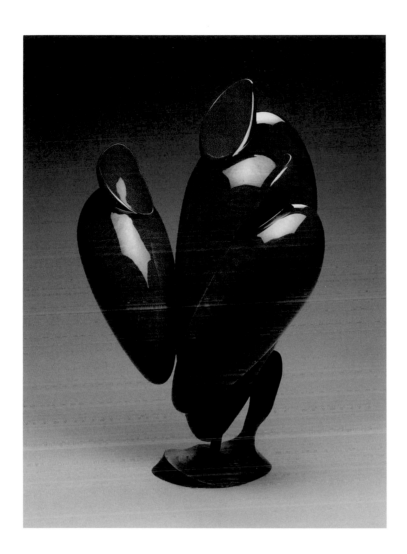

112 DONALD DERRY
 Of the Rainforest, 1992

 Elm, sumac, walnut, lacquer, 40 × 27 × 22 in.

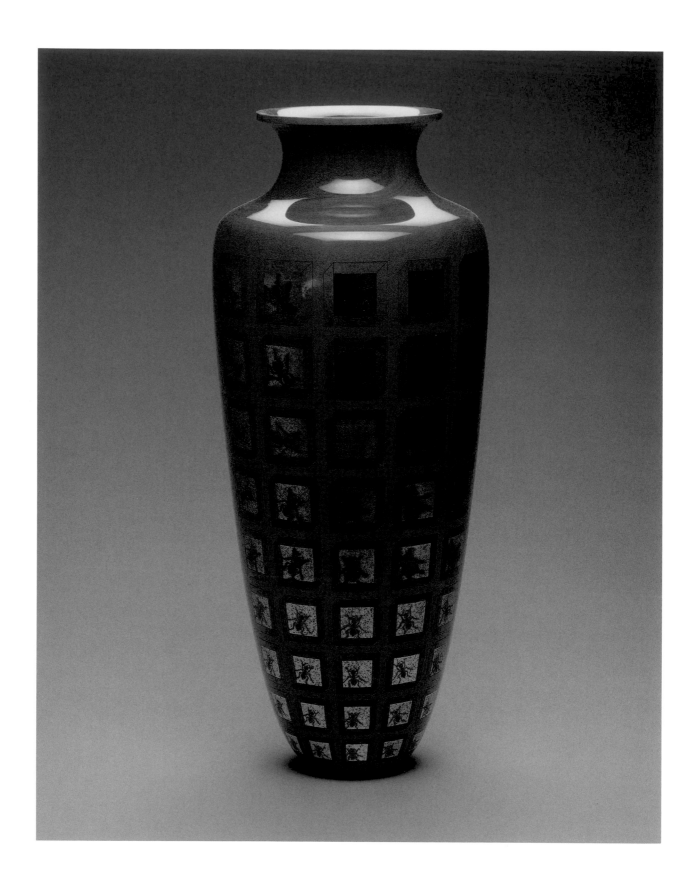

114 STEVE SINNER

Ant Farm, 2001

Maple, acrylic paint, ink, silver leaf, gold leaf, patina, 22¾ × 9 × 9 in.

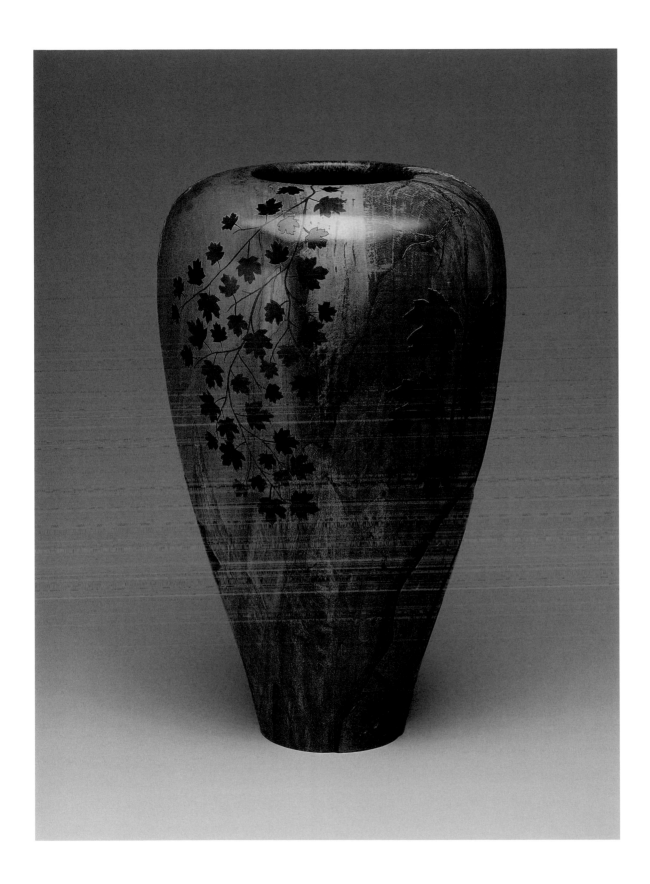

115 DARRELL DAVIS

Tree—Inside Looking Out, 2002

Maple, acrylic paint, aniline dye, 17 × 10 × 10 in.

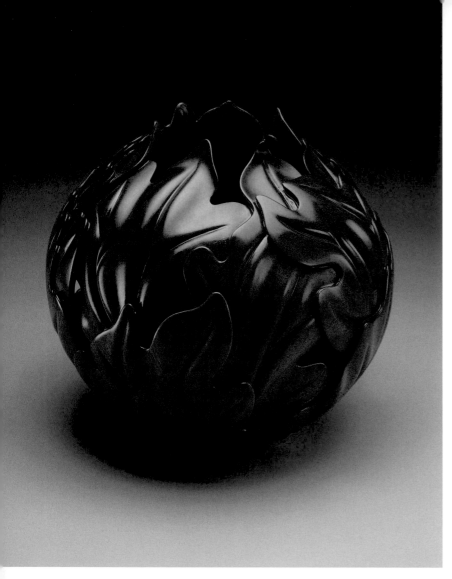

116 RON FLEMING
Pegasus, 1999

Pink ivory, 11 × 12 × 12 in.

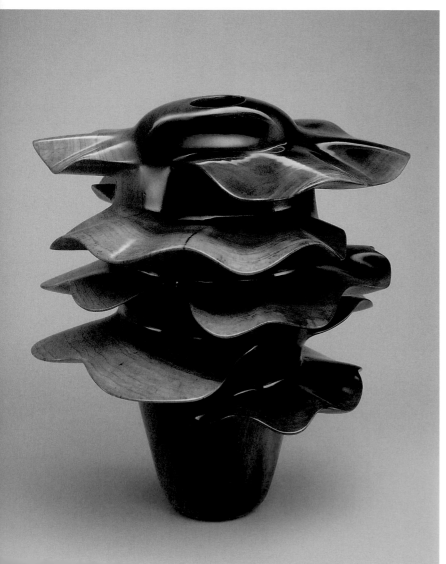

117 RON FLEMING
Ling Chih, 1997

Tulipwood, 17½ × 16 × 16 in.

118 RON FLEMING
Yama Yuri, 2001

Basswood, acrylic paint,
36 × 17 × 17 in.

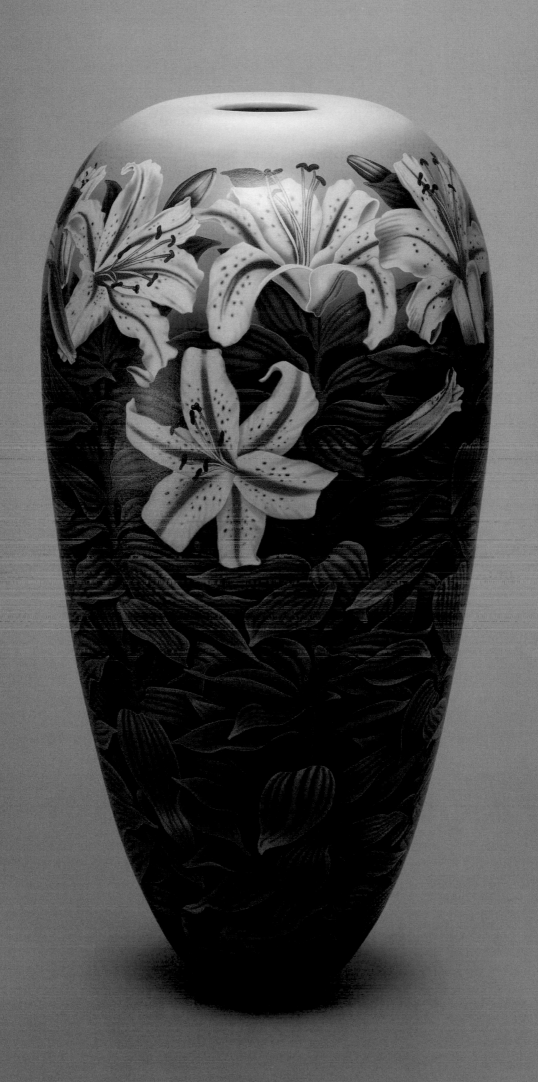

119 CLIFF LOUNSBURY
Into the Wind, 2001

Chokecherry burl, 15 × 9 × 9 in.

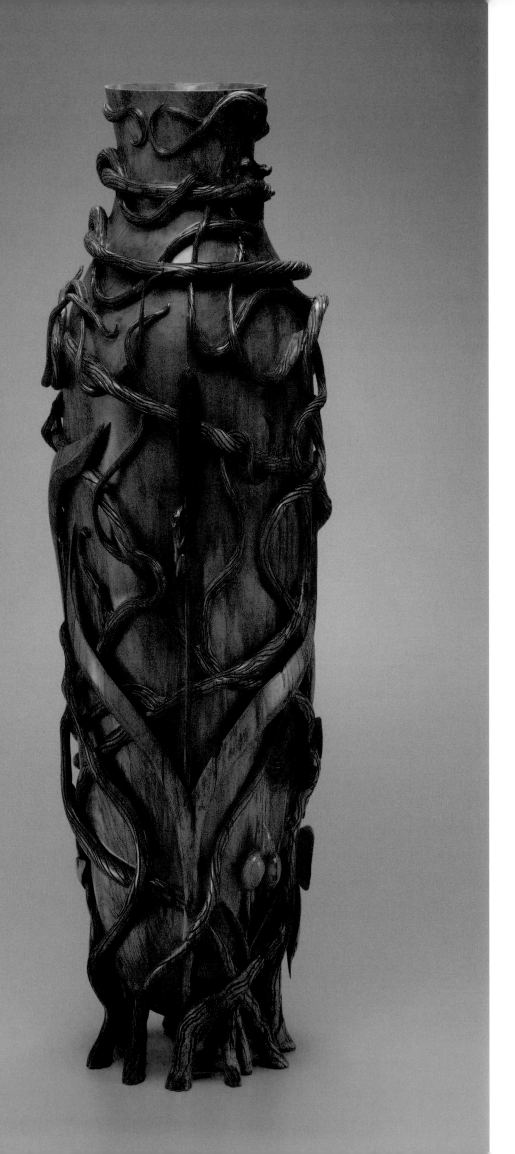

120 CLIFF LOUNSBURY
Tangled in Time, 2001

Spalted maple, 50½ × 14½ × 14½ in.

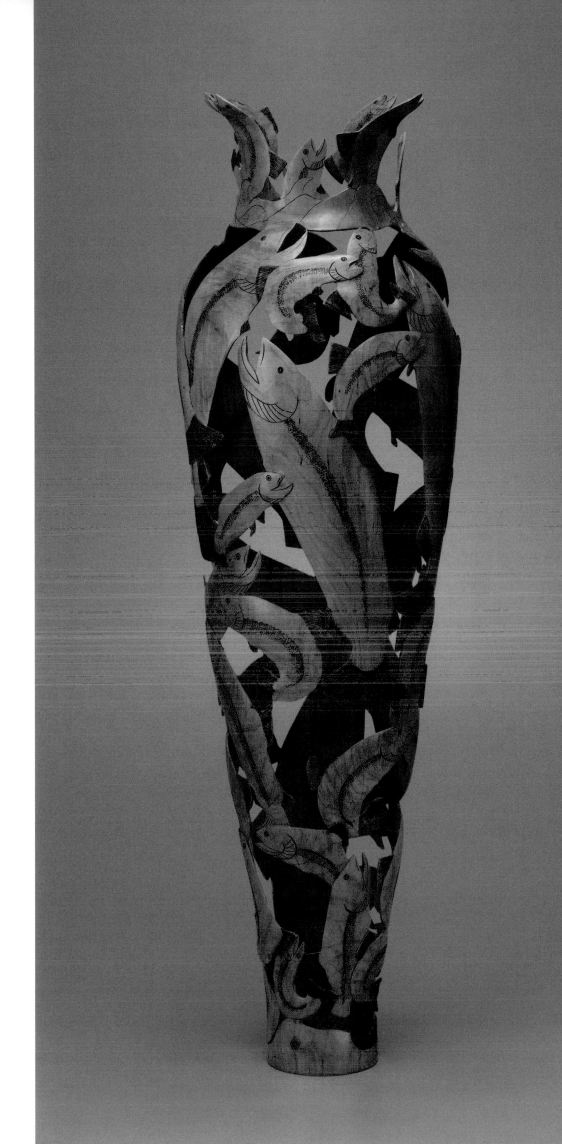

121 CLIFF LOUNSBURY

Jumping for Joy, 2001

Sugar maple, pearlescent pigment,
52 × 17 × 17 in.

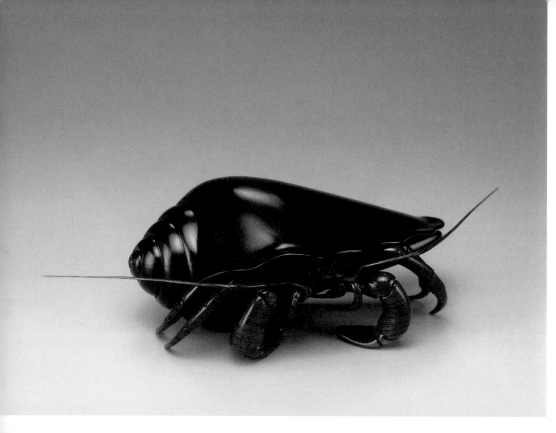

122 GARY MOORE
Crab, undated

Padauk, zebrawood, 4 × 11⅛ × 5¾ in.

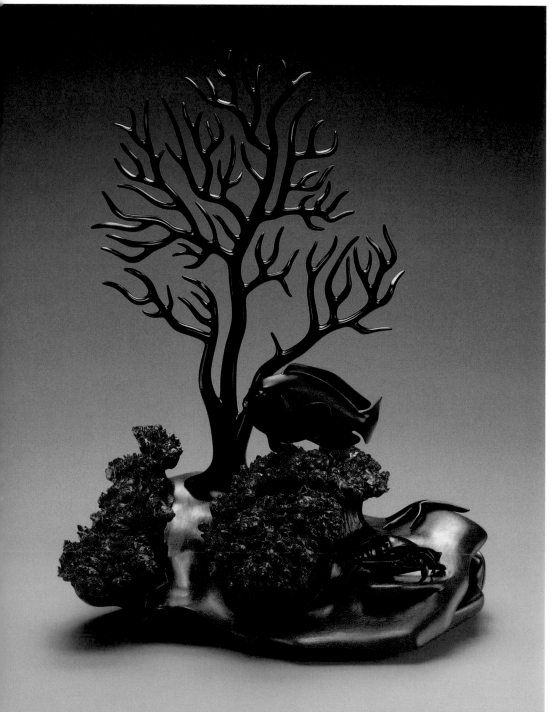

123 GARY MOORE
Fish and Coral, 1992

Pau ferro, cherry, maple burl, wenge,
18 × 14 × 11¼ in.

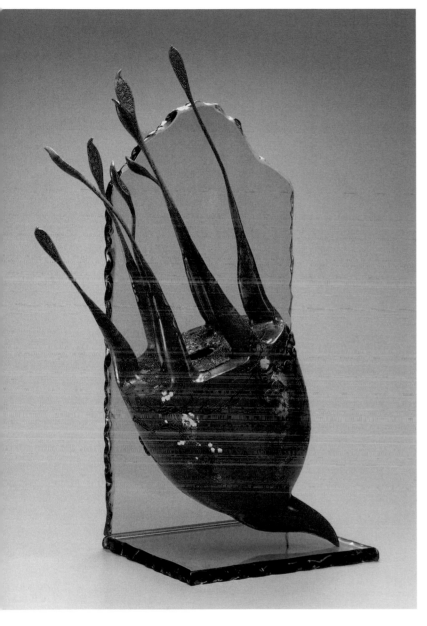

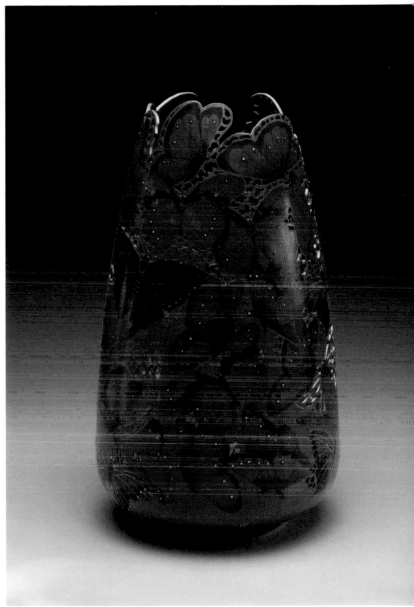

124 BINH PHO

When Medusa Met Chihuly, 2001

Maple, acrylic paint, metal leaf, glass,
27¾ × 19 × 10 in.

125 BINH PHO

Emperor, 2000

Ginkgo, acrylic paint, 14¾ × 9 × 9 in.

126 FRANK SUDOL AND C. R. MERKLE
Hawks and Owls, 2000

Birch, acrylic paint, 12½ × 5¾ × 5¾ in.

127 FRANK SUDOL
Autumn Leaves, 1997

Birch, rice paper, dye, 18¼ × 8¼ × 8¼ in.

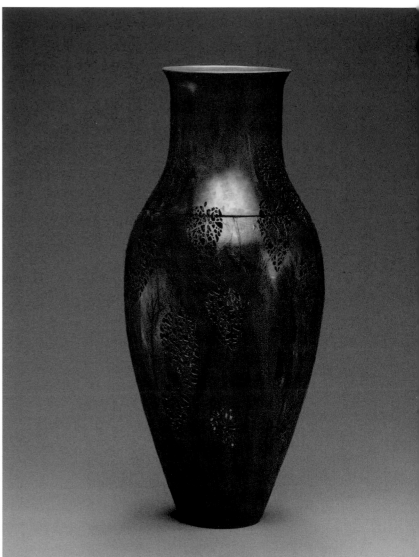

128 FRANK SUDOL
Left to right: *Tiger Tiger,* 2002; *Ice Bears I,* 2001;
Never Cry Wolf, 2001

Birch, dye, left to right: 24 × 8 × 8 in.; 21⅛ × 6 × 6 in.;
21⅛ × 6¼ × 6¼ in.

129 TERRY MARTIN
 Bonsai, 2002
 Jarrah burl, 4½ × 8 × 5¾ in.

130 TERRY MARTIN
 Temple, 2002
 Jarrah burl, 9¼ × 24½ × 7 in.

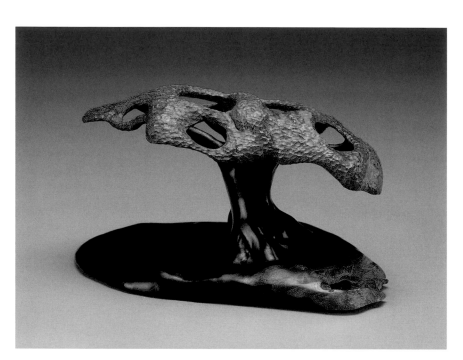

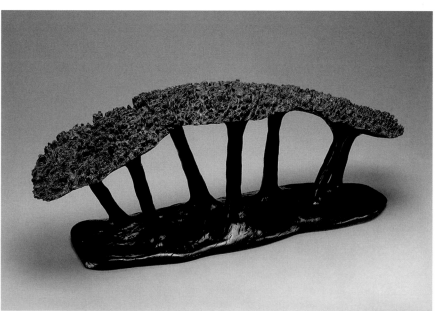

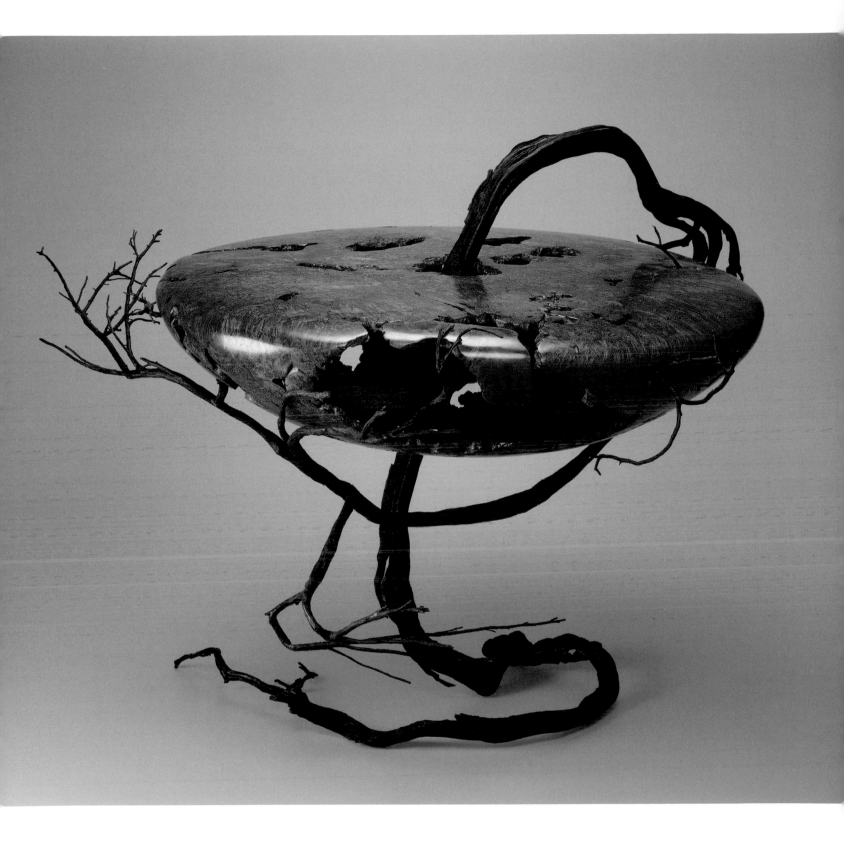

131 RONALD GERTON
A Tree Runs Through It, 1998
Spalted maple burl, bronze, 28 × 40 × 38 in.

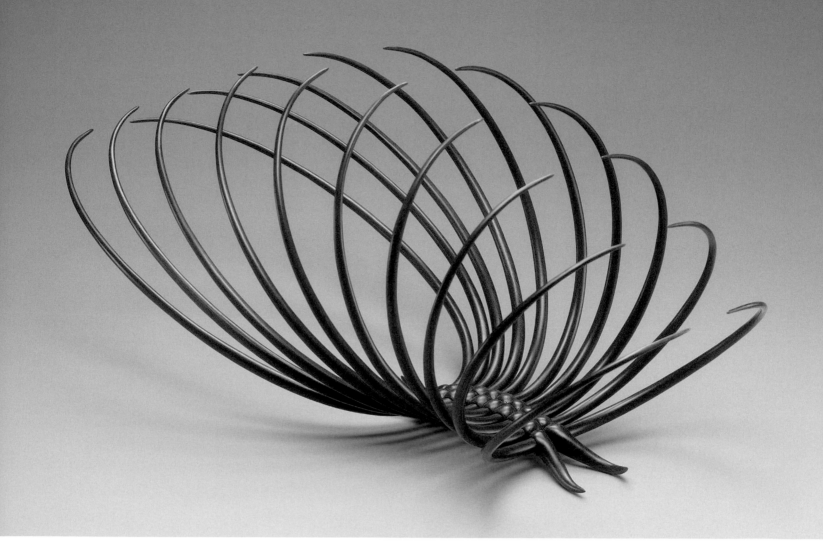
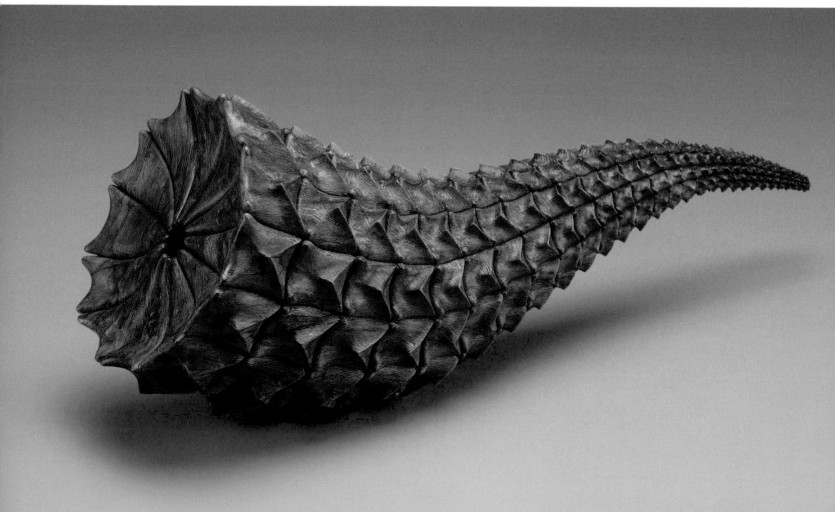

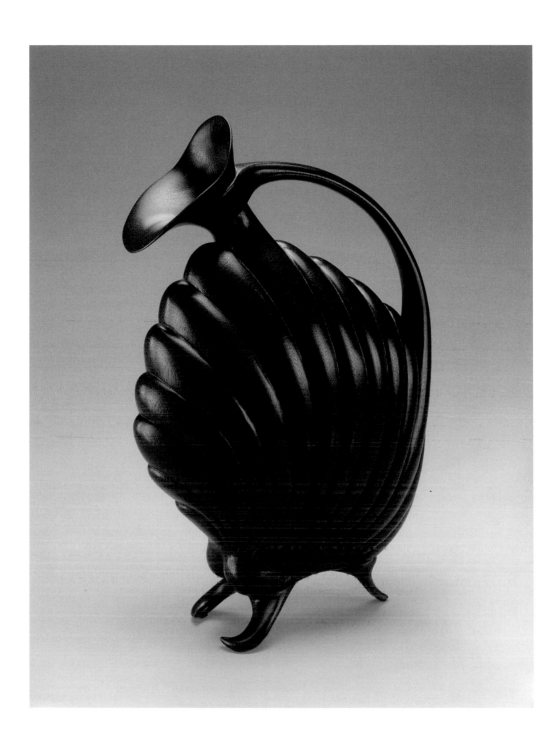

132 ARTHUR JONES
 Exhibitionist, 2001

 Walnut, 11 × 15 × 10 in.

133 ARTHUR JONES
 Spiny Dodecadon, 1999

 Sycamore, 6½ × 17½ × 5½ in.

134 ARTHUR JONES
 Clam Pitcher, 1995

 Mahogany, 11 × 4 × 7 in.

135 DAVID SENGEL
The Kiss, 2000

Pear wood, locust, rose thorns, dye,
9 × 6½ × 6 in.

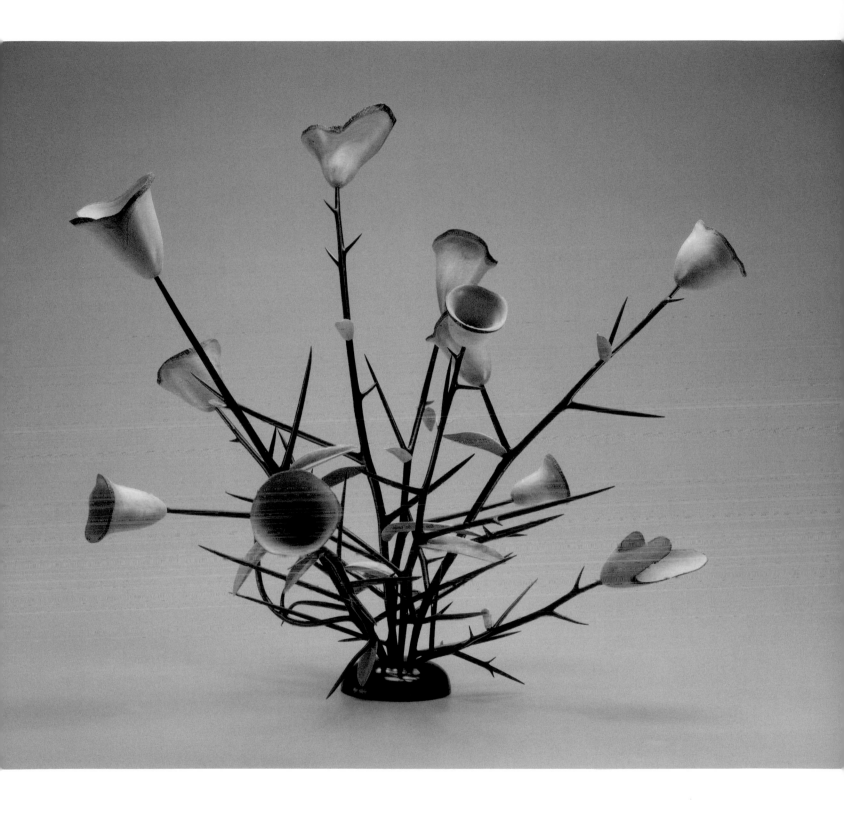

136 FRANK SHARP JR. AND MEMBERS OF THE BIG ISLAND
WOODTURNERS CLUB
Touch Me Nots, 2002

Honey locust thorns, tangerine wood, lacquer, 18½ × 20 × 18 in.

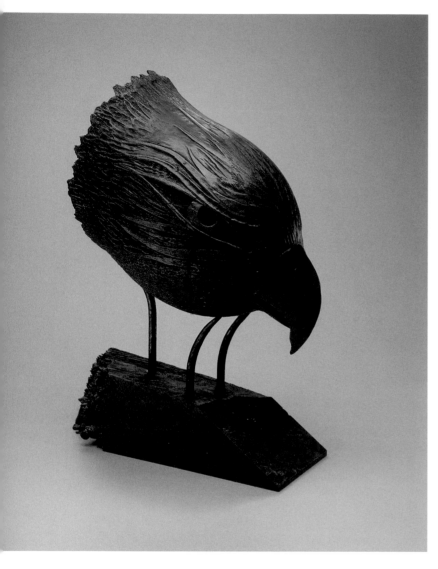

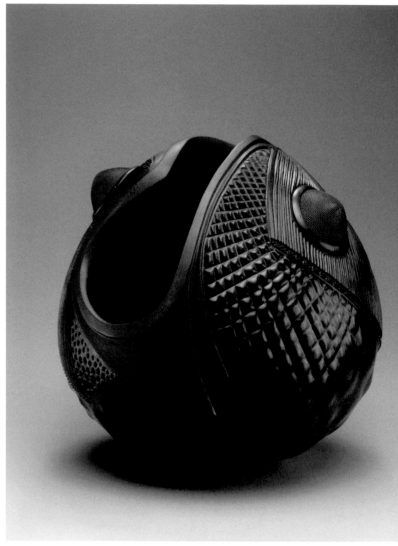

137 RON LAYPORT

Mask of Falcon: Vessel from a Distant Dance, 2002

Maple burl, steel, paint, 16 × 13 × 7 in.

138 ROLLY MUNRO

Hapuku II, 1998

Pohutukawa wood, brass mesh, copper, epoxy,
polyester resin, pigment, 14 × 13 × 13 in.

139 MICHAEL BROLLY

Squatapotamus, 1992

Mahogany, maple,
4½ × 11¼ × 11¼ in.

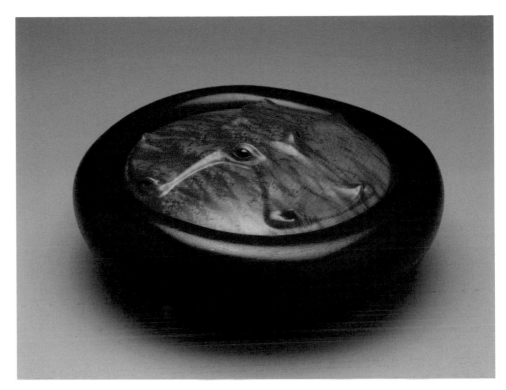

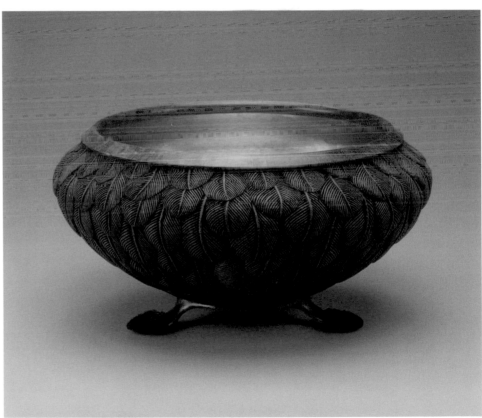

140 JACQUES VESERY

Searching for the Mystic Winds, 2001

Box elder, cherry burl, 23½-karat
French gold leaf, 4⅜ × 8⅞ × 8½ in.

143 GILES GILSON
Bouquet de Vie: Fleur de Courage, Fleur de Sagesse,
Fleur de Compassion, 1998–99

Fleur de Courage: padauk, pearlescent lacquer, Corian,
lacquer, 19½ × 7½ × 7½ in.
Fleur de Sagesse: butternut, pearlescent lacquer, Corian,
lacquer, 24½ × 7 × 7 in.
Fleur de Compassion: mahogany, pearlescent lacquer,
Corian, lacquer, 21 × 7 × 7 in.

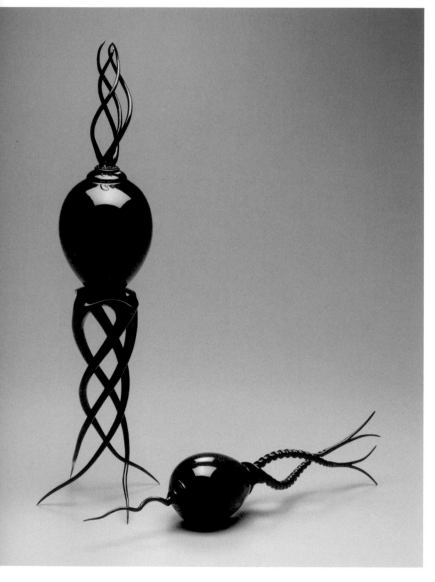

141 STUART MORTIMER
Squid Series #2 (left) and *Squid Series #1* (right), 2002

Pink ivory, ebony, left to right: 22½ × 7 × 7¼ in.,
3½ × 17½ × 3¼ in.

142 WILLIAM MOORE AND CHRISTIAN BURCHARD
Cradles in the Sea, 2000

Madrone burl, copper, 13¾ × 6 × 4½ in.

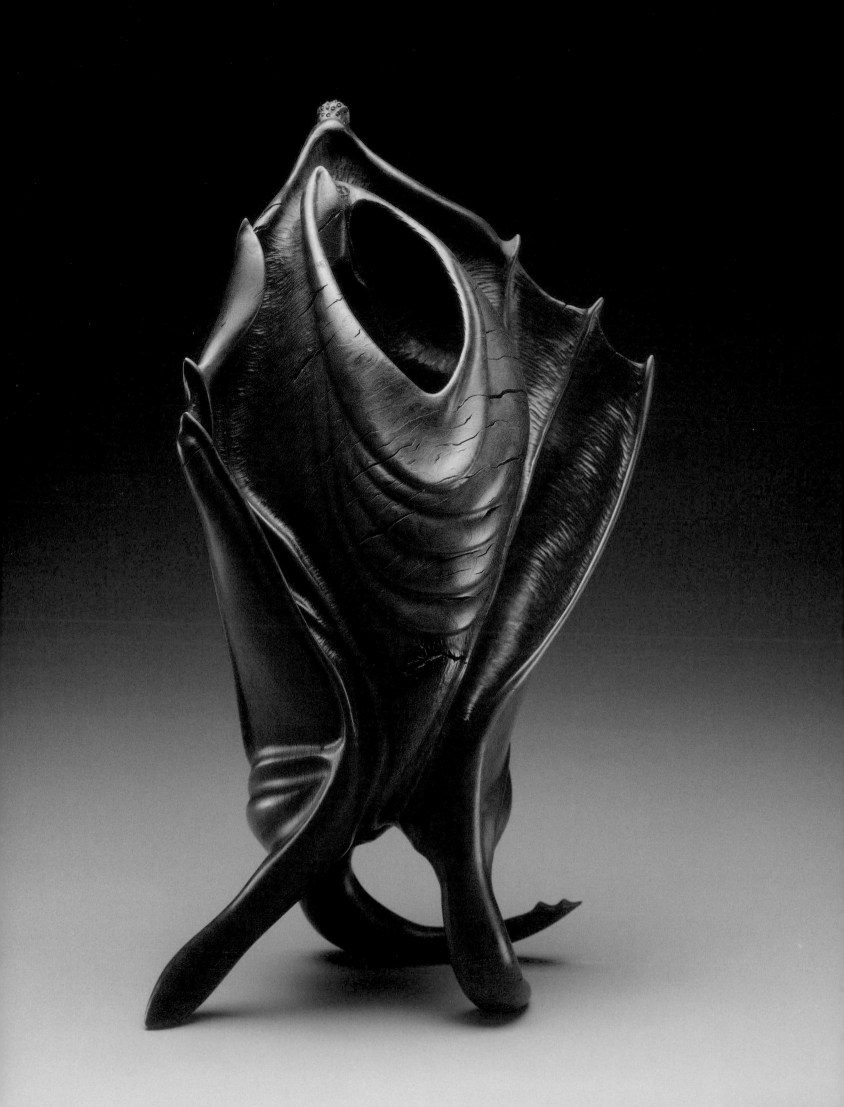

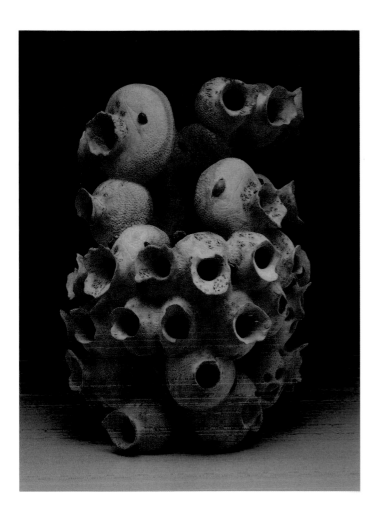

145 ALAIN MAILLAND
The Stone Eater, 2000

Elm burl, Italian stones, 17 × 12 × 12 in.

146 DWAYNE ROHACHUK
Untitled, 1992

Ash, 12¾ × 5 × 5 in.

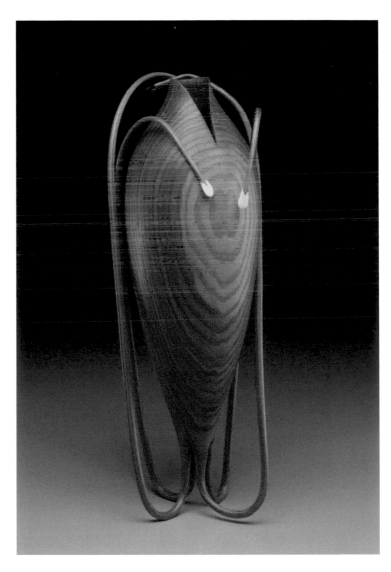

144 MICHAEL LEE
Pterosaur, 1994

Madrone burl, 16 × 9¼ × 5½ in.

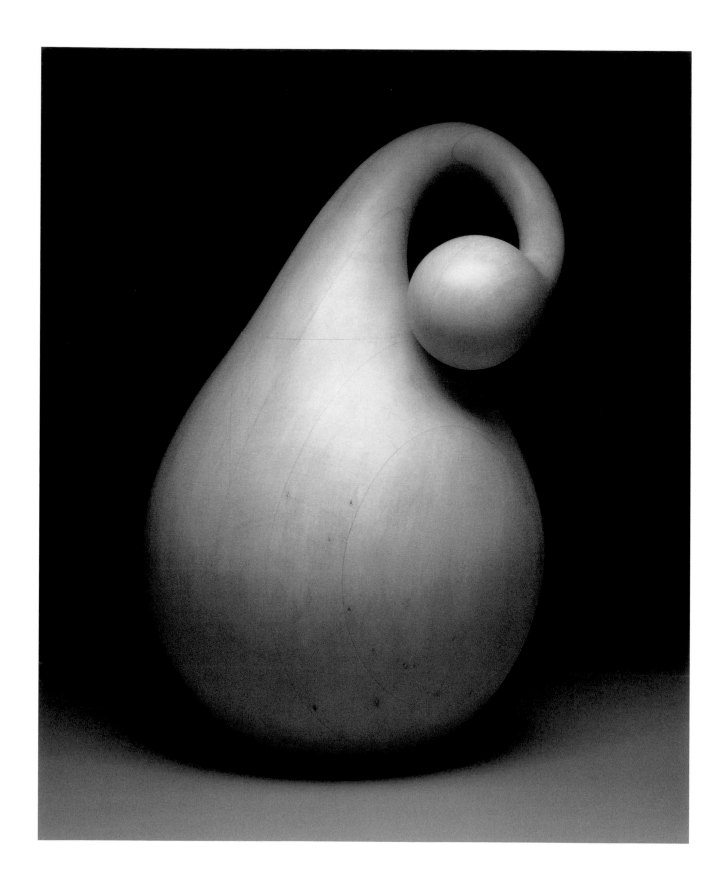

147 ANDREW GITTOES
Gourd, 2000

Jelutong, 19 × 11 × 11½ in.

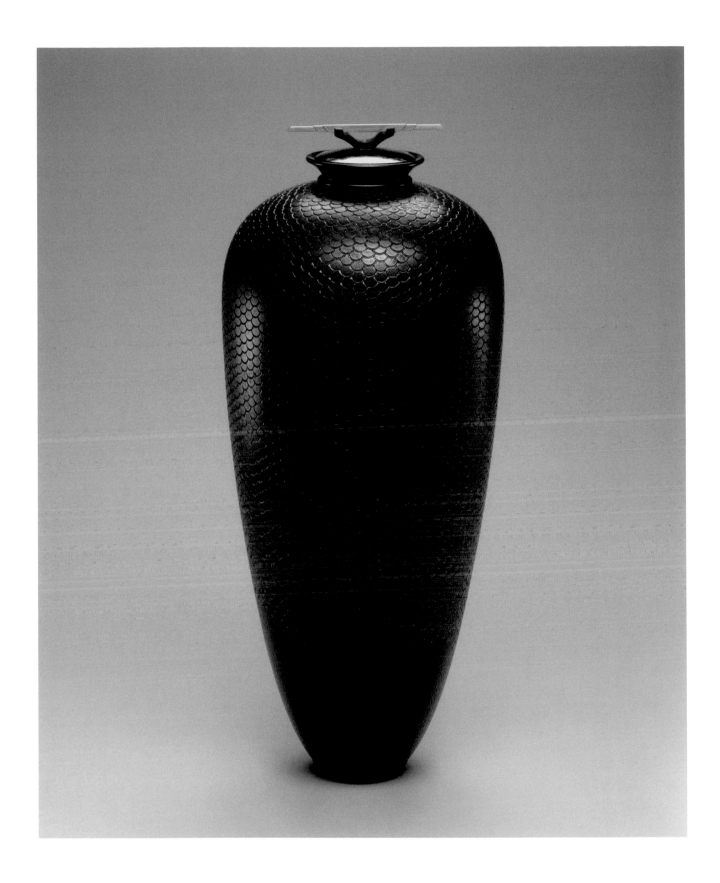

148 DICK CODDING
Piscatorial Vessel #7, 1999
Cherry, brass, 16½ × 7 × 7 in.

CONVERSATIONS WITH THE ARTISTS

From September 2003 through January 2004, I conducted a series of interviews with six wood artists from around the United States and beyond—Derek Bencomo (Lahaina, Hawaii), Mark Bressler (Santa Fe, New Mexico), Ron Fleming (Tulsa, Oklahoma), Ronald Gerton (Richland, Washington), Stuart Mortimer (Hampshire, England), and Frank Sudol (Paddockwood, Saskatchewan, Canada). The highlights of these conversations, which were intended to investigate a wide range of issues surrounding wood art, are presented here. I asked questions about how the artists conceptualize their pieces before even beginning to work the material, questions about the process of creation and the relationship each artist has with the medium of wood, and questions about their choice of material as well as their perceptions about the field of wood art and its future direction.

As a curator of modern and contemporary art who received no formal instruction in wood art, I approached these objects first as pieces of sculpture. Three-dimensional form was the way in which I contemplated the objects, considering them in terms of line, balance, color, and myriad other terms typically used to appreciate art. The result was an engaging dialogue for me, enlivened even further by the openness and accessibility of the artists themselves. Eager to speak about their work, the artists educated me not only in the wide variety of techniques and processes available to help them realize their artistic vision but also about the influences shaping that vision. I am extremely grateful to them for their time, energy, and enthusiasm.

The field of wood art is growing and changing as wood artists push themselves into new and uncharted territory and explore new subject matter and relationships to their medium. Collectors, galleries, and museums are a part of the evolution of wood art as well—commenting upon, responding to, and challenging the artists, as well as looking for ways to connect wider audiences with the art form. I hope that readers of this volume will enjoy thinking about these issues and hearing from these lively, creative, and thoughtful individuals as much as I have.

—Sean M. Ulmer

Working the Wood: Influences and Forms

SEAN ULMER: When you see a large block of wood, do you see the finished product and then work on the lathe to achieve that product, or do you work gradually with the wood, so that the wood tells you what the form is going to be?

RONALD GERTON: It's usually a one-way conversation: the wood tells you. I mean I started out originally thinking, okay here's the shape. I'd sketch . . . and as I'd start, I would see either a beauty in the wood that, if I cut deeper, I would lose, or I saw flaws in the wood that said, "Boy this thing won't be strong enough if I leave it this shape. I've got to cut that flaw out." So it became apparent to me within a month of wood turning, that the beautiful thing that is inside a piece of wood is there, but it may not be the same beautiful thing that you would like it to be.

STUART MORTIMER: When you get any piece of wood—whether it be a rotten old piece or whatever—you'll find cracks, spalting, burrs, fiddleback and all sorts of features worth exploration. . . . Spalting is a self-destruction mechanism built in which results in black lines. When these black lines turn into powder and expand . . . like a fungus, the tree breaks up—that is the spalting process. When you catch it in the very beginning, you can make some beautiful patterns in the wood and you can use that. The effect is beautiful. In fact, I'm working on two pieces now that have really the

most beautiful spalting I have ever seen. You try to find the best features in the wood, careful not to go too far. I always kick myself when I go too far and miss the best part of a feature. So I shape the wood to get the best out of a burl or some sort of grain structure, like fiddleback, where the grain of the wood is compressed—rays that come out later when you turn the wood and it appears as rays of different colors. The wood is still alive—even if it's been cut down for hundreds of years—it still moves and its beauty is still there.

RON GERTON: I am not trained enough in art to decide ahead of time what the end product is going to be. It's kind of like doodling for me. And not everything works. I've got some experiments that I'm not too excited about sharing with people, but the ones that do work have been spectacular. I've just been thrilled with them . . . and then to find that someone else enjoys them . . . that's the frosting on the cake.

SU: Derek, I read in a catalogue that you "never fight the wood because it has too loud a voice." Can you explain what you mean by this?

DEREK BENCOMO: I have learned by experience over the years that if you force a shape on a piece of wood, if you have to poke and jab at the wood and it seems to beat you down, then the final piece will not flow. It will look like it was poked and jabbed into shape, that the life of the piece was not brought out. If I am carving with the grain, I can feel a little harmony in the piece, I am coaxing life out of the piece. When I am doing the final polishing of a piece that I worked with instead of against, the grain direction of the wood flows with my forms, or maybe my forms flow with the wood.

SU: Mark Bressler, you often use color in your work. Do you know before you begin to work with a piece of wood what form the piece will take or whether or not it will be one of your colored works? Or is it more of an evolutionary process, developing as you work with the piece?

MARK BRESSLER: When making large sculptures, I know I am going to use the natural wood. Large sculptural pieces start with a chunk of burl, usually weighing between 1200 and 2400 pounds. I start with a chain saw and saw away the least spectacular burl, usually in 200-pound chunks. I can remove 60 percent of the wood before really starting on the piece. . . . [A]s your piece rapidly dwindles in size, you slowly start wondering when that "genius" people talk about will

appear! The process of cutting away the excess wood is not as rapid as it sounds. I can spend a week cutting away the first round of wood. The pieces are lifted with my forklift, so I can see them at eye level. Next, I calculate what wood will be removed. During this process, the piece tends to take on a life of its own. Many times, the difference from nighttime to first light will reveal the piece in a new way. Madrone [as seen in the piece *Spirit Dancer*] is a volatile wood. If not brought down to size equal in thickness, the sculpture tends to blow apart. Once this occurs, there is no saving it. You end up with very expensive firewood!

On my lacquered pieces, I tend to use redwood burl cutoffs for the vessel. These are planned. I like using redwood, because it is so easy to cut, especially when hollowing the vessel. I like using the burl, because it tends to stabilize with little or no movement. After its initial turning, to about five-eighths of an inch thick, I can return it to the lathe and finish the basic shape in three to four months' time. I need the vessel to be very stable, so its eventual "tail" will always seat securely. The tails, or fuses, [of the cherry bomb pieces] are always made from six-inch-by-six-inch-by-six-foot-long pieces of fiddleback maple. They are mounted on the lathe and spend weeks there. The fiddleback tends to have tremendous strength in all directions. Not only is the strength important when it is finished and lacquered, it is extremely important while I am creating it. The toughest decision I have [to make] is how much of the fiddleback pattern do I want the piece to have in the end. I love the wood pattern . . . but the color can be so cool.

SU: Ron, all of your work to date has been strongly influenced by nature and natural forms. Why is nature such an important source for you and how did you come to that realization?

RON FLEMING: One day I was working on an illustration using a rose. As I was painting it, I kept looking at the bud and thought the image would make a wonderful vase. I turned the shape and carved it [to resemble] what I had painted. It was a big step going from two-dimensional to three-dimensional work. I began to see things in nature as images on different vessels—along with different textures, shapes, and colors. I found that the asymmetric composition of leaves, flowers, and so on was a design idea that could enhance my pieces—a difference in length or angle of a petal, how one side of a leaf varies slightly from the other. Objects of nature are both incredible in their composition and uniqueness, and surprising in their complexity and diversity. It always catches me off guard. The mystery is why something forms in such a manner—contrary to order and consistency.

SU: Frank, almost all of your work seems environmentally conscious in its theme, featuring animals, leaves and natural forms.

FRANK SUDOL: Most important to me is the idea of nature being a very delicate thing, and the work relates to that. You can just watch people—they don't want to pick up a particular piece because it's so delicate. . . . I wanted to portray the fragile earth, and that it is not only fragile but delicate and also precious. From the beginning I called my work in general the Fragile Earth series.

SU: How do you achieve the gradual lacework, the weblike pattern that connects your animal and natural images on the exteriors of your pieces?

FRANK SUDOL: It first happened by accident. These accidents . . . they come. I call them miracles—I don't believe in them but I just rely on them all the time.

Wood Choices and Conservation Issues

SU: Do you have a particular type of wood you prefer to use and, if so, why?

DEREK BENCOMO: I really do not have a favorite wood to work on, but I have noticed over the years that for the pieces in my own collection, as well as those in important public and private collections, the wood of choice seems to be Hawaiian milo wood. In the past the Hawaiians used this tree for their own wooden vessels, medicine, and even dyes. It is hard to get, and big pieces are rare. The grain is tight, the color is rich, and it patinas nicely over time. It forms a perfect silhouette for my current forms as well as for a nicely shaped bowl.

STUART MORTIMER: Maybe Scottish elm. If I have a favourite it is English Yew, which grows all over the United Kingdom. It is a very lovely, lovely wood, and it can come in all different colors and shapes. I never cut a tree down. It's always old wood or wood that has been discarded, etc., and people give me wood and people look out for wood for me. I'm loath to cut down a tree at any time. In fact, I preserve

trees rather than cut them down. I was . . . brought up with trees in Scotland, my home country. It has a very good program with preservation, and in fact a replanting program since World War II, which is very, very good. So exotic woods—I have a conscience when it comes to exotic woods, pink ivory and ebony—some of it is very old, some of it is given to me. I have some pink ivory that I have had for years. It's very, very old stuff. What I try to do is bring out the best in the wood so that the memory of the tree lives on. Pink ivory I've seen in the past, being cut up into small pieces—to me a great waste. I didn't like that. I buy pink ivory in a log, and I turn it into larger works that will preserve the color of the wood and the nature of the tree. . . . Hopefully I am creating a memorial to the tree. I am very conscious of the destruction of trees. I hate the fact . . . so does my family.

MARK BRESSLER: I have only two sources for wood. All the wood I receive is the finest burl available. Even under my wild electric-colored pieces, you will find beautiful burl. I am fascinated by what lies under the bark. I am knocked over by the patterns Mother Nature creates. I generally work with what is provided. I have only made a handful of the colored pieces; they are generally reserved for collectors who have acquired six or more of my pieces. The process takes double the time of a standard piece. After all, the piece is done and sanded before a lacquer process is started, and it generally takes six more weeks of spraying and sanding and rubbing out before it is finished. During the painting process, I am making no new pieces, due to dust. . . . Then, it's back to what Mother Nature offers.

SU: Ron Fleming, I notice that you work with a wide variety of woods. Why? What have you discovered in the process of working with so many different woods, each with it own characteristics?

RON FLEMING: I just like working with a variety of woods. Some woods have very beautiful patterns, especially the burls, crotches, and quilting. I like this type of wood for a simple form or minimum carving, as the detail of the carving is simply lost in the pattern of the wood. On the other hand I like to use a plainer wood, such as mahogany, redwood burl, pink ivory, or blackwood, to carve a piece with a lot of detail. It lets the carving stand out more. Each wood has its own turning and carving characteristics. Some are fairly easy to work for turning and carving, while others, such as the hardwoods, take more skill and time.

The State of the Art

SU: I think there is extraordinary potential in the field of wood art, and I think there is a perception in the general public that it is for pretty vessels. But there are rogue woodturners who think beyond that—think more on the edge of what wood art can be. Those are people that a select number of us—a growing number—are already calling artists.

FRANK SUDOL: Yeah, there are just a couple of problems with it. Some of us actually are making a living at it, and we have to get a steady income off this. And then of course there are others who are retired, and they really don't care whether they sell [their work] or not. I look at painters and I look at writers, and they've all made significant contributions. They talk about life and not all of their work is about pretty things—film [especially]. [Wood art is] an art form that has potential and . . . this is an art form where we can really talk about life . . . like other artists.

MARK BRESSLER: When you create pieces that have never been seen before, you are considered cutting edge. . . . The public does not always accept unique; it is the cutting-edge collectors who do. All the artists in this exhibition are doing unique, one-of-a-kind, pieces. Without visionaries like Bob Bohlen and insightful museums, the public wouldn't have the opportunity to see works of this creative level in one venue. It is when close to one hundred pieces are shown in a grouping that the range of creativity becomes fully apparent. It is through this type of expression that the public can grasp the range of this medium. Without public support, some artists would financially be unable to exist. Each artist is critical to the growth of this field, especially at this early stage. . . . The challenge lies in the public's understanding of where we are heading, not in the physical properties of wood.

RAY ALLEN
1930–2000
Born Dickson, Tennessee

Ray Allen earned his livelihood as a carpenter for nearly thirty years before he produced his first turned object. Drawing upon Native American and prehistoric pottery around his home in Yuma, Arizona, for inspiration, Allen created vessels that reflect the painstaking precision of their construction. Combining thousands of pieces of wood glued together and turned on a lathe, the segmented vessels integrate a wide variety of woods into intricately designed patterns. Plate 48

GIANFRANCO ANGELINO
Born 1938, Naples, Italy
Lives and works in Milan, Italy

Gianfranco Angelino brings a distinctly scientific perspective to the art of wood turning. While holding an advanced degree in aeronautical engineering, Angelino is also a self-taught botanist. His work in the field has revealed nearly fifty species of trees in and around his home in Italy. These woods, generally considered unsuitable for common use due to their irregularities in size, grain, and fiber, have inspired Angelino to develop new tools and techniques to use these unique materials. As a result, Angelino's delicate works possess an inherently organic quality. Plate 57

DEREK BENCOMO
Born 1962, Los Angeles, California
Lives and works in Lahaina, Hawaii

The influence of his surroundings is apparent in the work of Hawaii resident Derek Bencomo. Following a move with his wife from southern California to Maui in 1984, Bencomo soon discovered the centuries-old tradition of wood turning in Hawaii. Inspired by the island's rich history in the art of wood and the variety of Hawaii's native and exotic woods, Bencomo bought a lathe and taught himself to turn wood. His vessels, both sculptural and organic, suggest a fluidity of form that evoke the artist's coastal environment. Plates 17, 110, 111

TRENT BOSCH
Born 1970, Akron, Ohio
Lives and works in Fort Collins, Colorado

Trent Bosch developed an interest in wood turning while pursuing his undergraduate degree in photography and sculpture at Colorado State University. Bosch is known for rescuing and salvaging wood to create his innovative "vessels within vessels." Combining lathe work and hand carving, he uses a unique method to create pieces that evoke the birth or blossoming of a natural form. Bosch is also the founder of the Rescued Wood Bowl Company. Plate 32

MARK BRESSLER
Born 1951, Detroit, Michigan
Lives and works in Santa Fe, New Mexico

Mark Bressler has been a practicing licensed plumber for twenty-five years. He brought his diverse background and experience to wood when he gave up his full-time job to pursue his interest in turning. A self-described classically trained spindle turner, Bressler's work on the lathe is never charted. His pieces are a revelation by process—with shapes, twists, and turns revealing themselves with often surprising results. Plates 16, 25, 60, 61, 71

MICHAEL BROLLY
Born 1950, Philadelphia, Pennsylvania
Lives and works in Mertztown, Pennsylvania

Michael Brolly's work is inventive, anecdotal, and often surreal. His works reflect the heart of a woodturner and a storyteller. His wood art pieces are labor-intensive, composed of numerous pieces of turned and carved wood assembled into sculptural and often figurative forms that convey a sense of experimentation and spontaneity. Plate 139

CHRISTIAN BURCHARD
Born 1955, Hamburg, Germany
Lives and works in Ashland, Oregon

Christian Burchard was first introduced to wood as an apprentice to a furniture maker in his native Germany in the mid-1970s. He went on to study drawing and sculpture, influences that are apparent in his technically proficient and finely wrought vessels and sculptural turnings. Working almost exclusively with Pacific madrone burl, a species native to America's Pacific Northwest, Burchard turns the wood while green, allowing the inevitable warps and cracks to emerge in the drying process. His work reflects a fine blend of craftsmanship and artistry. Plate 142

MARILYN CAMPBELL
Born 1951, Niagara Falls, Ontario, Canada
Lives and works in Kincardine, Ontario, Canada

Marilyn Campbell's fascination with wood began with her experience building a ferro-cement sailboat in the mid-1970s. She now combines turned wood with epoxy, a medium used in boatbuilding that she found to be full of creative possibilities and now considers her second medium. Campbell's inspiration stems from the natural world, but she admits it "takes a twist in its passage through my imagination." Plate 39

CHRISTOPHER CANTWELL
Born 1960, Atwater, California
Lives and works in Oakhurst, California

A balsa wood sculpture won Christopher Cantwell the Central California Art League Young Masters Art Competition at the age of twelve. Just a few years later, Cantwell was selling his handcrafted furniture, but by his mid-twenties he took a break from artistic pursuits to rock climb professionally. A love of working with wood eventually drew him back, however, and he now devotes himself full-time to art. Cantwell works with nearly one hundred varieties of wood, seeking the more unusual for inspiration in his sculptural works. Plate 97

GALEN CARPENTER
Born 1946, Newton, Kansas
Lives and works in Sedona, Arizona

Galen Carpenter is a self-taught woodturner whose vessels are painstakingly crafted and intricately worked, created by laminating segments of wood turned on a lathe. Carpenter makes detailed plans for his 120 works a year. His geometrically patterned objects, evocative of classical vessels, are frequently enhanced with bone, antler, coral, epoxy, and turquoise. Plate 40

ROBERT CHATELAIN
Born 1945, Eagle Pass, Texas
Lives and work in Camel's Hump, Vermont

Robert Chatelain studied chemistry before turning to art in the mid-1970s. A self-taught lathe worker, he embarked on a professional wood-turning career, producing pieces made from a variety of native and exotic woods. Chatelain gradually introduced other materials into his turned-wood pieces, including semiprecious and precious metals and epoxy resins, to give his works a multidimensional appearance. Referring to what he calls the "hand of man in nature," Chatelain creates work that joins the organic and the synthetic in traditional vessel forms. Plates 33, 34

DICK CODDING
Born 1942, Akron, Ohio
Lives and works in Leesburg, Florida, & Cobden,
Illinois

A ten-year veteran of the Navy, Dick Codding worked as a salesman, carpenter, nurseryman, and construction carpenter until 1990, when a wood-turning course changed the direction of his life. Within a few years, Codding had become a prolific turner with a national reputation for his classically beautiful vessels that incorporate color and texture to dramatic effect. Plates 106, 148

ROBERT J. CUTLER
Born 1944, Wendell, Idaho
Lives and works in Kenai, Alaska

Robert Cutler's work shows his deep affinity and respect for nature and reflects his Alaskan upbringing. Devoting himself exclusively to his art, Cutler preserves his connection to his home state by working with birch burl, precious and semiprecious metals, walrus ivories, and other materials indigenous to Alaska, to create designs that reflect a strong instinct for shape and form. Plates 44–46

DARRELL DAVIS
Born 1950, Portland, Oregon
Lives and works in Portland, Oregon

After studying under fellow wood artist Frank Sudol, Darrell Davis furthered his training in wood turning through demonstrations and workshops led by many of the top woodturners working in the United States. Davis works exclusively with dead or damaged trees he salvages himself. Davis says his aim is to "push the limits of distressed woods," using them liberally in his mixed-media works. Plate 115

DONALD DERRY
Born 1956, Othello, Washington
Lives and works in Ellensburg, Washington

Donald Derry likens the physical demands of wood turning to a fluid, free-form dance. This embrace of process is apparent in the highly stylized, striking forms that at times appear to be suspended in midair. After years of crafting small wood pieces, Derry, in 1999, devoted himself to larger works of art: hollow vessels—vibrantly colored and polished to a gleaming luster—that give the impression of blown glass. Plates 15, 112, 113

DENNIS ELLIOTT
Born 1950, London, England
Lives and works in Cape Coral, Florida

Dennis Elliott played drums with the rock band Foreigner in the 1970s and '80s. He discovered an alternative venue for creative expression when his wife gave him a lathe attachment for his Black & Decker drill for Christmas in 1972. Elliott was inspired by the imaginative woodturners working in the United States when he moved here in 1975. He works almost exclusively in big leaf maple burl, producing vessels and wall sculptures turned on the lathe and enhanced with sandblasting, burning, and carving. Plate 19

DAVID ELLSWORTH
Born 1944, Iowa City, Iowa
Lives and works in Bucks County, Pennsylvania

A lifelong interest in the vessel began with David Ellsworth's first exposure to wood turning at the age of fourteen and was reinforced by his pursuit of a master's degree in sculpture. By the mid-1970s Ellsworth had turned exclusively to wood turning, custom designing tools that allowed him to create thin-walled vessels in a process he calls "blind turning." Graceful and delicate in form, Ellsworth's work is understated, right down to the subtle grain of white oak he often uses. Preferring to work in series, Ellsworth's works are explorations in process and very personal expressions. Plate 62

TERRY EVANS
Born 1951, Chetopa, Kansas
Lives and works in Olathe, Kansas

Terry Evans is dedicated to promoting a wide range of hardwoods that he believes are underutilized and underappreciated by wood artists. In addition to searching for little-known species, Evans is committed to environmentally responsible work, using, when he can find them, woods destined for landfills. His love of wood is apparent in objects that highlight the natural beauty of the medium through signature geometric imagery incorporating detailed inlay with a spare use of veneers. Plate 42

J. PAUL FENNELL
Born 1938, Beverly, Massachusetts
Lives and works in Scottsdale, Arizona

J. Paul Fennell worked on the Apollo space program as a mission analyst. He looked to wood turning to occupy his spare time, taking adult education courses in lathe work and attending symposia to learn more. Soon Fennell's work became linked with that of fellow turners David Ellsworth and Rude Osolnik. His delicate works are vessels that reinterpret classical shapes in unusual colors, grains, and surfaces. Plate 35

CORIANDER FIRMAGER
Born 1975, Redhill, Surrey, England
Lives and works in Wedmore, Somerset, England

Coriander Firmager is the daughter of wood artist Melvyn Firmager. Their collaborative pieces have appeared in exhibitions in New York and Los Angeles. She holds a diploma in art and design from Somerset College of Arts and Technology and a bachelor's degree in fine art from Falmouth College of Arts, Cornwall. She describes her work as "an interpretation of the inner landscape through to the outer," influenced by a sense of place. Plate 86

MELVYN FIRMAGER
Born 1944, Walton on Thames, Surrey, England
Lives and works in Wedmore, Somerset, England

Melvyn Firmager has turned the traditional vessel form on its head. Working at his farm, Firmager began turning forms such as bowls, candlesticks, and goblets. In the late 1980s he turned to wood turning professionally, and his pieces made a change from the functional to the dramatic, such as the multirim objects for which he is best known. Inspired by organic forms that suggest petals and wings, the artist designs his own tools specifically for this process of hollow work. Plate 86

RON FLEMING
Born 1937, Oklahoma City, Oklahoma
Lives and works in Tulsa, Oklahoma

The influence of nearly forty years spent as a commercial artist is evident in Ron Fleming's vessels. Fleming's lathe-turned works are painstakingly detailed with hand carving that reveals Fleming's strong graphic sensibility. Made of what he calls "given" wood, rather than working from live, green medium, his works are celebrations of the natural world in the overlapping, fluid leaf and petal forms that compose the walls of his vessels. Plates 116–118

DEWEY GARRETT
Born 1947, Richmond, Missouri
Lives and works in Livermore, California

An interest in developing his woodworking skills for furniture making first led Dewey Garrett to lathe work. Both artistic skill and a background in engineering are evident in his explorations with wood. Garrett has said that at the heart of his work is the fascinating pursuit of symmetry in the transformation of a wood block on the lathe. Plate 7

RONALD GERTON
Born 1946, Denver, Colorado
Lives and works in Richland, Washington

Ron Gerton has been producing art throughout his thirty-one-year career as a mechanical engineer. A maker and seller of handcrafted gold and silver jewelry, Gerton also works in large-scale bronze objects at his studio foundry. His latest body of work, which combines turned wood and bronze, is influenced by the desert environment of eastern Washington State. Plates 92, 131

GILES GILSON
Born 1942, Philadelphia, Pennsylvania
Lives and works in Schenectady, New York

Giles Gilson's rich and varied background brings dimension to his art. His education in music, design, and fine art was followed by years as a jazz musician and then a theater director. A passion for the technical aspects of cars and airplanes led him to race-car design while pursuing wood turning. His work combines graceful form and tactile, innovative surfaces, marrying precision with improvisation. Plates 28–31, 65, 143

ANDREW GITTOES
Born 1959, Goulburn, New South Wales, Australia
Lives and works in Goulburn, New South Wales, Australia

Australian native Andrew Gittoes studied as a resident at the Wood Turning Center in Philadelphia before returning to Australia to create pure, elegant objects that have an organic quality. Gittoes is a passionate conservationist who works only with salvaged wood. He has planted and maintains nearly ten thousand trees on his property on the eastern coast of Australia. Plate 147

MATTHEW HATALA
Born 1952, Portland, Oregon
Lives and works in Danielsville, Georgia

Following undergraduate work in art history at the University of Oregon, Matthew Hatala became a homebuilder. Citing his wife Beatrice Lilly, a glass artist and photographer, as inspiration, Hatala pursued his lifelong love of woodworking and in the mid-1990s embarked on a career as a wood artist. He works with a wide range of woods and a variety of other materials, such as plastic, nuts, grasses, seed pods, and stone to create works as diverse in style as they are in material. Plates 11, 12

MICHAEL HOSALUK
Born 1954, Invermay, Saskatchewan, Canada
Lives and works outside Saskatoon, Saskatchewan, Canada

Michael Hosaluk grew up on a Saskatchewan farm lacking in many modern conveniences. He learned at an early age to work with wood and to value handwork. He continues to live in the region and works with wood native to the area, found in logging sites, obtained from tree cutters, and at salvage yards. Creating both sculptural and functional vessels, Hosaluk regards his turned wood objects as very personal expressions that tell the stories of his life and reflect the importance of place. Plate 67

TODD HOYER
Born 1952, Beaver Dam, Wisconsin
Lives and works in Bisbee, Arizona

Following his father's death in the 1960s, Todd Hoyer moved with his mother from Wisconsin to Scottsdale, Arizona, where he first saw the work of legendary turners Bob Stocksdale, Ed Moulthrop, and Alan Stirt. When his uncle gave him his first lathe several years later, Hoyer embarked upon a lifelong journey turning wood. Hoyer finds wood's intricacies and irregularities of great appeal and uses the texture and warmth of his medium to its full advantage, calling it his "canvas" for expression. Plates 38, 64

STEPHEN HUGHES
Born 1958, Melbourne, Victoria, Australia
Lives and works in Aspendale Gardens, Victoria, Australia

Australian woodturner Stephen Hughes received formal training in wood turning from fellow artist Vic Wood, though he regards his work, at its essence, as an instinctive response to the medium. His medium is Australian timber, which offers a great range of qualities. Proceeding from preliminary designs on paper, he creates objects that reflect the connections between wood and other natural elements in a way that highlights the sense of the organic in his art. Plate 76

WILLIAM HUNTER
Born 1947, Long Beach, California
Lives and works in Rancho Palos Verdes, California

Despite having received degrees in both fire science and sociology, wood turning is the only profession William Hunter has known. While still in high school, he began turning wood to raise money for college. A self-taught wood artist, Hunter has pioneered the process of "subtractive sculpturing," in which he redefines the vessel form. His spiral-fluted vessels can be both skeletal and sensual, evocative of a graceful, fluid movement, which he describes as expressing "motionless movement." Plates 21, 63

MIKE IROLLA (MEI)
Born 1974, Irvington, New York
Lives and works in Marquette, Michigan

Interested in woodworking since taking a high school industrial-design class, Mike Irolla first studied wood products technology at the State University of New York–Morrisville before transferring to Northern Michigan University in Marquette, where he obtained a bachelor's degree in fine arts. Irolla began turning professionally eight years ago. His work exhibits his particular interests in incorporating bark and the wood's natural edge, and in the use of fire as an important element in the completion of the work. Plate 26

LYLE JAMIESON
Born 1946, Detroit, Michigan
Lives and works in Traverse City, Michigan

Lyle Jamieson was introduced to wood turning at a young age by his father, a wood pattern maker in Detroit. Jamieson has a business degree from Michigan State University and works as a circulation manager for a local newspaper. Jamieson seeks to combine the sensual qualities of wood with emotive and graceful movement, resulting in a body of work that makes explicit reference to the human form. Drawing inspiration from ancient art and artifacts, Jamieson uses the grain of the wood to help him realize his vision. Plate 105

ARTHUR JONES
Born 1937, Lake Charles, Louisiana
Lives and works in Orlando, Florida

Despite working in the construction trade during high school summers, Arthur Jones did not learn to turn wood until after his retirement in 1990 from teaching sociology and criminology at Rollins College in Winter Park, Florida. Jones turned his first object in late 1992 and has gone on to become a major figure in the field of turned and carved wood art. Carefully preconceived, Jones's objects are expressive and contemplative, an arena for fantasy, myth, and symbol. Many of his works evoke natural forms or make symbolic references to natural phenomena. Plates 72, 132–134

JOHN JORDAN
Born 1950, Nashville, Tennessee
Lives and works in Antioch, Tennessee

A self-taught woodturner, John Jordan worked as a computer systems engineer and occasional furniture maker before he started turning wood in 1986. He is best known for his elegant and classically shaped vessels, which are often interestingly textured and colored. Finely detailed, Jordan's objects are often as much about the play of light across the surface as they are about the form itself. Plate 37

CHARLES AND TAMI KEGLEY
Born 1953, Houston, Texas; 1961, Waco, Texas
Live and work in Boerne, Texas

Charles and Tami Kegley are artists with a wide variety of interests. Known primarily for their exquisite one-of-a-kind jewelry, they also make carved figurative sculpture and works on canvas. They produced the platter that appears in this volume in 1995 as a special thank-you to collector Irving Lipton, who helped them after their house and studio were flooded. Intentionally retrospective, the platter evokes a style from several years prior because Lipton's collection did not possess a Kegley piece from that period. A sister piece, produced from the same plank of wood and under similar circumstances for Fleur Bressler, is now in the Smithsonian Institution's Renwick Gallery. Plate 55

RON KENT
Born 1931, Chicago, Illinois
Lives and works in Kailua, Hawaii

Armed with a degree in mechanical engineering from UCLA, Ron Kent began his career as an aerospace engineer before spending thirty years as a stockbroker. Kent began turning in the early 1970s on a lathe his wife gave him as a gift. Using Norfolk Island pine, abundant in the South Pacific, Kent seeks simple forms, which he turns to an extremely thin translucency. Some pieces are intentionally cracked and stitched together with patinated copper braid. They form a series the artist calls "Post-Nuclear," a reference to a damaged future world in which new things would be stitched together from broken remnants of the old. Plate 18

WILLIAM KENT
Born 1919, Kansas City, Missouri
Lives and works in Durham, Connecticut

After obtaining a science degree from Northwestern University and studying music at Yale, William Kent began carving wood in the late 1940s. His study of music led him to experiment with painting and then printmaking. His interest in wood carving grew out of carving slate for his printmaking. In addition to a stint as curator of the John Slade Ely House Art Center in New Haven in the early 1960s, Kent has been carving wood for the past fifty years. His wood creations usually represent everyday objects, realized on a grand scale. Plates 103, 104

TED KNIGHT
Born 1947, Dallas, Texas
Lives and works in Dallas, Texas, and Pagosa Springs, Colorado

Ted Knight moved to Los Angeles in his teens and obtained a degree in architecture from the University of California, Berkeley. Knight has loved things made out of wood since he was a young boy and began working on a lathe in his junior high school wood shop. He combined interests in wood and architecture by creating architectural millwork of various historical periods and styles. He has been woodturning professionally for the last ten years and prefers woods from the Pacific Northwest and those indigenous to his Dallas, Texas, home. Plate 13

DAN KVITKA
Born 1958, Los Angeles, California
Lives and works in Portland, Oregon

Dan Kvitka received a bachelor's degree in industrial design from the Art Center College of Design in Pasadena, California. He uses exotic species and seeks to release the hidden qualities inherent in the wood. He has said that every new piece is part of his ongoing education as well as being part of a larger continuum, connected to wood artists who have preceded him. "The significance of the vessel, both functional and decorative, has for millennia attached us to who we are and where we have come from," he said. Plate 108

STONEY LAMAR
Born 1951, Alexandria, Louisiana
Lives and works in Saluda, North Carolina

After studying industrial art and wood technology at Appalachian State University, Stoney Lamar borrowed a lathe from a friend and soon the art of wood turning supplanted his original goal of designing and building furniture. Apprenticeships with Melvin and Mark Lindquist and David Ellsworth helped Lamar hone an individual approach to work, one in which multiple axes are used to sculpt the form. This subtractive process of construction results in asymmetrical objects that evoke forms both figurative and abstract. Plate 69

RON LAYPORT
Born 1942, Elyria, Ohio
Lives and works in Pittsburgh, Pennsylvania

For nearly forty years Ron Layport worked as a creative director for films and television commercials and received some of the advertising field's most prestigious honors. In 1985 he began designing and producing one-of-a-kind handmade furniture. In 1993 he took a course in wood turning at the studio of David Ellsworth and seven years later left advertising to devote himself full-time to producing art. He cites ancient cultures, nature, and the animal world as inspirations for his signature winged vessels. Plate 137

MICHAEL LEE
Born 1960, Honolulu, Hawaii
Lives and works in Kapolei, Hawaii

Michael Lee bought his first lathe on a whim. Armed with a book and a set of tools, he set about learning the art of turned wood. After several years of what he calls the "fine art of bludgeoning wood," Lee's work began selling well enough to allow him to leave his job as a data processor. Between 1990 and 1993, he spent time at the Arrowmont School of Arts and Crafts in Gatlinburg, Tennessee. Lee's current work focuses on carved pieces with an emphasis on design and texture. Some of Lee's forms derive from his experience as a surfboarder and his knowledge of the motion of the sea. Local sea creatures and indigenous fossils also serve as inspiration for his pieces. Plate 144

MARK LINDQUIST
Born 1949, Oakland, California
Lives and works in Quincy, Florida

Although Mark Lindquist holds two art degrees, it was the experience of working with his father, woodturner Melvin Lindquist (1911–2000), that has most influenced him. Both of the Lindquists are credited with popularizing the use of spalted wood, characterized by elaborate patterns of brown and black lines, which occur as a piece of wood decomposes. Mark Lindquist is also credited with introducing the aesthetic of Asian ceramics into wood art. As a teacher and a writer, Mark Lindquist has played a significant role in revolutionizing the field of wood art, encouraging fellow artists (and the public at large) to look beyond function and see the full potential of wood as a medium. Plate 1

CLIFF LOUNSBURY
Born 1957, Tarrytown, New York
Lives and works in East Tawas, Michigan

A graduate of Appalachian State University, Cliff Lounsbury has been turning wood for over ten years. Focusing on woods that are often overlooked, Lounsbury seeks to transform the ordinary into the extraordinary. He often selects burls for their distinctive wood grains and twisted appearance. Plates 119–121

BARRY T. MACDONALD
Born 1954, Detroit, Michigan
Lives and works in Grosse Pointe, Michigan

Macdonald holds degrees in Chemistry, Music History, and English Literature from Wayne State University in Detroit, Michigan, but he is best known as a self-taught woodturner and furniture maker. He has operated his own business, The Good Turn, since 1984 but works alone, employing no assistants or apprentices. In the process of building his business, Macdonald realized the full potential of the lathe to create aesthetic as well as functional forms. Macdonald's focus has been to render in wood a wide array of vessel forms that are more typically created from clay or glass. The result is a varied and dynamic body of work. Plate 14

STEVEN MACGOWAN
Born 1953, Sodus, Michigan
Lives and works in Sodus, Michigan

Specializing in painted wood reliefs, Steven MacGowan captures the often overlooked details of urban life: sidewalks, puddles, and shadows all play an integral role in his compositions. MacGowan combines carved relief work with illusionistic painted details so that the final piece becomes a hybrid between a painting and a sculpture. Plates 101, 102

ALAIN MAILLAND
Born 1959, Ivory Coast, Africa
Lives and works in Uzès, France

Alain Mailland studied at the National Art School of Cergy-Pontoise, where he first investigated landscape painting. Mailland worked as a mason and carpenter, took his first course in wood turning at age twenty-eight, and established his own woodworking shop specializing in stairs, cabinetry, and verandas. In the early 1990s, he shifted his focus to wood art exclusively. Taking classes with other notable woodturners, such as Michael Hosaluk and Terry Martin, Mailland soon developed his own style. "In my pieces, I try to express the beauty of life by revealing the forces in the wood. . . . By carving I give soul to turned shapes, and this is my pleasure." Plates 2, 84, 107, 145

DEAN MALCOLM
Born 1965, Perth, Western Australia
Lives and works in Albany, Western Australia

Shortly after graduating with a bachelor's degree in industrial design from Curtin University in 1985, Dean Malcolm established a workshop near Denmark, in the Great Southern Region of Western Australia. He lives at the edge of a lagoon in a house he built himself, working on a lathe that he also built. Malcolm is best known for his fluted or ridged hollow vessel forms, which assume a variety of shapes and sizes and are striking for their subtlety. He is an educator as well as an artist. Plate 90

TERRY MARTIN
Born 1947, Melbourne, Victoria, Australia
Lives and works in Brisbane, Queensland, Australia

Terry Martin's varied careers have included stage managing London's Royal Ballet Company, ski patrolling in Austria, and conducting mining exploration in Papua, New Guinea. He began turning in 1984, before devoting his life to it five years later. Martin has actively promoted the field through articles, books, lectures, and his role as curator of numerous exhibitions. He is the author of the 1996 book on contemporary Australian wood turning, *Wood Dreaming*. Martin's distinctive work, whether vessel-like or more sculptural, possesses both a sense of playfulness and an eerie otherworldliness. Plates 85, 89, 129, 130

HUGH MCKAY
Born 1951, Long Beach, California
Lives and works in Gold Beach, Oregon

A self-taught woodturner, Hugh McKay has been exhibiting since 1984. Setting up his own shop in 1979, intending to make a living as a furniture maker, McKay quickly became absorbed in the expressive possibilities of wood turning. This interest in expression extended beyond wood, and McKay's pieces often have cast lead crystal and cast bronze embellishments. Keenly aware of the vessel tradition in wood turning, McKay has, during the course of his career, helped to transform the concept of the vessel, moving it away from the idea of a functional container into the realm of vessel-like sculpture. Plates 8, 23, 24, 77–79

CAM MERKLE
Born 1957, Saskatoon, Saskatchewan, Canada
Lives and works in Martensville, Saskatchewan,
Canada

A frequent collaborator with wood artist
Frank Sudol, Cam Merkle has been creat-
ing and teaching bird carving for more
than twenty years. Founder of the Sas-
katchewan Wildlife Art Association, a
non-profit group, Merkle has a company,
Razertip Industries, which manufactures
pyrographic (woodburning) tools. Using
these tools, Merkle creates detailed effects
that often mirror those found in nature.
Merkel observes wildlife and nature on his
property, which is a designated protected
wildlife habitat with the Saskatchewan
Watershed Authority. Plate 126

ELISABETH MEZIERES
Born 1963, Nîmes, France
Lives and works in Uzès, France

Originally a painter, Elisabeth Mezieres
learned wood turning and carving from
her husband, wood artist Alain Mailland.
In addition to creating unique pieces and
sculptural works such as *Vegetal Dream,*
Mezieres is also involved in making Chinese
bowls for eating and cooking. Plate 88

MICHAEL MODE
Born 1946, Quakertown, Pennsylvania
Lives and works in New Haven, Vermont

Michael Mode's technical skills were
honed primarily through his work produc-
ing guitar bodies destined for Martin Guitar
Company and building his own harpsichord
and clavichord. Travels to Kashmir, India,
and the Middle East, and the architecture
he saw there, greatly influenced his work.
His earliest work centered on lidded con-
tainers, and these forms continue to interest
him. Mode has also explored open forms
while maintaining his characteristic interest
in geometric patterns and graceful curves.
Plates 4, 47

EUCLED MOORE
Born 1955, Abilene, Texas
Lives and works in San Miguel de Allende, Mexico

Eucled Moore first worked on a lathe while
attending school in the Rift Valley of Kenya,
where he lived when his father, a Baptist
minister, worked as a missionary in Tanza-
nia. Moore has specialized in polychromatic
segmented lathe turnings in which various
woods are incorporated into colorful pieces
that highlight the natural hues of the wood.
The resulting works often display inspira-
tion from Native American patterns, which
Moore sketches out prior to creating his
pieces. Plates 50–52

GARY MOORE
No biographical information available

Plates 122, 123

WILLIAM MOORE
Born 1945, Arlington, Virginia
Lives and works in Hillsboro, Oregon

William Moore received bachelor's and
master's degrees from the University of
Michigan. He has created a body of work
that weds metal and wood into sculptural
forms. He has spent many years exploring
the sculptural possibilities of the vessel
form, combining turned wood with non-
ferrous metal spun on a lathe. Moore's
pieces often involve a component of bal-
ance, carefully constructed, which serves
to enliven the final works. Plate 142

JOHN MORRIS
Born 1963, Sheffield, England
Lives and works in Brisbane, Queensland,
Australia

John Morris began his artistic career in
graphic design at Queensland College of
Graphic Design and worked as a freelance
illustrator and sculptor before turning to
wood in 1996. One of Australia's leading
fine wood sculptors, John Morris's highly
individual and idiosyncratic works reflect
his fascination with anatomy. Usually cul-
minating in an assemblage work, Morris's
work often centers on the human form,
although he has also explored animal and
insect forms in his work. Plates 81–83

STUART MORTIMER
Born 1942, Aberdeenshire, Scotland
Lives and works in Hampshire, England

Stuart Mortimer grew up in a farming
community in Scotland and has always felt
connected to nature. Introduced to wood
turning in school, it wasn't until 1968 that
he explored wood turning as a hobby. After
his retirement in 1989 from twenty years
in the police force, Mortimer began to turn
full-time. Although best known for his signa-
ture delicate spiral forms, Mortimer explores
a wide variety of forms, from miniature
pieces and goblets to large vessels over
eight feet in diameter. Plates 6, 20, 141

PHILIP MOULTHROP
Born 1947, Atlanta, Georgia
Lives and works in Marietta, Georgia

Philip Moulthrop worked as a chemist
after college before joining the Navy as
a language instructor in Vietnam. He
attended law school in the mid-1970s
and practiced insurance and construction
law for nearly twenty years. It was his
father, architect and woodturner Edward
Moulthrop (1916–2003), who exposed
Philip to the art of wood turning, but it
was years before he was finally seduced by
the wood itself. Having turned wood for
nearly twenty-five years, Philip Moulthrop
became a full-time woodturner in 1996. He
uses wood from trees native to the south-
eastern United States. Plate 43

ROLLY MUNRO
Born 1954, Rotorna, New Zealand
Lives and works in Normandale, New Zealand

Rolly Munro graduated from Otago Art
School in 1978 and Teachers College in
1986 and currently lives on the eastern
coast of New Zealand's North Island. He
draws inspiration from indigenous New
Zealand traditions, a variety of sea life,
and the Oceanic artistic tradition. Munro's
sculptural vessel forms, which include a
range of materials such as mesh, epoxy,
copper, and pigment, evoke the sense of
power and the supernatural found in the
work of native Maori artists. Plates 80, 138

DALE NISH
Born 1932, Cardston, Alberta, Canada
Lives and works in Provo, Utah

Dale Nish earned advanced degrees from Brigham Young University, where he eventually served as professor of industrial engineering. Nish's lifelong interest in woodworking and his extensive background in education naturally led him to teach wood turning. Working exclusively in wormy ash, Nish embraces a material in an early state of decay and transforms it into vessels of great and unusual beauty. He has also written extensively on woodturning technique. Plate 36

DAVID NITTMANN
Born 1944, Schenectady, New York
Lives and works in Boulder, Colorado

After two years at the University of Colorado and three years in the United States Army, David Nittmann enrolled at Colorado State University, where he received a bachelor's degree in wildlife biology and a master's degree in watershed science. He was employed in industrial, commercial, and residential construction before starting his own cabinet and furniture shop in 1980. Chair making and repair led him to the lathe, and in 1994 Nittmann cofounded the Rocky Mountain Woodturners and served as its president for the first three years. David Nittmann is a part-time faculty member at Arrowmont School of Arts and Crafts in Gatlinburg, Tennessee. Plate 52

NIKOLAI OSSIPOV
Born 1954, Novosibirsk, Russia
Lives and works in Chino, California

Russian-born artist Nikolai Ossipov began studying art with his father at the age of three. After working as a book illustrator and a designer of public buildings and private commissions in the Ukraine, he visited and exhibited in America in 1991. A year later he immigrated to the United States, where his work can be found in museums and many private collections. Plate 100

MARK PARISH
Born 1950, Canton, Ohio
Lives and works in New Philadelphia, Ohio

Mark Parish has worked with wood for more than thirty years while at the same time working for a bearing and steel manufactory in northeastern Ohio. In 1993, inspired by an article in *Wood* magazine on wood-turned vessels, Parish shifted his focus to lathe work. He is known for turnings that combine traditional vessel shapes with unusual, exotic woods. Plate 41

STEPHEN PAULSEN
Born 1947, Palo Alto, California
Lives and works in Redway, California

The son of an expert woodworker, Stephen Paulsen not surprisingly had his first gallery showing at the age of fifteen. After completing his education at the University of California, Santa Barbara, in 1971, Paulsen moved to the Pacific Northwest, where he worked in the logging, millwork, and lumber manufacturing trades. In 1980 he opened Paulsen Fine Art Woodworks, where he created turned, carved, machined, and inlaid scent bottles. Five years later, Paulsen's woodworking took the direction of wall constructions, and by 1991 he had created more than three hundred of these works. Plate 99

MICHAEL JAMES PETERSON
Born 1952, Wichita Falls, Texas
Lives and works on Lopez Island, Washington

When Michael Peterson began turning in 1980, it was his surrounding native environment that served as the inspiration for his work. Specifically, he credits the natural history of the West—its landscapes, culture, and the spirit existing within these elements—as the foundation for his work. Plate 91

BINH PHO
Born 1955, Saigon, Vietnam
Lives and works in Maple Park, Illinois

Binh Pho entered the world of woodworking as a hobbyist. He studied architecture in college before he fled to the United States, where he continued his education in Kansas City. When he saw a presentation about John Jordan at a woodworking show he decided to enroll in an introductory class taught by Leonard Hartline, who became Pho's best friend and teacher. Pho and his work were also inspired and influenced by his mentors: Michael Mode, who helped Pho find his "voice and identity" in the world of wood; Frank Sudol, whose piercing techniques can be seen in some of Pho's work; and Michael Hosaluk, whose use of bold colors opened doors of exploration for Pho. Plates 53, 54, 70, 124, 125

DWAYNE ROHACHUK
Born 1957, Prince Albert, Saskatchewan, Canada
Lives and works in Prince Albert, Saskatchewan, Canada

In 1990, while earning a living as a cabinet and furniture maker, Dwayne Rohachuk first discovered the art of wood turning when he had the opportunity to view the work of Frank Sudol. Inspired, he began taking classes with Sudol and fellow woodturners Michael Hosaluk and John Jordan. Just two years later, Rohachuk helped found the Prince Albert Woodturners Guild, which today boasts thirty-five active members and a yearly symposium. Rohachuk also teaches wood turning in his home studio. Plate 146

MARGARET SALT
No biographical information available

Plate 76

BETTY J. SCARPINO
Born 1949, Wenatchee, Washington
Lives and works in Indianapolis, Indiana

Betty Scarpino attended the University of Missouri–Columbia, where in 1981 she received a degree in industrial arts, with a specialty in woodworking. Her earliest works were functional objects, but over the years her style has evolved into more sculptural forms that are created well after the lathe work has been completed. Carving, bleaching, and enhancing texture are some of the ways this artist has brought her signature style to this medium. Plates 73, 74

PETER SCHLECH
Born 1947, Oahu, Hawaii
Lives and works in San Diego, California

Peter Schlech pursued his studies in art and literature at the University of Miami and the University of Maryland. He worked designing and constructing wooden yachts for thirty years prior to pursuing wood turning seriously. In 1996, after attending an exhibition on woodworking, he was inspired to try his hand at it. Since that time, his work has won numerous wood-turning awards and has been exhibited in many galleries. Plate 98

BRAD SELLS
Born 1969, Cookeville, Tennessee
Lives and works in Cookeville, Tennessee

Brad Sells began working professionally as a woodturner after completing college in 1994, the same year he opened his studio in Cookeville, Tennessee. His studies in the natural and social sciences are reflected in the organic forms and themes of his work, which revolve around life, the process of nature, and the passage of time. Because of the unique shapes his work takes, there is a misconception that his turning process involves bending or chemically manipulating the wood, but it does not. Sells's pieces are created through a unique process he developed, which involves using a chain saw to carve out the form and refining it through the use of grinders. Plates 9, 10, 94, 95

DAVID SENGEL
Born 1951, Radford, Virginia
Lives and works in Boone, North Carolina

David Sengel first learned woodworking as a child in his father's home workshop. With a degree in music from North Carolina's Davidson College, he worked as a piano technician and opened his own restoration and repair business. A familiarity with and interest in wood led to lathe work and classes with wood artists Del Stubbs and David Ellsworth. Since 1987 Sengel has devoted himself full-time to wood art. Following a car accident several years ago, Sengel has tempered his use of the physically demanding lathe with hand carving. Plate 135

FRANK SHARP JR. (AND BIG ISLAND WOODTURNERS CLUB)
Born 1942, New Richmond, Ohio
Lives and works in Honoka'a, Hawaii

Frank Sharp Jr.'s service with the 25th Infantry Division took him to Vietnam and to the island of Oahu. Choosing to remain in Hawaii, Sharp worked with wood throughout his career working for a sugar plantation and later for the county. In retirement, Sharp has focused on lathe work and the vessel form. He is active in the wood art community and is a member of Hawaii's Big Island Woodturners Club. Plate 136

MICHAEL SHULER
Born 1950, Trenton, New Jersey
Lives and works in Santa Cruz, California

Michael Shuler started turning wood in 1964 at the age of fourteen by using a pocketknife and makeshift lathe. Mostly self-taught and self-employed, he has been an independent studio artist since 1973. In 1985 he began creating works using a segmented turning technique that requires cutting and reassembling a single board, a technique that has become his specialty. Plate 49

STEVE SINNER
Born 1942, Omaha, Nebraska
Lives and works in Bettendorf, Iowa

Steve Sinner's introduction to wood turning came as a preteen when his father gave him a used lathe. Sinner attended Iowa State University, where he studied industrial education and went on to a career with the farm-machine manufacturer J. I. Case. It was the discovery in 1975 of woodturner Dale Nish's book *Creative Wood Turning* that inspired Sinner to pursue his childhood interest in earnest, and in 1998 he devoted himself full-time to art, specializing in deep hollow vessels. Plate 114

HAYLEY SMITH
Born 1965, Cardiff, Wales
Lives and works in Bisbee, Arizona

With an educational background in both design and art education in her native Cardiff, Hayley Smith has emerged as one of a growing number of female woodturners in the United States. A frequent collaborator with her husband, Todd Hoyer, her own works are a celebration of the process, which the artist finds both therapeutic and mesmerizing. Plate 75

ALAN STIRT
Born 1946, Brooklyn, New York
Lives and works in Enosburg Falls, Vermont

Alan Stirt graduated from Harpur College in 1969 with a B.A. in psychology. The following year he discovered wood carving and through books soon schooled himself in lathe work. By 1977 his distinctive style, which combines turned vessels with intricate hand-carved textures, had brought him acclaim in the wood art community and eventually a Lifetime Achievement Award from the American Association of Woodturners. Plate 5

FRANK SUDOL
Born 1933, Paddockwood, Saskatchewan, Canada
Lives and works in Paddockwood, Saskatchewan, Canada

A lifelong love of nature is reflected in Frank Sudol's works of art as well as his choice of careers. A degree in biology was followed by his employment as a Parks Canada naturalist; a subsequent degree in education led him to a career as a high school science teacher. In addition to his regular employment, Sudol has also furthered the tree industry in his native Saskatchewan by establishing the Saskatchewan Christmas Tree Growers Association. An artist and teacher, Sudol's wood art reflects his interest in conservation issues and ecology. His lathe-turned vessels, made primarily from the birch trees on his farm, are detailed using a high-speed dental drill to create the lacelike images inspired by the environment, which he says illustrate the "fragility of our eco-system." Plates 58, 59, 126–128

JACQUES VESERY
Born 1960, New Milford, New Jersey
Lives and works in Damariscotta, Maine

Before establishing himself in the wood art field, Jacques Vesery served in the Navy as a submariner and worked in northern New Jersey as a forest ranger and forest fire warden. Self-taught, the artist references both his European roots and Native American culture in his work. His small-scale pieces are a study of the vessel form, which in Vesery's hands goes beyond the purely functional to evoke spirituality and a deep reverence for nature and the circle of life. Jacques Vesery teaches, lectures, and demonstrates wood turning throughout the world. Plates 3, 140

HANS WEISSFLOG
Born 1954, Hönnersum, Germany
Lives and works in Hildesheim, Germany

German-born artist Hans Weissflog studied
mechanical engineering for two years prior
to entering the field of design. While study-
ing design, he simultaneously apprenticed
with a wood-turning professor. At the age
of forty, he received the Lower Saxony State
Award, the highest honor for a German
craft artist. Plates 22, 87, 93

GEOFFREY WILKES
Born 1951, Jacksonville, Florida
Lives and works in Gerrardstown, West Virginia

Geoffrey Wilkes attended California State
Polytechnic University, where he received
a degree in economics. In 1994 his career
as a nationally renowned wood artist took
off. A self-taught woodturner, he uses local
found wood near his studio in the hard-
wood forests of West Virginia to produce
his lathe-turned vessels. Plate 68

JOHN WOOLLER
Born Australia
Lives and works in Foster, Victoria, Australia

John Wooller worked as an aircraft re-
searcher and taught aerodynamics, thermo-
dynamics, and fluid dynamics before he
turned his attention to art. Unlike many
of his fellow Australian woodturners,
Wooller creates work that breaks free from
the traditional vessel form. Working with
native burls, Wooller turns wood on a lathe
and then hand carves his pieces. He cites
music and literature as inspiration for his
wood art. Plates 66, 96

BOB WOMACK
Born 1947, Silver City, New Mexico
Lives and works in Cortez, Colorado

Following twelve years as a practicing
psychologist, Womack's wood-carving
hobby became his life's work. Self-taught
in free-form carving techniques that in-
volve the use of a chain saw, Womack's art
reflects a fusion of natural and designed
forms, smooth and textured surfaces, and
unusual domestic hardwoods. Although
it was his hiking experience in the woods
of New Hampshire that fascinated him as
a young adult, Womack has made Colorado
his home, and its canyons and mountains,
his inspiration. Plates 27, 109

MELSIK YEGHIAZARYAN
Born 1947, Yerevan, Armenia
Lives and works in Hewitt, New Jersey

Melsik Yaghiazaryan began studying art at
age seven. After graduating from the Arme-
nian Academy of Art in 1985, Yaghiazaryan
worked for ten years as a furniture designer
in his native country. In 1995 he continued
his work in the design field after relocating
to California, where his works were also
exhibited. Since 1996 he has been working
as an interior designer while creating fine
wood carvings. Yaghiazaryan is a National
Master of Armenia, and his woodwork is dis-
played in the House of the Armenian Gov-
ernment as well as in private collections
around the world. Plate 56

ABOUT THE AUTHORS

JANICE BLACKBURN is curator of contemporary art at Sotheby's London and was former assistant curator at the Saatchi Collection (1985–1994). She is also contributing editor to *Arts Review,* a freelance curator specializing in contemporary applied art, an art collector, and an organizer of education projects in the arts. Ms. Blackburn resides in London.

DAVID REVERE MCFADDEN is Chief Curator and Vice President for Programs and Collection at the Museum of Arts and Design in New York and previously served as the executive director of the Millicent Rogers Museum in Taos, New Mexico. Mr. McFadden has organized more than one hundred exhibitions and authored more than seventy books, reviews, and articles. He is a resident of New York City.

TERRY MARTIN has served as editor-in-chief of the woodturning journal *Turning Points* and has published extensively on the art of woodturning. His work has been shown in more than fifty exhibitions worldwide and is held in the collection of several museums, including The Detroit Institute of Arts, The Los Angeles County Museum of Art, and The University of Michigan Museum of Art. He lives in Queensland, Australia.

SEAN ULMER is University Curator of Modern and Contemporary Art at the University of Michigan Museum of Art in Ann Arbor. He is the former Assistant Curator of Painting and Sculpture at the Herbert F. Johnson Museum at Cornell University and has served as Exhibitions Coordinator at the Wexner Center for the Arts. Mr. Ulmer has contributed essays to several books, most recently *Picturing French Style: Three Hundred Years of Art and Fashion* (Mobile Museum of Art).